# THE VISUAL DIMENSION

# THE VISUAL

*The Oxford Centre for Postgraduate Hebrew Studies is extremely grateful to the Waechter Foundation, Geneva, for the financial assistance that has made the publication of this volume possible.*

# DIMENSION

## Aspects of Jewish Art

▶ ▶

Published in Memory of
ISAIAH SHACHAR
(1935–1977)

▶ ▶

edited by
CLARE MOORE

Published in cooperation with
The Oxford Centre for Postgraduate Hebrew Studies

**Westview Press**
*Boulder • San Francisco • Oxford*

*The figure on the title page is from the Photographic Archives of the National Gallery of Art, Washington, D.C.; © 1967, Sotheby's, Inc.*

Copyright © 1993 by Westview Press, Inc.

Published in 1993 in the United States of America by

Westview Press, Inc., 5500 Central Avenue, Boulder, Colorado 80301-2877, and in the United Kingdom by

Westview Press, Inc., 36 Lonsdale Road, Summertown, Oxford OX2 7EW

Library of Congress Cataloging-in-Publication Data
The Visual dimension : aspects of Jewish art / edited by Clare Moore.
       p.      cm.
    Papers presented at a conference held Oct. 23–25, 1977 in Oxford, England under the aegis of the Oxford Centre for Postgraduate Hebrew Studies and the Tarbuth Foundation.
    "Published in memory of Isaiah Shachar (1935–1977)."
    Includes bibliographical references and index.
    ISBN 0-8133-1259-0
    1. Art, Jewish—Congresses.   I. Moore, Clare.   II. Shachar, Isaiah.
N7415.V57   1993
704'.03924—dc20                                            92-13089
                                                              CIP

Printed and bound in the United States of America

 The paper used in this publication meets the requirements of the American National Standard for Permanence of Paper for Printed Library Materials Z39.48-1984.

10   9   8   7   6   5   4   3   2   1

# Contents

# *Preface*

THE FIRST INTERNATIONAL CONFERENCE on Jewish art was held in St. Edmund Hall, Oxford, from October 23 to 25, 1977, under the aegis of the Oxford Centre for Postgraduate Hebrew Studies and the Tarbuth Foundation, New York. This memorial volume commemorates the life and work of Isaiah Shachar through the medium of papers given at that conference, of which he was the instigator and organizer.

I had met Ishay Shachar only once or twice before the conference was mooted. He lived in London, but when I joined the staff of the Oxford Centre in March 1975 he was its Littman Fellow for 1975–76. From the time the first notices of the conference were dispatched in December 1976 he was not well enough to visit Oxford except for the most urgent reasons, but letters and telephone calls passed almost daily between us as he considered every detail of the approaching meeting. The sharp, critical mind not sparing of himself or others of which Professor Abramsky writes in his Appreciation was a marked part of the character that I saw, as was the lightness and charm and the reaching out to share ideas.

Dr. Shachar wrote an article that appeared in *The Times* of London on August 20, 1977 (reprinted in this volume), outlining the history of Jewish art and the background to the first conference. (A summary by Vera Emmanuel of various conference events and personalities appeared in *The Jewish Quarterly* 25 [93] [Autumn 1977], pp. 34–36, and a report by David Patterson appeared in *Jewish Affairs* [February 1978], pp. 11, 13–14, and in *Reconstructionist* [April 1978], pp. 27–28). Dr. Shachar was to have given a lecture on some aspect of eighteenth-century Jewish art, but his health at the time of the conference was too poor. We were indebted to Professor Dov Noy, director, Folklore Research Centre, the Hebrew University of Jerusalem, for filling this gap at the eleventh hour. Professor Noy's lecture on Jewish folk art as part of Jewish folk culture is not included in this volume, but the work has been published elsewhere. Likewise, Dr. Mendel Metzger's lecture "The Italian Haggadah, Its Rite and Iconography from the Thirteenth to Nineteenth Century" is not included: Although he and I worked prodigiously on the wealth of material he has gathered on this subject it proved impossible to reduce it to Dr. Metzger's satisfaction in order to fit the scope of our book. Instead, the lecture will be published as a monograph, with an acknowledgment to the conference organized by Dr. Shachar as its source and inspiration.

Interest in the coming conference was high in the early months of 1977. The number of participants was restricted in the interests of informality and ease of communication. Messages of goodwill came from those, like the late Rachel Wischnitzer in New York, who were unable to attend. Ishay Shachar's underlying purpose for the conference, to encourage the systematic photographic recording of Jewish art and artifacts worldwide, was quite clear. But without the impetus that he would have provided had he lived, the proposal coming from the conference (confirmed in a press

release) for the setting up of a central photographic archives of Jewish art has not been realized.

In the event, the conference was attended by about a hundred people concerned with the scholarship and collection of Jewish art. Although many years have passed since the conclusion of the conference, I hope the publication of these papers will recall for those who participated the high enthusiasm exhibited there. Professor Bernhard Blumenkranz's paper (p. 121*) especially recalls the missing presence amid this celebration of common interests and enthusiasms.

Today, our recollections of the quality and style of this most distinguished scholar—who would have surely, had he lived, produced more notable work—are still most potent. I have prepared this volume with all possible care, knowing whose memory it honors. The volume is dedicated fondly by his colleagues and friends to the life and work of the late Isaiah Shachar.

*Clare Moore*
Administrative Secretary, 1975–80
Oxford Centre for Postgraduate
Hebrew Studies

---

*Professor Blumenkranz's chapter remains as it was prepared for the conference, but the other authors have taken the opportunity to make some alterations and/or additions to their texts.

# Acknowledgments

I AM BEHOLDEN to many colleagues and friends for their help both at the time of the conference and since—Dr. David Patterson, president of the Oxford Centre for Postgraduate Hebrew Studies and Cowley Lecturer in Post-Biblical Hebrew at the University of Oxford from 1956 to 1989, for permitting me to take up Ishay Shachar's role as editor of the conference lectures; David Redstone, Dr. Richard White, Fellow in Hebrew and Aramaic Studies, and Dr. Dovid Katz, Wolf Corob Fellow in Yiddish Language and Literature at the Oxford Centre, for their help with Hebrew and Yiddish translation and transliteration; in particular, Dr. George Mandel, David Hyman Fellow in Modern Jewish Studies at the Oxford Centre, for his patient advice; and my office colleagues at the time of the conference, Mollie Tew, Beryl Hill, Jane Swan-Taylor, Mandy Baxter, and Toni Dutson, for their daily help and friendship. My especial thanks are due to Hannah Safran, archivist of the Oxford Centre from 1977 to 1986, and Giora Hon for their hospitality and friendship during my many trips to Oxford since 1980. For their loving interest my thanks are always due to my parents, James and Kathleen Moore.

The authors and I wish to thank the owners of the photographs that we have used; every care has been taken to acknowledge and attribute them correctly.

*C. M.*
London, England

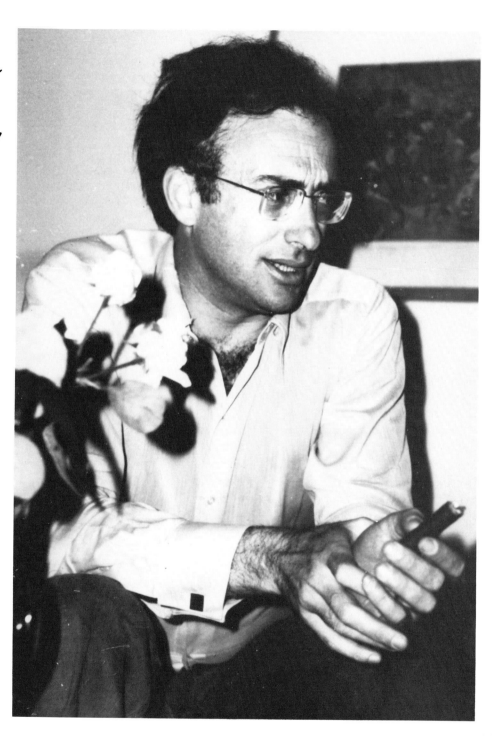

I. Shachar

יואל שחר

# *Yeshayahu Shachar: An Appreciation*

D r. Yeshayahu Shachar (known to his friends as Ishay) died on September 19, 1977, after a long illness. He was in the prime of his life at the age of 42. An outstanding and pioneering scholar in the history of Jewish art and folklore, in which field some of his contributions will remain standard studies for a long time, he combined this scholarship with a solid knowledge of the history of the Jews—particularly in eastern Europe and principally in the period of the early Ḥasidic movement—and with groundbreaking work in the study of anti-Semitism.

He was born Yeshayahu Stengel in Haifa on August 6, 1935. His father belonged to the leftist socialist movement Poalei Zion and was a militant follower of the Marxist teachings of Ber Borochov. From childhood Ishay rebelled against accepted views, whether of his parents or of society in general. He changed his name to Shachar, translating his mother's maiden name, Morgenstern, into Hebrew. He longed to study history and Judaism, and after spending his years of military service in Naḥal, the agricultural division of the Israeli army, and then in kibbutzim, he entered the Hebrew University of Jerusalem, where he studied European history under the late Jacob Talmon and Jewish history in eastern Europe under the late Israel Halperin. He admired Talmon's ideas, though he was also attracted to Halperin's method of analyzing and describing documents in meticulous detail. After graduation he worked for a year as research assistant to Talmon.

From 1958 on he was drawn to late medieval Jewish art—ceremonial, graphic, and manuscript illumination. He divided his time between the Bezalel (later The Israel) Museum, where he worked with Jewish ceremonial artifacts and amulets, and the Department of History of the Jewish People at the Hebrew University, where he worked under the direction of the late Professors H. H. Ben Sasson and Shmuel Ettinger. Under the latter he completed his master's thesis entitled "Criticism of the Jewish Community and Its Leadership in the Ḥasidic and Non-Ḥasidic Literature of Eighteenth Century Poland—A Comparative Study," in which he revealed himself to be an excellent researcher. In his thesis he proved "that compared with the extent and acuteness of non-Hassidic social criticism, the Hassidic literature has very little to say on these subjects and that little is moderate in tone."[1]

From Professor Halperin he learned the careful checking of documents and the veracity of texts, and from Ettinger he learned the history of Russia and Poland and particularly of the place of Jewish history within the wider context of general European history. Ettinger's profound knowledge of historiographic problems left an indelible mark on Shachar's intellectual development.

In 1963, with help from Ettinger, Shachar received a grant to go to London to work on his doctorate at the Warburg Institute of the University of London under

the supervision of the late Professor Otto Kurz and Sir Ernst Gombrich. There he became close friends with Michael Baxendall, Michael Podro, and Simon Pembroke, now well-known art historians. He chose for his doctoral thesis the stereotypic image of the Jews in European art and was awarded his degree in 1967.

While working on his doctorate Shachar became research assistant to Otto Kurz and helped him in recasting completely the skeleton sketch of Professor Leo Mayer's plan for a bibliography of Jewish art. This became subsequently the accepted standard text, *Bibliography of Jewish Art*.[2] Professor Kurz, who was not prone to flattery, paid this generous tribute to Shachar's help:

> Everybody using this bibliography will be grateful to Mr Isaiah Shachar who spent much time in compiling an index which is not the usual string of names and numbers but a veritable key to the contents of the BJA. Only somebody who has his profound knowledge of Jewish Art, and is so familiar with the literature on the subject, could have done it so efficiently.[3]

Shachar's first marriage broke down, though he maintained close contact with his young son, Yaïr. In 1968 he met the very young and vivacious Bérénice Waechter in Jerusalem. Their wedding in Geneva in March 1969 was a memorable occasion not only for Shachar but for his close friends too. Bérénice's knowledge of French and German was extremely useful to him. They traveled extensively in Europe, particularly in Germany, Austria, and Czechoslovakia, and his letters to me included beautiful impressions of the places they visited—he had a keen eye, not only for churches and art but for situations at frontiers and in towns and for vivid reportage about people he met. Together he and Bérénice visited a large number of old churches where they discovered many anti-Jewish iconographic motifs, which they photographed and which were later incorporated in his monograph on the Judensau.

In 1974 the Warburg Institute published his monograph *The Judensau: A Medieval Anti-Jewish Motif and Its History,* and in 1975 Shachar completed a long article entitled "The Emergence of the Modern Pictorial Stereotype of the Jew in England."[4] The first work shows not only his painstaking attention to detail but his extremely wide reading of German sources and excellent bibliographic descriptions. The book evoked great praise from German scholars but some reservations from Israeli scholars because of its rather extensive recourse to the work of Nazi-tainted scholars, whose conclusions Shachar seemed sometimes to accept too simplistically but which he included mainly to show the intellectual spirit of the times. Conversely, the 1975 article was highly praised. Both works are pioneering studies, the first in medieval folk beliefs and the other in the rise and spread of the caricature of the Jew with marked anti-Semitic characteristics. They remain pioneering studies of primary importance in popular anti-Semitism.

On his return to Jerusalem after his honeymoon–cum–study trip Shachar was promoted to senior lecturer in Jewish history at the Hebrew University; he was also by then curator of Judaica at The Israel Museum. He compiled the major catalog of the Feuchtwanger Collection of Jewish Art, whose acquisition for the museum by the Rapaport family of Geneva he instigated. It will remain a model of bibliographic and artistic description, minute attention to detail, and concise scholarly references. It is considered the best catalog of Judaica written and is a pioneering reference work,

describing as it does many items previously ignored by scholars. It remains *the* handbook used by dealers and collectors in the field of Judaica. After Shachar's death The Israel Museum published an English translation of the catalog, on which Shachar had been working intensively for two years, making changes and additions to the Hebrew version.

In 1972 he published a monograph on the engraved glass dishes used by Jewish burial societies in Bohemia-Moravia. And when an amateur archaeologist discovered the seal of Naḥmanides and presented it to The Israel Museum, Shachar published the first monograph on a medieval Hebrew seal (1972). Both booklets, like his earlier studies, broke new ground and are of major historical interest.

While in Israel, Shachar had differences with a number of his colleagues. Sometimes these were temperamental differences, and occasionally they bordered on ideological issues. He, therefore, decided to take leave for a couple of years, and in 1973 he and his wife moved to London. They did not consider themselves emigrants but rather as temporary residents.

In 1974, the year his daughter, Davina, was born, he was appointed visiting lecturer, and later visiting fellow, at the Oxford Centre for Postgraduate Hebrew Studies. He planned a richly illustrated history of Jewish customs and ceremonies to appear in the series *Iconography of Religions,* but only fascicle 3 was published. Among his other projects, he dreamed of editing a critical text of the *Shivḥei ha-Besht* (In praise of Israel Ba'al Shem Tov), the first Ḥasidic hagiographic biography of the founder of the Ḥasidic movement. In this project he was greatly encouraged by Gershom Scholem. He had assembled all the known editions and was beginning to compare the different texts, but beyond this he did not advance.

While in London he became ill, and doctors took a long time to diagnose his illness as a rare lung disease, fibrosing alveolitis. In spite of his physical deterioration he remained optimistic. My wife and I saw a lot of him during his illness, and we admired his ability to continue to discuss historical problems brilliantly and to argue heatedly while at the same time remaining a *raconteur extraordinaire.* He kept on inquiring about every new publication on Jewish history, especially on matters relating to Jewish art, and continuously widened and extended his knowledge of illuminated Hebrew manuscripts. In the last few months of his life he was busy organizing the first international conference on Jewish art, of which this book is the record. Alas, he was too ill to attend the conference and did not succeed in completing his paper for it, although he published an article in *The Times* of London on August 20, 1977 (see p. xiv), outlining the purpose of the symposium and his hope that it would act as a catalyst for the foundation of a central archive of Jewish art.

Shachar was a man of many elements: strikingly tall and handsome, with immense personal charm and considerable powers of acting and mimicry (as he exhibited in the Israeli-Hebrew film *Le'an Ne'elam Daniel Wacks?* [Where did Daniel Wacks disappear to?], made by Avraham Heffner, in which Shachar played the male lead under a pseudonym). He had an acute sense of humor combined with a biting and mordant tongue that knew no respect for great or small, friend or foe. Because of his profound love for Israel he was also its most bitter critic; a born rebel against the conformity of society, he was also a conservative, especially in his private life.

An exceptional and near-fanatical bibliophile, Shachar amassed a very impressive

library, which included the bulk of the Ḥasidic library of the late Professor Joseph Weiss. His collection of books on Jewish art was one of the best in the world. He had an insatiable desire for knowledge and was not only a brilliant scholar but an eternal student, learning from everybody he met. His letters, beautifully written in a fine script and an elegant Hebrew, were full of humor, a search for knowledge, and acute observations on people and books.

The last eight years of his life were, in spite of his terrible illness, the happiest of his life. He found great joy and happiness in Bérénice, who devoted herself to helping him, and in his young daughter, Davina. For his family and intimate friends his death was a tremendous blow, and for Jewish scholarship it was a major loss.

---

# The battle to save the Jewish art which has survived the ravages of persecution

The first international conference to be dedicated entirely to Jewish art will take place on August 23, 24 and 25 at St Edmund Hall, Oxford, under the aegis of the Oxford Centre for Postgraduate Hebrew Studies.

Learned debates about the definition of "Jewish art"—or indeed the possibility of its existence in the light of the iconoclastic Second Commandment—have been increasing repetitively, since the late nineteenth century. Yet that was also the period during which the field was largely discovered and made known to a wide public.

A private collection of Jewish ceremonial art was shown at the 1878 international exhibition in Paris, and the exhibits (today part of the Musée Cluny) were shown again, together with rich material from British collections, in the impressive Anglo-Jewish Historical Exhibition of 1887 at the Royal Albert Hall.

America had its first exhibition of Jewish ceremonial art in 1892, when a private collection (subsequently lent to the United States National Museum in Washington and later to become the nucleus of the Jewish museum of New York) was exhibited in Chicago. In 1898 the famous *haggadah* of Sarajevo, a mediaeval illuminated Hebrew manuscript from Spain, was published by the Viennese art historian,

Julius von Schlosser, working with the Hebrew scholars, David Heinrich Müller and David Kaufmann, and the existence of the hitherto unknown art of mediaeval Hebrew book illumination was revealed to the world.

Societies for the preservation and study of Jewish monuments and works of art were founded in Vienna (1897) and Frankfurt am Main (1900), and a steady flow of learned publications, reports and inventories followed.

By the First World War public collections of Jewish ceremonial art had been formed in Danzig (Gdansk), Jerusalem, Prague, Warsaw and elsewhere, and the number of Jewish museums has been increasing ever since. The private collecting of Judaica became a fashion and Jewish ceremonial art an established category in the antique markets as well as the auction houses.

Sharp dealers and inventive forgers were quick to capitalize on the new enthusiasm. It is perhaps not entirely accidental that the new interest in this aspect of the Jewish heritage coincided with the spread of secularization in Jewish society as well as with the emergence of the Jewish national movement (the first Zionist congress assembled in 1897). The craving for cultural roots, symbols and a national artistic tradition has clearly inspired discoveries and research in this new field.

The Second World War resulted in the disappearance of millions of Jewish ceremonial objects. Poland was robbed of most of its Jewish treasures. Throughout Germany precious metals were collected from Jewish homes and melted down. The train load of Jewish ceremonial silver which the Americans found at Wiesbaden towards the end of the war was only a fraction of what had actually been destroyed.

Select collections of synagogue silver, like the one formerly in the museum of Augsburg, disappeared either during the war or in the harsh months following its end. The sense of tragic loss, and the real shortage, endowed the remaining objects with a sentimental value which was soon reflected in the movement of prices as well as other activities in the market.

A curious outcome of the Nazi occupation of Czechoslovakia was the setting up of the Jewish museum (today the State Jewish museum) of Prague in its present form. The Nazis, with a perverse didactic urge, decided to create out of Prague's old Jewish synagogues and cemetery an anthropological museum describing the history, religion, customs and ceremonies of the exterminated race. Many thousands of books, synagogue textiles, ceremonial objects and even household utensils

---

This article first appeared in *The Times* (London) of August 20, 1977.

# Notes

1. See Shmuel Ettinger, "The Hassidic Movement—Reality and Ideals," in Social Life and Social Values of the Jewish People, *Journal of World History* XI (1–2) (1968), p. 255.
2. L. A. Mayer, *Bibliography of Jewish Art*, ed. O. Kurz (Jerusalem, 1967).
3. Otto Kurz's tribute in his preface to L. A. Mayer's *Bibliography of Jewish Art*, p. 15.
4. For publication data on Shachar's works, see the Curriculum Vitae on p. 169.

were systematically collected from all over the *Protektorat* and carefully catalogued by a team of Jewish experts.

Other large collections of Jewish ceremonial art, more varied than that of Prague, are owned by the Jewish museums of New York, Jerusalem, London and Los Angeles.

These comprise, with some notable exceptions, material dating mainly from the seventeenth to nineteenth century and include decorative artefacts for synagogue ritual throughout the Jewish year as well as the domestic and personal ceremonies of the individual Jew—textiles and embroidery, silver, brass, pewter, wood, glass and ceramics, illuminated marriage contracts, late illuminated manuscripts, bookbindings, jewelry, tombstones, amulets, and more.

Mediaeval illuminated manuscripts are stored in the Bibliothèque Nationale, the British Library, the Bodleian, and the National Library and The Israel Museum in Jerusalem.

The 80 participants in the Oxford conference, familiar with this overwhelming evidence, will probably not be worried about the abstract definition of Jewish art. They will be concerned with more concrete problems. The lecturers will come from London, Vienna, Strasbourg, Jerusalem and Detroit, and will expound on six themes: The continuation of Ancient Jewish art in the Middle Ages; The Iconography of the Hebrew Psalter, thirteenth–fifteenth centuries; Illuminated and engraved Italian haggadot from the thirteenth to the eighteenth century; and Synagogue architecture between neoclassicism and historicism.

An art historian from Wayne State University will discuss the inevitable question, Is there a Jewish art? and a folklorist from Jerusalem will attempt to define Jewish folk art as part of Jewish folk culture. Each lecture will be followed by discussion and the entire proceedings of the conference will be published in a special volume.

The meeting together may be no less important than the content of the lectures. For it is the first conference to bring together all the categories of people who are professionally and personally involved in Jewish art: academic scholars and students, curators, collectors and owners of most distinguished private collections.

The present situation in most Jewish museums is a melancholy one. They are without adequate funds and badly understaffed. They are constantly called upon to perform communal and educational tasks which make them neglect their primary duties of research and preservation.

Trained museum staff are badly needed everywhere but, quite apart from the lack of funds, there is no academic or professional institution that offers a course in Jewish museology or Jewish art. The Oxford Centre for Postgraduate Hebrew Studies could play a role here.

The Oxford conference might seem too topical in its readiness to launch yet more projects in a crowded field. Yet its task may be of an entirely different nature. Jewish ceremonial art and related Judaica are to a large extent in private hands and the recording of this material is therefore urgent. There is no need to underline the urgency of establishing a centre for the training of museum staff.

Both projects seem manageable, although they will depend on the good will and cooperation of individuals and the museums whose representatives will meet at the conference. If they decide to establish the central photographic archives for Jewish ceremonial art as well as the training centre for Judaica museology, they will have given an additional and worthy purpose to the Oxford Centre.

*Isaiah Shachar*
Visiting Fellow, Oxford Centre
for Postgraduate Hebrew Studies

JOSEPH GUTMANN

# Is There a Jewish Art?

> We talk a good deal about Jewish Art. We ask one another if there is such a thing. We write about it. We interview one another upon it. We deplore that there isn't any; and regret that it is so poor or so unnational, or so uncharacteristic. We discuss it from every point of view. We inquire into its history, if any. We claim distinguished artists as Jews, and debate their identity, which others deny. We boast of the strides that Jewish Art is now making, while doubting its very existence.
>
> —**Rose Kohler**, *Art as Related to Judaism*

THE STATEMENT ROSE KOHLER made in 1922 still holds true today. Among Jewish disciplines the study of Jewish art is probably the newest and most misunderstood branch of the *Wissenschaft des Judentums*. Jewish art has been called a "*contradictio in adjecto*," a "strange combination of these two almost mutually exclusive words."[1] It has been likened to ghosts, which "don't exist, and so keep cropping up forever."[2] In a lighter vein, a friend of mine wrote me that "Jewish art is what remains after you have taken the goy [the non-Jew] out of it."[3]

The earliest mention of "Jewish art" appears to be in the short paragraph devoted to the subject in Johann J. Winckelmann's 1764 edition of *Geschichte der Kunst des Alterthums*.[4] Somewhat later appeared *Histoire de l'art judaïque*—a book devoted primarily to biblical antiquities—written in 1858 by the Christian archeologist and numismatist Louis-Félicien de Saulcy (1807–80).[5] It was not until 1878, however, that Rabbi Dr. David Kaufmann wrote the first significant scholarly article on the topic, entitled "*Etwas über jüdischer Kunst*."[6] Kaufmann (1852–99) had just visited the Universal Exposition held at the Trocadéro in Paris, where for the first time a collection of Jewish ceremonial art—that of Isaac Strauss—was on public display. He wrote that whoever visited the Paris exhibition under the impression that Jews lacked any talent for the visual arts would be in for a pleasant surprise.[7]

Kaufmann's acute observation must be seen against the eighteenth and nineteenth century background, where traditionalists, or orthodox Jews, were inclined to deny the actuality of art among Jews on the grounds of the taboo the Second Commandment had supposedly imposed on art and the elaboration of that taboo in the *Shulḥan Arukh*.[8] In the eighteenth century, for instance, Claus Gerhard Tychsen, a Christian Hebraist and Orientalist, was intrigued to discover in Hebrew manuscripts a number of marginal illustrations of masoretic notes in the shape of animal and human figures. When Tychsen turned to Jewish scholars of his time for more information about these

figural decorations, some of his Jewish respondents categorically denied their existence and chastised Tychsen for not knowing that Judaism does not tolerate the adornment of Hebrew manuscripts.[9]

Similarly, in 1860 a Jewish congregation in New Orleans was contemplating the erection of a statue in tribute to the American patriot and philanthropist Judah Touro. An itinerant Moldavian, Israel Joseph Benjamin—Benjamin II, as he styled himself—was visiting the city at that time. Incensed and indignant that a Jewish congregation should even consider such an action, he admonished the members, saying that he had visited "four continents and have learnt something at first hand about millions of my fellow Jews. Nowhere did I see or find the statue of a Jew: because this is clearly against the principles of our holy religion."[10] As the local congregation remained unmoved by his arguments, he tried to stir up religious leaders "to prevent a step" he considered "so decidedly in conflict with our holy religion."[11] The leading rabbis who were consulted, luminaries like Samson Raphael Hirsch of Frankfurt, Zacharias Frankel of Breslau, and Nathan Marcus Adler of London, expressed negative views on the subject. All concluded that it would be against "ancient Jewish custom and usage"[12] to erect a monument in honor of a man and that such an action would be, "according to Jewish law, prohibited."[13]

This traditional stance is not too difficult to grasp, as Jewish literature has few positive remarks about art and artists. Exodus 31:3–5 may represent Bezalel, the desert artist, as "endowed . . . with a divine spirit of skill, ability and knowledge in every craft," and the Spanish-Jewish grammarian and polemicist Profiat Duran (1360–1412) may assert that "the contemplation and study of pleasing forms, beautiful images and drawings broaden and stimulate the mind and strengthen its faculties"[14]—but these affirmations are mere islets in a sea of negations. The fact that extant rabbinic literature would never have led us to suspect the extravagant and widespread use of decoration and images found in Jewish catacombs and synagogues of the third to the sixth century C.E. even forced the late Erwin Ramsdell Goodenough to conclude that what we accepted as "normative rabbinic Judaism" had been, at most, something of a minor sect—the religion of an intellectual minority responsible for the compilation of the Babylonian and the Palestinian Talmuds.[15]

Along with the negation of art among traditional Jews, Hegelian metaphysics played a crucial role in this issue. Hegel (1770–1831), one of the most influential German philosophers of his time, maintained that the "individual spirit [of every people], their *Volksgeist*, was a temporary form of the absolute Spirit [*Zeitgeist*] on its path through history."[16] "Thus the art of every period," asserted the Hegelian art historian Carl Schnaase in 1843, is "both the most complete and the most reliable expression of the national spirit in question, it is something like a hieroglyph . . . in which the secret essence of the nation declares itself. . . . "[17] Influenced by Hegelian thought that a unique *Volksgeist* (national spirit) dominated or controlled each nation or ethnic group, the Protestant theologian and Orientalist Immanuel Benzinger claimed that the "Hebrews had absolutely no gift for the pictorial arts."[18]

What is surprising is that so many Jewish scholars, beginning with the noted historian Heinrich Graetz, affirmed that the Jewish *Volksgeist* had denied the Jews any artistic talent. Graetz wrote in 1846, "Paganism sees its god, Judaism hears Him."[19] This essentially Hegelian idea has been repeated many times by Jewish and non-Jewish

scholars. "The Jew of antiquity," stated Martin Buber, "was more of an aural [*Ohren-mensch*] than a visual being [*Augenmensch*] and felt more in terms of time than space." Bernard Berenson believed that "the Jews like their Ishmaelite cousins the Arabs, and indeed perhaps like all pure Semites (if such there be), have displayed little talent for the visual, and almost none for the figurative arts. . . . To the Jews belonged the splendours and raptures of the word." Sigmund Freud, too, felt that "the prohibition against making an image of God . . . signified subordinating sense perception to an abstract idea; it was a triumph of spirituality over the senses."[20] In other words, the Jew lacked the dimension of aesthetics. He excelled in ethics, but "in everything else" he was insignificant, said Matthew Arnold—in everything else he belonged to a "petty . . . unamiable people, . . . without science, without art, without charm. . . ."[21]

In light of the traditional negation of Jewish artistic creativity and the Hegelian metaphysical claim that the Jewish *Volksgeist* lacked artistic sensitivity, what, we may ask, led to a discovery of Jewish art?

Virulent political and racial anti-Semitic movements and discriminatory legislation in the 1870s and 1880s made central European and especially German Jews aware that they had been deceived. The hopes they had nourished, the expectation that "legal emancipation would destroy the last vestiges of the discrimination and isolation that separated them from their Christian fellow citizens," proved illusory.[22] Persistent anti-Semitism not only sparked the founding of Jewish defense organizations in the 1890s but proved the Jewish realization that full acceptance within the German body politic was virtually unattainable.[23] Some German Jews, therefore, chose the road of assimilation; others turned within—to a greater Jewish self-consciousness; still others turned outward toward Zionism.

It was Jewish self-awareness that effected the realization of Jewish art. In 1895 the Gesellschaft für Sammlung und Conservierung von Kunst und Historischen Denkmälern des Judentums was established in Vienna. Prominent Jewish intellectuals and artists became members of the organization, people like Dr. Hermann Adler of London, Dr. Adolf Neubauer of Oxford, Dr. Albert Harkavy of St. Petersburg, and Dr. David Kaufmann of Budapest.[24] In 1897 David Kaufmann proudly wrote in the Gesellschaft's first annual report, "The fable of the enmity of the synagogue toward all the [visual] arts until the Middle Ages and even modern times should finally be dismissed in the light of the facts of life and the testimony of literature."[25] A year later, David H. Müller and Julius von Schlosser broke new ground in presenting the first art historical analysis of an important fourteenth-century illuminated Spanish haggadah, the so-called Sarajevo Haggadah.[26]

Around the same time, in 1897, Heinrich Frauberger (1845–1920) (*Fig. 1.1*), the German-Catholic director of the Industrial Arts and Crafts Museum in Düsseldorf (Das Düsseldorfer Kunstgewerbemuseum), and the banker Charles L. Hallgarten helped to establish in Frankfurt the Gesellschaft zur Erforschung jüdischer Kunstdenkmäler. Two years before, an architect had sought Frauberger's advice on appropriate Jewish symbols for a grille he was to design around the grave of the parents of a Jewish banker, but the museum director found he could be of little help because there were no photographic archives, studies, or resource people available on the subject.[27] This situation made Frauberger determined to help establish the society and to gather around him such outstanding Jewish scholars as Erich Toeplitz, Alfred

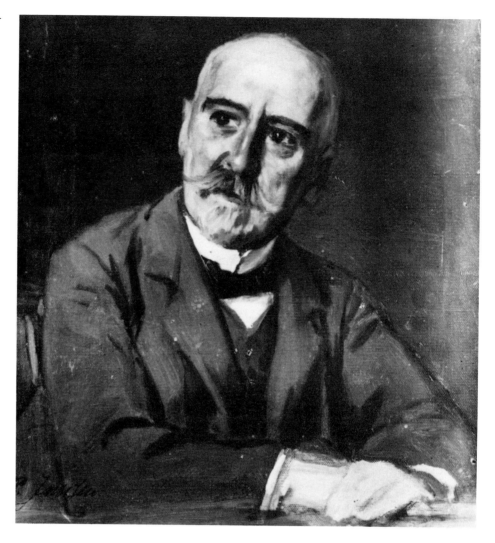

Grotte, and Rudolf Hallo. In 1900 the first volume of *Mittheilungen der Gesellschaft zur Erforschung jüdischer Kunstdenkmäler* appeared, and in 1902 the first issue of the *Notizblatt* of the society was published.

The program of the society was extremely ambitious:

1. To collect the finest surviving antique ceremonial objects used in the synagogue and home, and to gather photographs, prints and drawings of synagogues and Judaica.
2. To make the collection readily available for scholarly and artistic purposes.
3. To act as an agency for the preservation of Jewish artistic monuments.
4. To further artistic creativity in contemporary art and art objects used for Jewish purposes.[28]

Heinrich Frauberger and David Kaufmann can truly be called the founding fathers of the science of Jewish art. Their efforts were considerably aided not only by the prevailing anti-Semitic climate but also by the establishment of ethnographic mu-

seums in the second half of the nineteenth century,[29] which gradually led to the establishment of Judaica museums. Salli Kirschstein, an avid collector of Judaica who set up one of the first private Jewish museums in Berlin (the collection is now the nucleus of the Hebrew Union College Skirball Museum in Los Angeles), noted that "in the last years of the nineteenth century I frequently visited the Ethnographic Museum [Museum für Völkerkunde] in Berlin." All the cultures of the world were represented. "Only the Jews were absent from this museum. As if a Jewish people never existed, as if they had no indigenous cult or culture. . . . Then and there arose the wish, no the will, that a museum for Jewish ethnography must be established . . . in order to assure our place among the peoples of the world."[30]

It is true that several international expositions had called attention to the Jewish artistic heritage amid the displays of other ethnic groups. As already mentioned, the first exposition of 1878 at the Trocadéro in Paris contained the collection of Isaac Strauss (now in the Cluny Museum). In 1887 the Royal Albert Hall in London featured a display of Judaica that was accompanied by a splendid catalog.[31] The 1893 Columbian Exposition in Chicago included the collection of Ephraim Benguiat (which is now the nucleus of the Jewish Museum in New York). Public Judaica museums, however, did not emerge until the beginning of the twentieth century.

Together with the unfolding of a Jewish ethnic consciousness and the beginnings of the study and collection of the Jewish artistic heritage, the 1890s also witnessed the emergence of political Zionism—a response to the persecution of Russian and Polish Jews in the East and the upsurge of anti-Semitism in the West. At the Fifth Zionist Congress held in Basel in 1901 a dedicated group of individuals (which included Martin Buber, Davis Trietsch, Berthold Feiwel, and Ephraim Moses Lilien), dissatisfied with the strictly political emphasis of Zionism, formed the "Democratic Fraction" to express a cultural Zionism.

Part of cultural Zionism's program was devoted to furthering "Jewish art" because a "full-fledged Jewish art," it was felt, was "possible only on Jewish soil."[32] As ardent nationalists the members of the Democratic Fraction reasoned that every nation had developed an art of its own; a Jewish national art was a prerequisite of Jewish statehood. They also wanted to refute the anti-Semites' insistence on Jewish inferiority in the visual arts and pointed proudly to contemporary "Jewish artists" whose works were published by their newly established Jewish publishing house, Jüdischer Verlag, founded in Berlin in 1902.[33] Evidence of Jewish art on the contemporary scene was eagerly sought, even where none existed, and the past was ransacked in order to reestablish and justify the idea of a distinctive national Jewish art. Their search was partly aided by the publication of Raffaele Garucci's work on the Jewish catacombs of Rome and by the publication of studies of ancient synagogues and other archeological remains by such scholars as Charles Clermont-Ganneau, Salomon Reinach, and Charles Wilson during the second half of the nineteenth century. Both cultural Zionism and ethnic Jewish self-consciousness brought to light Jewish participation in the arts of many cultures and led to the synthesis of the collected information in the publication of the first *History of the Jews in Art* in 1928. Karl Schwarz (*Fig. 1.2*) cautiously wrote, " . . . we are dealing with art of the Jews, not Jewish art."[34] Although many scholars and artists opted for this sensible conclusion, others saw the matter otherwise.

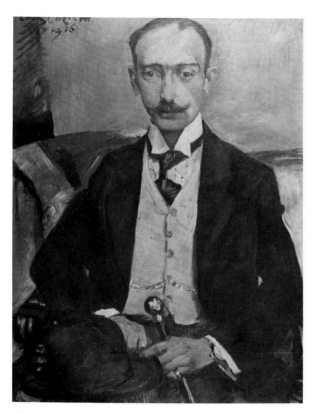

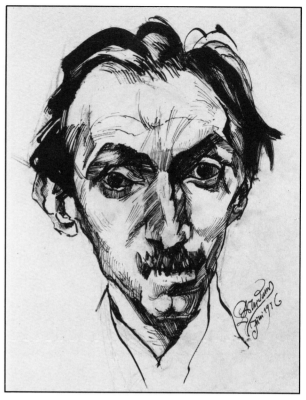

*Fig. 1.2 Portrait of Dr. Karl Schwarz (1885–1962) by Joseph Lovis Corinth, 1916, oil on canvas (Milwaukee Art Museum, gift of Thomas Corinth; photo courtesy of Milwaukee Art Museum).*

*Fig. 1.3 Portrait of Dr. Ernst Cohn-Wiener (1882–1941) by Ludwig Meidner, 1916, pen and wash over pencil on card (photo courtesy of Städtische Kunsthalle Mannheim).*

The art historian Ernst Cohn-Wiener (*Fig. 1.3*) entitled his 1929 book *Die jüdische Kunst* (Jewish art) and stated that "for the Jewish religion forms are only hieroglyphs expressing the spiritual."[35] Denying a Jewish artistic inclination (*jüdisches Kunstwollen*), he tried to define Jewish art in iconographic terms—that is, solely on the basis of the content of the works. By this definition the biblical works of Rembrandt and Michelangelo are to be regarded as Jewish, whereas the depictions of Jesus by Max Rosenthal (*Fig. 1.4*),[36] Moses Jacob Ezekiel (*Fig. 1.5*),[37] and Marc Chagall are to be excluded, despite the fact that all of these works were created by Jews.

Granted that we cannot explain Jewish art in iconographic terms, can we perhaps accept Stephen Kayser's definition? He contends that "Jewish art is art applied to Judaism. . . . Jewish art does not depend on who produced it. The accident of birth may make an artist Jewish, but this fact alone does not permit us to characterize his works as Jewish. . . ."[38] Such a definition, which employs function as the determinative factor, seems much too constrained. It would include only those works having a utilitarian function for Jews, and then only within the Jewish religious sphere. It would of necessity exclude ceremonial objects made or commissioned by Jews that have on occasion been presented as gifts to heads of state. One of several such examples would be the handsome silver Torah case (*Fig. 1.6*) made by Ludwig Wolpert, which was presented to President Harry S. Truman and is now part of the Truman

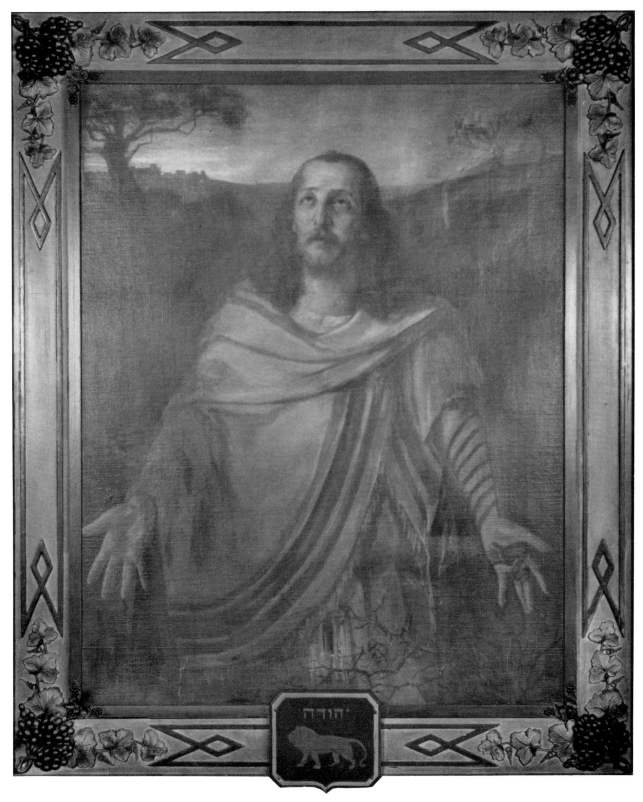

**Fig. 1.4** *"Jesus at Prayer" by Max Rosenthal, 1904, oil on canvas (formerly collection of Dr. Joseph B. Wolffe, present whereabouts of painting unknown; photo courtesy of the author).*

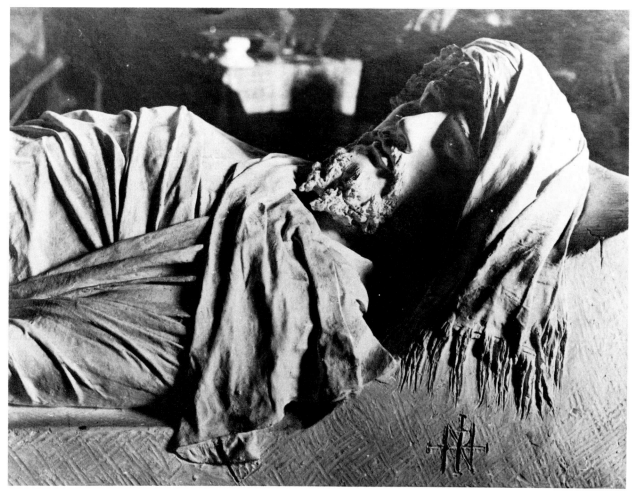

*Fig. 1.5* *"Christ in the Tomb" by Moses Jacob Ezekiel, ca. 1890, marble (Chapel of Notre-Dame de Consolation, Paris; photo courtesy of the author).*

Library at Independence, Missouri.[39] It would also ignore portraits and illuminations in Hebrew manuscripts of a secular nature, for instance, the Hebrew translation of Avicenna's *Canon of Medicine* (*Fig. 1.7*), written by and illuminated for Jews yet unrelated to the pieties of Judaism.[40]

Cecil Roth and Franz Landsberger (*Fig. 1.8*) defined Jewish art in ethnic terms. Roth wrote,

> "English Art" is in fact simply the sum of the artistic production of persons, however influenced, born or active in England, so that it is legitimate to include in the category of "Jewish Art" the artistic productions of persons, however influenced, professing the Jewish religion or of Jewish stock. . . . The term "Jewish" thus applies here to authorship and to object; it is not intended to apply to the content.[41]

Similarly, Landsberger claimed that

> Roman art is, as we know, an echo of Greek art; Japanese art is derived from Chinese art; American art is a branch of European art. And yet the art of these—the Romans, the Japanese and the Americans—has always been dealt with as a special field. Why should this not apply to Jewish art?[42]

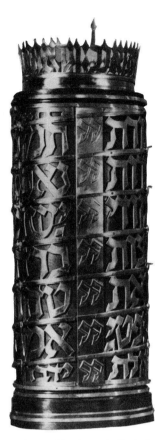

**Fig. 1.6** *Torah case by Ludwig Wolpert, 1949, silver and copper (photo courtesy of The Jewish Museum, New York).*

**Fig. 1.7** *Canon of Avicenna, northern Italy, fifteenth century (Bologna University Library, Ms. 2197, fol. 448v).*

**Fig. 1.8** *Portrait of Franz Landsberger (1883–1964) (photo American Jewish Archives, HUC-JIR, Cincinnati).*

If we define Jewish art in ethnic terms as Roth and Landsberger do, then we should be able to speak of Jewish art in the same way as we speak of English art during the Gothic period, Roman art during the Flavian period, and Japanese art during the Heian period. Consequently we should be able to discern within any given Jewish culture, over a significant period of time, certain common stylistic traits that would enable us to speak of Jewish art as a separate and distinct entity, as is the case in many periods of English, Roman, and Japanese art. Furthermore, that ethnic quality should be evident even in the works of an apostate Jew like Eduard von Bendemann (for example, in his painting "By the Waters of Babylon," shown in *Fig. 1.9*[43]) and in buildings produced by Jews for secular purposes (for example, Alfred Messel's Wertheim department store in Berlin[44]).

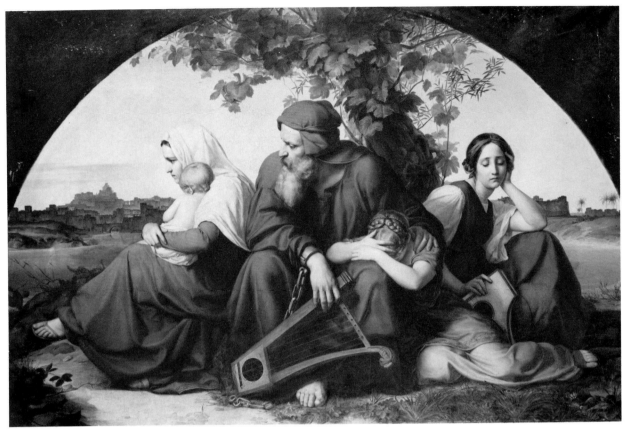

**Fig. 1.9** *"By the Waters of Babylon" by Eduard von Bendemann, Germany, 1832 (Wallraf-Richartz-Museum, Cologne; photo courtesy of Rheinisches Bildarchiv, Cologne, RBA-no. 98 601).*

An examination of a few representative, random samples of so-called Jewish art should enable us to determine whether, in fact, there is "the constant form—and sometimes the constant elements, qualities and expression—in the art of a [Jewish] individual or group . . . peculiar to a period of [Jewish] culture."[45]

If we look at an early fourteenth-century Spanish haggadah (for example, MS. Add. 27210 in the British Library in London[46]), we note that it shares all the characteristics typical of Spanish Gothic art. If we examine an eighteenth-century Torah shield from Nuremberg (*Fig. 1.10*)[47] we are aware of the German rococo style, including such typical Christian symbols as the double-headed eagle of the Holy Roman Empire and the unicorn. It must be admitted, therefore, that stylistically we cannot speak of Jewish art as a distinct entity.

If Jewish art cannot be said to have existed over the ages, did it come to the fore in the modern period? Some scholars feel that a "modern Jewish style" indeed emerged in Paris in the so-called *école juive*. "'Jewish' art," according to Josef Paul Hodin, is "entirely the product of painters who have not only Jewish origin, but also a Slavonic background."[48] Most scholars contest the putative birth of a collective Jewish art in Paris; some of these Parisian artists, they concede, may have had similar youthful Jewish experiences or reminiscences, but their work reveals few specific or distinctive

*Fig.* 1.10 *Torah shield, late eighteenth century, probably from Nuremberg. Silver: gilt with appliqués, No. 7.21. From the collection of the Hebrew Union College Skirball Museum (photo Hebrew Union College Skirball Museum, Los Angeles).*

Jewish peculiarities.[49] A glance at the paintings of such acknowledged masters as Jules Pascin and Chaim Soutine certainly shows no unique Jewish style. Moreover, it should be pointed out that although some of these Parisian artists were Jews in the sociological, political, and religious definitions of the term, they "had dissolved their links to Judaism and were internationalists of the purest water."[50]

Jacques Lipchitz, reminiscing about his Paris days, tells us,

> In Paris . . . we had a society of Jewish artists to which I belonged—the *Société des arts juifs*. We formed it to help each other. We often had meetings to discuss the question of what is Jewish art. Did it exist? We concluded that Jewish art was a bit *nebbish*—you know, broken down and melancholy. . . . I said that I was not *nebbish* and that it was time others outgrew such a feeling.[51]

If we turn to the modern State of Israel, should we not expect to find a Jewishly steeped and specifically national Israeli art emerging as a consequence of the Jewish experience with nationalism? Had Israel been established early in the nineteenth century, an art expressive of national goals might indeed have come to the fore, and the idealistic efforts of Boris Schatz and his associates at the Bezalel School of Arts and Crafts in Jerusalem to create a "Jewish art" might not have failed so abysmally. However, because Western art had by now transcended the national phase, Boris Schatz's return to an academic realism and chauvinism in art was rejected by his more sensitive and creative students.[52] They preferred to identify themselves with the aims of artists in the more advanced Western countries and to seek an artistic expression that would be universal. Is there any better evidence than the following statement by Miron Sima, an Israeli artist, that there is little likelihood that a specifically Israeli art will develop? "The time when art was influenced by the bounds of geography is past . . . art is changing from a national language to a cosmopolitan one."[53] Similarly, the late Eugene Kolb of the Tel-Aviv Museum of Art argued that "the abolition of rigid national boundaries on the one hand, and the accentuation of artistic values common to all peoples on the other, is not a specifically Israeli phenomenon but a general tendency in modern art."[54]

What do artists of Jewish background have to say on the subject of Jewish art? Generally, they deny its existence. Only a minority of artists—for instance, Abel Pann, an Israeli artist who worked with Boris Schatz—seem willing to agree that "when a Jewish artist expresses himself sincerely, he will reflect something specially Jewish in his work: he will create Jewish art."[55] The German artist Hermann Struck also firmly believed that "Jewish art may best be described as that which distinctly belongs to Jews and cannot be effected by non-Jews." He went so far as to claim Rembrandt as Jewish: the "sentiment underlying [his paintings] is Jewish," he asserted, and "he must have been of Hebrew descent."[56] Solomon J. Solomon, the nineteenth-century English artist, when asked to write an article on Jewish art, replied that he "could more easily write an apology for its non-existence."[57] Jozef Israels, the noted nineteenth-century Dutch artist, responded to the question of whether Jewish art exists with a decisive no. "The phrase 'Jewish Art,'" he claimed, "was invented by some German journalists and has been exploited by them. There is a Jewish publishing house [Jüdischer Verlag] in Berlin which has given strength to the idea, and is fond of describing the work of every Jewish artist as Jewish art. But I am not a Jewish artist, nor do I want to be. I am a Dutch artist."[58]

In a similar vein, the nineteenth-century American sculptor Moses Jacob Ezekiel wrote,

I must acknowledge that the tendency of the Israelites to stamp everything they undertake with such an emphasis is not sympathetic with my taste. *Artists* belong to no country and to no sect—their individual religious opinions are matters of conscience and belong to their households and not to the public. In reference to myself, this is my standpoint. Everybody who knows me knows that I am a Jew—I never wanted it otherwise. But I would prefer as an artist to gain first a name and reputation upon an equal footing with all others in art circles. It is a matter of absolute indifference to the world whether a *good artist* is a Jew or a Gentile and in my career I do not want to be stamped with the title of "Jewish sculptor."[59]

The well-known American artist Ben Shahn began a lecture on the subject of Jewish art by stating, "There is no such thing."[60] Similarly, the celebrated Jacques Lipchitz, when asked about Jewish art, replied that "there is no such thing as an ethnic Jewish art."[61] Leonard Baskin, the son of an orthodox rabbi and himself steeped in yeshivah learning, contends that "a particular constellation of form and content [cannot] be deemed Jewish. . . . It would require," he declared, "a delirious bit of sophistry (not impossible) to relate my once intimate relations with Rashi to my wood carving."[62] An American silversmith, the late Ilya Schor, clearly emphasized that "thousands of Jewish vessels and manuscripts would lose their Jewish character if not for the Hebrew script by which they are identified."[63] Even Marc Chagall, who has most often been linked with Jewish art, wrote, "I . . . and others . . . taken together are still not Jewish art."[64]

If artists dispute the existence of Jewish art, and if definitions of Jewish art in ethnic, iconographic, functional, and national terms do not adequately cover all relevant aspects of the subject, is there any way that we can understand Jewish art? The only definition that would seem meaningful and accurate is one that will do full justice to the contradictory nature of the phenomenon of Jewish art. The history of Jewish art has been a manifestation of the historical processes that Jews have undergone. Because Jewish history, unlike that of other continuous entities, developed and evolved primarily within multiple societies, cultures, and civilizations, it bears the imprimatur of this long and diverse multicultural experience. A critical inquiry into all known artistic remains reveals no isolated, unique thread but, on the contrary, a many-colored thread interwoven into the fabric of Jewish involvement in the larger non-Jewish society. Thus, something so distinctly Jewish as the Temple of Solomon turns out, on examination, to be an intricate part of ancient west Asian art;[65] the art of the synagogue is not *sui generis* but grows out of Greco-Roman art;[66] and the art in medieval Hebrew manuscripts is inseparably linked to the art in medieval Christian and Islamic manuscripts.[67]

The style, decoration, and, often enough, even the subject matter of the art of the Jews have always been rooted in and adapted from the dominant contemporary non-Jewish society. Yet until the nineteenth century, the art of the Jews was an intrinsic and inseparable part of the specific, legally constituted Jewish community that produced it. It expressed a distinctive Jewish life and tradition; it reflected the collective Jewish thought, feeling, and symbolism of that community. When describing art cre-

ated before the nineteenth century there is warrant for using the term "Jewish art" in a religio-communal sense. With the legal emancipation of the Jews in the nineteenth century, however, the artist of Jewish origin was freed from working under the jurisdiction of or on behalf of the Jewish community. Consequently, his identification with contemporary national—non-Jewish—commitments gradually led to the severance of his ties to a legally organized, self-governing, medieval-type Jewish community, and he no longer expressed the collective beliefs and symbols of that community. Generally functioning as an individual belonging to a particular country, he employed his art to reflect his national or international or personal beliefs. He was Jewish—but mainly by accident of birth or by affiliation with the Jewish religion; he was not Jewish as an artist. Even the occasional use of Jewish subject matter in an artist's work expressed his individuality rather than his religio-communal background. The manifestation of religious feeling was personal, not communal.

Those who yearn for an obvious Jewish art face the same problems as those who seek a distinctive Catholic or Protestant art. In today's essentially secular world, the Synagogue and even the Church (which has not actively sponsored art since the late Middle Ages) have had to be content with choosing those art styles emerging from the secular sphere that seem to be most in consonance with their own religious purposes.[68]

Hegel aptly said that in an age of piety one need not be religious to create a truly religious work of art, whereas today the most pious artist is incapable of producing such a work.[69] Today, in the absence of a truly religious art, saccharine, melodramatic Madonnas are officially endorsed by the Church, just as bearded, sentimentalized, pietistic rabbis or "pseudo-modern pictures such as abstractions made kosher by the deliberate inclusion on the canvas of a shield of David, a Menorah . . . or bits of Hebrew script"[70] are, albeit unofficially, of course, accepted in many Jewish circles. This kitsch art, superficial, frequently mass-produced, is vacuous; it lacks any enduring power to move or to challenge. "It is an art that can be looked at without being seen."[71] It cannot be expected to arouse sentiments that demand a genuinely deep emotional involvement. It is a complacent art of stereotypes, leading to the acceptance and sentimentalization of what has rightly been called "a metaphysical *shtetl*."[72]

The midrash relates that although Moses excelled most men in nearly every respect, he was seen as inferior to Bezalel in the realm of art. According to the midrash, Moses had great difficulty with the construction of the menorah.

> Twice he ascended Mt. Sinai to receive instructions from God, and twice he forgot the instructions on his descent. The third time, God took a menorah of fire and showed him every detail of it. And yet Moses found it hard to form a clear conception of the menorah. Finally God told him: "Go to Bezalel, he will make it." When Bezalel had no difficulty in executing it, Moses cried out in amazement: "To me it was shown many times by the Holy One, blessed be He, yet I found it hard to grasp, but you without seeing it, could fashion it with your intelligence. Surely you must have been standing in the shadow of God [*bezel-el*], while the Holy One was showing me its construction."[73]

The midrash implies that the artist is God-directed and God-inspired. People, through the artist, can share in the artist's divine gift, for the artist is the final arbiter of what beauty is.

"Israeli art . . . Jewish art . . . does it really matter?" asks Mordecai Ardon, a leading Israeli artist. "When you look at a work of art, ask yourself only if it is original, interesting and well-handled. If it is, fine. And only then, ask if it has any Jewish content. If it has, *mach shabbes!* [there is cause for celebration]."[74]

## *Notes*

1. A. Werner, "Jewish Art or Jewish Artists," in *Jewish Existence in an Open Society: A Convocation,* ed. B. Cohen (Los Angeles, 1970), p. 99.

2. Letter to the author from the late Harry Bober, November 1, 1965.

3. Letter to the author from Bernard Goldman, May 22, 1964.

4. An English translation of this work is J. J. Winckelmann, *The History of Ancient Art,* trans. H. Lodge (Boston, 1880). Winckelmann wrote, "Art [among the Jews] must, however, have risen to a certain degree of excellence, I will not say in sculpture, but in drawing and . . . other arts [*künstlischer Arbeit*], notwithstanding the derogatory idea of it generally entertained among this people" (pp. 212–13). Winckelmann is discussing the art of the biblical period. I am indebted to Professor Walter Cahn for this reference.

5. [L.-] F. de Saulcy, *Histoire de l'art judaïque tirée des textes sacrés et profanes,* 2nd ed. (Paris, 1858), wrote in his foreword, pp. I and III, " . . . j'arrivai . . . à acquérir la certitude, preuves en main, que non-seulement l'axiome en question était faux [*l'art judaïque n'existe pas; il n'a jamais existé*], mais que la nation judaïque avait porté les arts à un très-haut degré de perfection." See V. Klagsbald, *Jewish Treasures from Paris: From the Collections of the Cluny Museum and the Consistoire,* catalog (No. 226) of an exhibition held at The Israel Museum (Jerusalem, 1982), pp. 109–10.

6. D. Kaufmann, "Etwas über jüdischer Kunst," in *Gesammelte Schriften von David Kaufmann,* ed. M. Brann (Frankfurt o.M., 1915), pp. 150–53.

7. Ibid., p. 150: "*Wer die Ausstellung von Paris mit den landläufigen Vorurteilen betritt, die zum Teil durch [Ernest] Renan von jener Stadt aus verbreitet wurden, dass die Juden die Anlage für die Kunst fehle, der erlebt seltsame Überraschungen.*" See also the use of the term "Jewish art" by the Russian art critic Vladimir Stasov (also written Stassoff or Stassof), and his lavish praise of the Paris exhibition, in J. Günzburg, "Juedische Nationalkunst," *Ost und West* 12 (1905), p. 775 ff.; A. Kampf, "In Quest of the Jewish Style in the Era of the Russian Revolution," *Journal of Jewish Art* 5 (1978), p. 49; and D. Günzburg and V. Stassoff, *Illuminations from Hebrew Bibles of Leningrad.* Introduction and New Descriptions by B. Narkiss (Jerusalem, 1990), pp. 11–15; A. Kampf, *Jewish Experience in the Art of the Twentieth Century* (South Hadley, Mass., 1984), pp. 15 ff. and 203 ff.; and R. Apter-Gabriel, ed. *Tradition and Revolution: The Jewish Renaissance in Russian Avant-Garde Art, 1912–1928* (Jerusalem, 1987).

8. *Shulḥan Arukh, Yoreh Deʿah,* 141.

9. O. G. Tychsen, "Von den mit künstlich geschriebenen Randfiguren gezierten hebräischen Bibl. Handschriften," *Repertorium für Biblische und Morgenländische Litteratur* II (Leipzig, 1778), p. 124 ff.

10. I. J. Benjamin, *Three Years in America, 1859–1862,* trans. from German by C. Reznikoff, with introduction by O. Handlin (Philadelphia, 1956), vol. I, p. 321. See also J. Gutmann, "Jewish Participation in the Visual Arts of Eighteenth- and Nineteenth-Century America," *American Jewish Archives* 15 (1963), pp. 21–22, and R. Kohler, *Art as Related to Judaism* (Philadelphia, 1922), pp. 2–3.

11. Benjamin (*n. 10*), p. 323.

12. Ibid., p. 331.

13. Ibid., p. 327.

14. *Maʿaseh Efod,* 19. See J. Gutmann, ed., *No Graven Images: Studies in Art and the Hebrew Bible* (New York, 1971), p. XIII ff., and idem, ed., *The Image and the Word: Confrontations in Judaism, Christianity and Islam* (Missoula, Mont., 1977).

15. See J. Gutmann, ed., *The Synagogue: Studies in Origins, Archaeology and Architecture* (New York, 1975), p. XV ff.

16. E. H. Gombrich, *In Search of Cultural History* (Oxford, 1969), p. 9.

17. Ibid., pp. 13–14.

18. I. Benzinger, *Hebräische Archäologie* (Freiburg i.B./Leipzig, 1894), p. 268: *"fehlte den Hebräern überhaupt der Sinn für bildende Kunst."* See also C. L. Stieglitz, *Geschichte der Baukunst vom frühesten Alterthume bis in die neueren Zeiten,* 2nd ed. (Nuremberg, 1837), p. 116 ff., who writes that *"die Juden in jeder Bildung zurück waren . . . ihrer düsteren Religion jede Kunst fremd blieb."*

19. H. Graetz, "Die Construction der jüdischen Geschichte," *Zeitschrift für die religiösen Interessen des Judentums* 3 (1846), p. 86 (idem, "Judaism Can Be Understood Only Through Its History," in M. A. Meyer, *Ideas of Jewish History* [Detroit, 1987], p. 223). See Pierre Jaccard's claim that the Semitic race was incapable of producing any kind of naturalistic art. See also R. Golan, "The 'Ecole Français' vs. the 'Ecole de Paris,'" in K. E. Silver and R. Golan, eds., *The Circle of Montparnasse: Jewish Artists in Paris, 1905–1945* (New York, 1985), p. 81.

20. Gutmann, *No Graven Images* (*n. 14*), p. XIII.

21. M. Arnold, *Literature and Dogma* (New York, 1906), p. 51. Already in the nineteenth century Vladimir Stasov dismissed Hegelian theories on art and the Jews as nonsense and affirmed the existence of Jewish art: see Günzburg (*n. 7*), 10–11 (1905), pp. 706–8, and Apter-Gabriel (*n. 7*), pp. 24–26 and 44–45.

22. J. Reinharz, *Fatherland or Promised Land* (Ann Arbor, 1975), p. 1.

23. Ibid., pp. 35–36. See R. S. Levy, *The Downfall of the Anti-Semitic Political Parties in Imperial Germany* (London, 1975); M. Lamberti, "Liberals, Socialists and the Defence Against Antisemitism in the Wilhelmenian Period," *Leo Baeck Institute Year Book* XXV (1980), p. 147 ff; and W. S. Bacharach, "Jews in Confrontation with Racist Antisemitism, 1879–1933," *Leo Baeck Institute Year Book* XXV (1980), p. 197 ff.

24. I. Kolb, "The Vienna Jewish Museum," in *The Jews of Austria: Essays on Their Life, History and Destruction,* ed. J. Fraenkel (London, 1967), pp. 147–48.

25. D. Kaufmann, "Zur Geschichte der Kunst in den Synagogen" (*Erster Jahresbericht für die Jahre 1895 und 1896, Gesellschaft für Sammlung und Conservierung von Kunst- und Historischen Denkmälern des Judenthums* [Vienna, 1897]), reprinted in Kaufmann (*n. 6*), p. 81.

26. D. H. Müller, J. von Schlosser, and D. Kaufmann, *Die Haggadah von Sarajevo. Eine spanisch-jüdische Bilderhandschrift des Mittelalters* (Vienna, 1898). Kaufmann's contribution to the volume was a pioneering survey entitled "Zur Geschichte der jüdischen Handschriften Illustration," p. 255 ff.

27. H. Frauberger, *Mittheilungen der Gesellschaft zur Erforschung jüdischer Kunstdenkmäler* (Frankfurt o.M., 1900), vol. I, p. 3 (reprinted H.M.Z. Meyer, ed., Osnabrück, 1970).

28. *Statuten der Gesellschaft zur Erforschung jüdischer Kunstdenkmäler in Frankfurt am Main* (Frankfurt o.M., 1897), p. 3. See also F. Heimann-Jelinek and A.-M. Kiessl, "Zur Geschichte des Museums Jüdischer Altertümer in Frankfurt am Main," in *Was übrig blieb. Das Museum Jüdischer Altertümer in Frankfurt 1922–1938* (Frankfurt o.M., 1988), pp. 13–38.

29. R. Goldwater, *Primitivism in Modern Art* (New York, 1967), pp. 4–6.

30. S. Kirschstein, *Jüdische Graphiker aus der Zeit von 1625–1825* (Berlin, 1918), p. 2. See also J. Gutmann, "The Kirschstein Museum of Berlin," *Jewish Art* 16/17 (1990–91), pp. 172–76. It should be noted that a small congregational museum, which housed the private collection of Jewish ceremonial art and Hebrew manuscripts of the court Jew Alexander David (1687–1765), was established in Braunschweig around 1875. See R. Hagen, "Jüdische Altertümer, Handschriften und Kultgeräte aus dem ehemaligen Lande Braunschweig," in *Lessings "Nathan" und jüdische Emanzipation im Lande Braunschweig* (Wolfenbüttel, 1981), p. 136. This is the catalog of an exhibition held in Bad Gandersheim and Wolfenbüttel in 1981.

31. *Catalogue of the Anglo-Jewish Historical Exhibition, Royal Albert Hall* (London, 1887).

32. M. Buber, "Von jüdischer Kunst" (*Aus einem Referat, erstattet auf dem V. Zionisten Kongress zu Basel am 27. Dezember 1901*), in *Die jüdische Bewegung, Gesammelte Aufsätze und Ansprachen, 1900–1914* (Berlin, 1920), pp. 62–63. Adolph Goldschmidt in *Gedenkrede auf Max Lie-*

*bermann 1935* (Hamburg, 1954), p. 6, wrote, "*Es gibt . . . keine speziell jüdische Kunst, sondern nur künstlerisch dargestellte jüdische Objekte, wie jüdische Historien, Porträts oder kunstvolle jüdische Kultgegenstände; ihr Stil aber hat sich stets dem allgemeinen angepasst . . .*" I am indebted to Professor Kurt Weitzmann for this reference.

33. See J. Gutmann, *Jerusalem by Ephraim Moses Lilien* (New York, 1976), pp. 10–12. K. Schwarz, *Die Juden in der Kunst,* 2nd ed. (Vienna/Jerusalem, 1936), p. 255, still believed Palestine could produce Jewish art, although he was more cautious about Jewish art in his *Jewish Sculptors* (Tel-Aviv, 1954).

34. Schwarz (*n. 33*), p. 254: " . . . *von jüdischer Kunst zu sprechen, wo es sich um Kunst von Juden handelt.*" See also P. Krasnow, "What of Jewish Art?" *The Menorah Journal* 11 (1925), pp. 535–43, for a sensitive appraisal of the problem. H. Rosenberg, "Is There a Jewish Art?" *Commentary* 42 (1966), p. 57, agrees that there is no Jewish style in art, but his historical analysis of Jewish art is unsound. See also the roundtable discussion in "Existe-t-il un art juif?" *L'Arche* 55 (1961), p. 56 ff.; B. Narkiss, "Does a Jewish Art Exist?" *Ha-Universitah* 11 (1965), pp. 31–40 (in Hebrew); and J. Gutmann, "Jewish Art: Fact or Fiction?" *Central Conference of American Rabbis Journal* (April 1964), pp. 49–54. Nicolai Lavrsky's *Art and the Jews* (Moscow, 1915) (in Russian) may have been the first book published on the history of Jewish art. I have been unable to locate a copy of this work. Professor John E. Bowlt graciously informed me that Lavrsky's book primarily "discusses the predicament of Jewish artists within a Russian context" (personal communication).

35. E. Cohn-Wiener, *Die jüdische Kunst* (Berlin, 1929), p. 11. H. Strauss in his *Die Kunst der Juden im Wandel der Zeit und Umwelt* (Tübingen, 1972) relinquishes his earlier ambivalent attitude toward Jewish art. See Gutmann (*n. 34*), p. 53, note 5.

36. "A Jewish Painter's Idea of Jesus," *The New Era* 5 (1904), p. 75.

37. J. Gutmann and S. F. Chyet, *Moses Jacob Ezekiel: Memoirs from the Baths of Diocletian* (Detroit, 1975), pp. 21–26. Cf. Z. Amishai-Maisels, "The Jewish Jesus," *Journal of Jewish Art* 9 (1982), pp. 81–104, and J. Gutmann, "Jewish Themes in the Art of Moses Jacob Ezekiel," in *Moses Jacob Ezekiel and the Classical Tradition,* ed. A. Greenwald (Philadelphia, 1985), pp. 27–33.

38. S. S. Kayser, "Defining Jewish Art," in *Mordecai M. Kaplan Jubilee Volume,* ed. M. Davis (New York, 1953), pp. 457 and 459. See also G. Schoenberger, "The Essence of Jewish Art: A Book Review," *Historia Judaica* 8 (1946), p. 194: "Jewish art is essentially applied art in the deepest sense, applied to the religious life of the people . . ." A. Werner, in "Story of Jewish Art," *Jewish Affairs* 1 (December 15, 1946), pp. 6–7, and in the bibliography cited in Gutmann (*n. 34*), p. 54, note 6, follows the above definition with some modifications, but he abandons this definition in Werner (*n. 1*), p. 99.

39. J. Gutmann, *Jewish Ceremonial Art* (New York, 1964), fig. 10.

40. J. Gutmann, *Hebrew Manuscript Painting* (New York, 1978), p. 109, pl. 35, and G. Tamani, *Il Canon medicianae di Avicenna nella tradizione ebraica* (Padua, 1988).

41. C. Roth, *Jewish Art: An Illustrated History,* 2nd ed. (Greenwich, Conn., 1971), pp. 18–19. See also J. Pinkerfeld, "On Jewish Art," in *In the Paths of Jewish Art* (Merḥaviah, 1957), p. 143 (in Hebrew), and H. Rosenau, *A Short History of Jewish Art* (London, 1948), p. 67: " . . . a Jewish spirit can be felt in works sponsored and influenced by Jews."

42. F. Landsberger, *A History of Jewish Art,* reissue (New York, 1973), pp. 8–9.

43. Ibid., p. 276 ff., fig. 170; Roth (*n. 41*), p. 193 ff.

44. Landsberger (*n. 42*), p. 320, fig. 195; Roth (*n. 41*), p. 264.

45. M. Schapiro, "Style," in *Aesthetics Today,* ed. M. Philipson (New York, 1961), pp. 81–82.

46. J. Gutmann (*n. 40*), pp. 61–62, pls. 11–12.

47. J. Gutmann (*n. 39*), pl. III.

48. J. P. Hodin, "The Problem of Jewish Art and Its Contemporary Aspect," in *Modern Art and the Modern Mind,* ed. J. P. Hodin (Cleveland, 1972), pp. 141 and 149, and idem, "The Visual Arts and Judaism," *Art Journal* 23 (1964), p. 222 ff. See also Silver and Golan (*n. 19*), p. 13 ff.

49. Strauss (*n. 35*), pp. 117–18: " . . . *ähnliche Erfahrungen in der Jugend, nicht durch eine besondere jüdische Eigenart . . .*" See W. George, "The School of Paris," in Roth (*n. 41*), pp. 229–

60. On the abortive attempts by nineteenth- and twentieth-century Jewish artists in Russia to create a national art, see Kampf (*n. 7*), p. 48 ff.

50. Werner (*n. 1*), p. 99.

51. A. Katz, "Jacob Lipchitz, Jew," *Philadelphia Jewish Exponent* (May 13, 1960), p. 2. See Kampf (*n. 7*), p. 34 ff., for a discussion about the *Maḥmadim,* another group of Jewish artists in Paris.

52. G. Ofrat, "The Utopian Art of the 'Bezalel' School," *Jewish Quarterly* 26 (1978), pp. 19–22.

53. Interview recorded in the *New York Times* (July 29, 1962), p. 60.

54. E. Kolb, "Art in Israel," in *Jewish Art,* ed. C. Roth (New York, 1961), p. 949.

55. A. Pann, "Concerning Jewish Art," *The Menorah Journal* 6 (1920), p. 220.

56. "Art in Relation to Judaism: Interview with Hermann Struck," *The Jewish Chronicle* (June 28, 1912), p. 24.

57. S. J. Solomon, "Art and Judaism," *Jewish Quarterly Review* 13 (1901), p. 553.

58. I. Cohen, "Two Interviews: Josef Israels and Max Nordau," *The New Era* 6 (1905), p. 359.

59. Gutmann and Chyet (*n. 37*), p. 21.

60. A. Werner, "An Interview with Ben Shahn," *Congress Bi-Weekly* (March 7, 1966), p. 23.

61. Katz (*n. 51*), p. 2. See also W. Berkowitz, "Jacques Lipchitz: An Interview," *The Reconstructionist* (February 1974), p. 21: " . . . there is no need to look for Jewish art . . . art is a universal language."

62. L. Baskin, "To Wear Blood Stain with Honor," *Judaism* 10 (1961), p. 295.

63. I. Schor, "A Working Definition of Jewish Art," *Conservative Judaism* (Fall 1961), p. 28.

64. M. Chagall, "What Is a Jewish Artist?" in *The Golden Tradition: Jewish Life and Thought in Eastern Europe,* ed. L. S. Dawidowicz (New York, 1967), p. 332. On Chagall's Jewishness, see the revealing article by S. L. Shneiderman, "Chagall-Torn?" *Midstream* (June/July 1977), pp. 49–62, especially pp. 61–62. See also Kampf (*n. 7*), p. 206, note 45, and p. 208, note 67.

65. See J. Gutmann, ed., *The Temple of Solomon: Archaeological Fact and Medieval Tradition in Christian, Islamic and Jewish Art* (Missoula, Mont., 1976).

66. J. Gutmann (*n. 15*).

67. J. Gutmann (*n. 40*), p. 12 ff.

68. See H. J. Muller, "The Jesuit Style in Architecture: Fact or Fiction?" *Michigan Academician* 3 (1970), p. 14: " . . . the legend of a Jesuit style has no basis in fact." The American artist John La Farge said, "There is no such thing as the Protestant in art" (Gutmann and Chyet [*n. 37*], p. 20).

69. W. S. Rubin, *Modern Sacred Art and the Church of Assy* (New York, 1961), p. 73.

70. Werner (*n. 1*), p. 106.

71. Rubin (*n. 69*), p. 12.

72. Werner (*n. 1*), p. 101. See the interesting remark by E. B. Feldman, *The Artist* (Englewood Cliffs, N.J., 1982), p. 204 ff.: "The first problem . . . faced by members of various minority groups . . . is the suggestion of inferiority when someone is called . . . a 'Jewish-artist.' . . . The hyphen—real or implied—has the effect of reducing the size of the category. It suggests that these artists need only be considered in relation to other . . . Jewish artists. The implication is that they are not strong according to 'universal' artistic criteria." See also J. Gutmann, "Jewish Art and Jewish Studies," in *The State of Jewish Studies,* ed. S.J.D. Cohen and E. L. Greenstein (Detroit, 1990), pp. 195–96.

73. *Midrash Numbers Rabbah,* 15:10; *Midrash Tanḥuma Behaʿalotekha,* 62; Babylonian Talmud, *Berakhot,* 55a.

74. M. Ronnen, "Art in Israel," *Midstream* (September 1964), p. 54.

VIDOSAVA NEDOMAČKI

# A Contribution to the Discussion "Is There a Jewish Art?"

The term "Jewish art" should be placed in the category of those concepts that cannot be determined with clarity, as is also the case with similar terms like "French art" and "English art." European art historians of the nineteenth and twentieth centuries coined this simplified terminology, which served them well when they had to write about various national arts or when they wanted to give titles to those studies. But in its essence this terminology was incorrect. If we wished to offer clear concepts we would have to say, for instance, the art of the French people (or the art of France), the art of the Persians (or the art of Persia), of this or that period, and of this or that region (if all the regions of a state were not covered by the study). One would also have to say the art of the Jews in Judea, or the art of the Jews in Israel, or the art of the Jews in the Diaspora (indicating in which area of the Diaspora the particular art developed), as well as specifying this or that period.

None of the civilized nations have an art of absolute ethnic purity, an art that originated and was cultivated exclusively in its midst. Only the creativity of an isolated tribe can have such purity. As to the Near East, there have been a variety of influences, and the region has seen larger and smaller degrees of syncretism in the artistic creativity of its nations ever since human civilization first entered the area. Even the oldest of the great civilizations like those of Sumer and Egypt are not "pure" in ethnic terms. Only an artistic style can be pure, but that too for only a limited period and, as a rule, pure only with regard to a limited number of art objects and monuments. There are substantial regional and chronological differences even within those great ancient arts that are considered the basic pillars of world art—for instance, those of ancient Egypt and Greece—and therefore the term "Egyptian art" or "Greek art" cannot be understood to indicate a monolithicity of ethnic components valid for the entire developmental period of the art.

When one wishes to analyze the art of a nation, in this case the Jewish nation, one has to determine its territorial and chronological frame and then separate the autochthonous elements, their developmental phase, and the various adaptations of the foreign influences to which the art was exposed. It is possible thereafter, on the basis of their use, to classify various artistic monuments and objects as either secular or religious, and both of these categories can be further separated into official art (and even

this category, in earlier periods of Jewish history, into royal and temple art) and popular art.

And yet, all that has been said notwithstanding, publications dealing with the history of art use simplified terms like "French art" and "Greek art" that require qualification. That being so, why should the term "Jewish art" not be used as well? One has, however, to stress that the criteria valid for the art of all the other nations of the world should be valid for the art of the Jewish people as well.

The term "Jewish art" should not be compared with the term "Islamic art" or "Christian art." "Jewish art" means *the art of the Jewish people*, created under various historical circumstances and in various periods of time. The mere fact that religion was of great importance for and played a specific role in the development of the Jewish people and their material and spiritual culture (and no one can deny that in the Ancient World, particularly in the ancient Near East, all the other nations went through more or less similar phases in their development) cannot be taken as justification for looking at the products of Jewish art on the basis of religious criteria alone. We can do so with even less justification if we apply the criterion of the Old Testament, which prohibits the representation of any living being, because in fact the purpose of this prohibition was to keep idolatry beyond the borders of an Erez Yisrael encircled by pagan societies. Jewish art cannot be restricted to those creations alone that by their theme, symbolism, or use are in one way or another linked to the Jewish religion or to events in the history, either early or more recent, of the Jewish people.

Why should Jewish art be approached with more rigid criteria than the art of any other nation? Why is it that exclusively Jewish ethnic, thematic, functional, and formal elements are required for a work of art to be considered Jewish? Many great national arts could not satisfy such criteria and yet they are, for all that, recognized as national arts (for instance, Greek and Roman art). The root of all artistic creativity is in essence the censure-free inspiration of the artist, while considerations such as the purpose for which a work of art was ordered and the purpose that it served are of secondary importance. If that is so in general, it should be valid for Jewish artists and their creations as well.

The development of each national art and the artistic creations of each nation have their more or less numerous characteristic features and longer or shorter time spans. Somehow the art of the Jewish people has more complex characteristic features than the art of other nations, but this can be explained by the complexity of its history not only on the soil of Erez Yisrael but in the vast Diaspora as well. In the Diaspora Jews lived either in compact communities or mixed within the local population, but they remained Jews either because they identified themselves as such (as the overwhelming majority did) or because they were considered as such by the local population, their more or less complete assimilation notwithstanding.

One should state very clearly that every work created by Jewish artists belongs to the art of the Jewish people, be it a painting with some biblical theme, an abstract composition, a Ḥanukkah chandelier, or a mosaic with pagan motifs.

In addition, there are works of art, synagogal or profane, created by non-Jewish artists and artisans but intended for Jews. How should we classify these? One has simply to accept the fact that in all phases of Jewish history there were non-Jewish artists who created objects (even, for instance, *rimonim* or *parohets* for synagogues)

ordered by Jewish clients, just as Jewish artists in earlier times worked for pagans and just as in the Middle Ages leather bindings for Christian Bibles were the work of Jewish artists and artisans.

Up until the present day works of art created by Jewish artists in the Diaspora have often had no specific Jewish feature in their theme or form. And yet those works belong to the artistic creations of the Jews in a given part of the Diaspora. It would be simply absurd, on the one hand, to consider as Jewish *sacralia* the metal binding of a prayer book that was the work of a non-Jew while, on the other, excluding from the category of Jewish art an amulet or a composition with a pagan or Christian theme that was the work of a Jewish artist.

There are in Israel today painters who record on their canvases biblical themes, events that occurred in Nazi concentration camps, or portraits of members of kibbutzim. But there are other painters who create abstract compositions similar to those we come across in many parts of the world, or who paint landscapes and motifs that catch their eye in Venice or on the banks of the Seine, or who paint subjects that have no connection whatsoever with Jewish history or religion. Shall we, therefore, exclude these artists from the family of Jewish artists? By no means.

One has to accept the facts of the development of Jewish art with all of its characteristic features, those that made their appearance in Israel and those that came into being in the Diaspora. Instead of trying in vain to find a concise phrase to define Jewish art (something that is not demanded of other national arts), it is wiser to busy ourselves with writing a complete history of the art of the Jewish people, in so doing analyzing all its components, categories, phenomena, and aspects, and then with endeavoring to give a synthesis of its development and characteristic features.

Soþlice egypta cyninge cpæþ toþam þinenum þþam ebri
ircum piþum þenodon þonne hig bearn cendon þæþa oþeþ þe
genemned gephoþa 7oþeþ phua 7bæd him þuþ þonne gyt ge
mað þam ebreiþcum piþum 7hropia cennað tyd cymþ gyf hit
hire cyld biþ oþþleaþ þæt gyf hit mæden cyld þy healdað þæt
Sod lice þaþinena him ondredon god 7hrdydonþpa þe egypta
cyne him be bead achrolðon þaþaþ nð cyld

Baclypoðr þecyng hitohim 7cepæþ tohim hþi poldon gyt þa
don þæt gyt þa þaþ nð cyld heoldon þa andþpanoðon hi 7cpe
don Neþynð þa ebreiþcan þiþ þpilce þa egyptan hiþ yndaþe
7cunnan þenunga 7hicennað æþþam þeþit cumaþ tohim
Preod lice god diðe þel þam þinenum 7þæt þolc þeox 7þeþþ þðe
gestrangoð 7foþþam þeþadinena him god ondredon heþe
tim bþoðr him huþ Soþlice þaraþ bebead eallum hiþ þolce
7cepæþ þþa hþæt þpaþaþ nð haðeþ bro acennes þiþiþaþ hine
onþæt þeþeþ 7healðaþ þamæðen cyld

§ AMRAM genuit MOYSEN cū esset annoꝝ seraguta et marie iochabeth et þea uxit annoꝝ seþa
ginta septē

§ Hec nomina filiouū lau p̄ cognationes suas. Gerson. & caat. & merari. fili gerson lobeni 7
semei fili caat anuim. iſhar. et hebron 7oziel fili merari mooli. et mousi. acceþ
amra uxore iochabed patruele suā. que & aaron 7moysen 7maria

ויבא חרן ויגידיו

ויתנכלו אותו להמיתו

וינאחהו איש והנה תעוה

ויצר

וירישאהו איש והנה תעוה בשדה

נשחת הארבעים יס וישב אל הכתונת כס

ישבו לאכול לחם והנה ארחת ... סו...

*Color plate 2* *Sister to the Golden Haggadah, fourteenth century (London, Brit. Libr., MS. Or. 2884, fol. 6v [Genesis 37:15–29]): top half, Joseph, led by an angel, reaches his brothers at Dothan; bottom right, Joseph being thrown into the pit; bottom left, the meal of Joseph's brothers (photo by permission of the British Library, London). Original size c. 160 × 130 mm.*

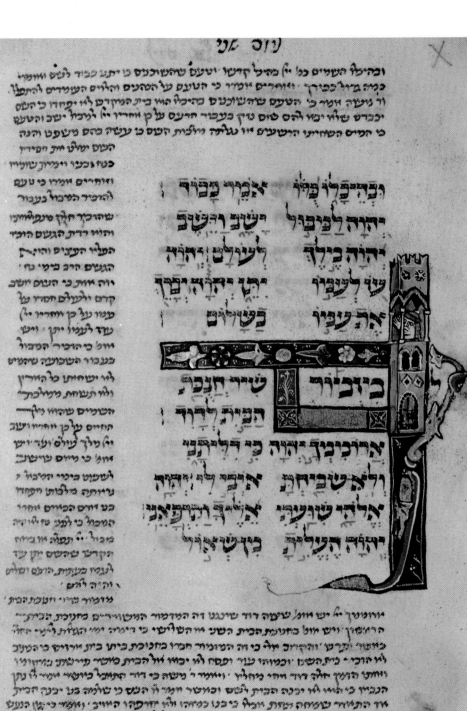

**Color plate 3** Parma, Bibl. Palat., Ms. Parm. 1870—De Rossi 510; psalter copied and decorated in Italy last quarter of thirteenth century; fol. 37r: illustration to Psalm 30, which is "a song at the Dedication of the House; a psalm of David." (photo M. Metzger, courtesy of Biblioteca Palatina, Parma). Main text measures c. 62 × 38 mm.

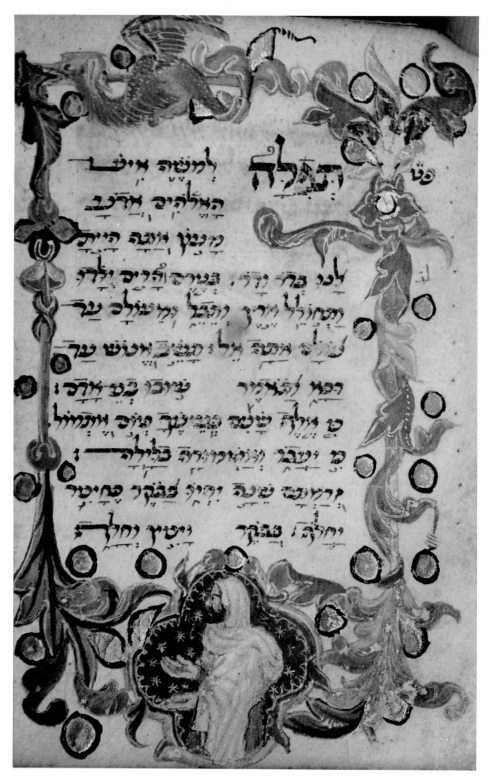

**Color plate 4** *Parma, Bibl. Palat., Ms. Parm. 1711—De Rossi 234; psalter copied and decorated in Perugia in 1391; fol. 115v: illustration to Psalm 90, "A Prayer of Moses, the man of God," which begins the fourth of the five parts of the psalter (photo M. Metzger, courtesy of Biblioteca Palatina, Parma). Page measures 106 × 76 mm, written area c. 60 × 40 mm.*

URSULA SCHUBERT

# The Continuation of Ancient Jewish Art in the Middle Ages

THE EXISTENCE OF A JEWISH ART in late antiquity became undisputed fact with the discovery in the 1930s of the synagogue of Dura Europos. We know from the original inscription on the ceiling that the synagogue was decorated with Old Testament scenes in 245 C.E. But the Roman frontier town of Dura Europos was conquered and destroyed by the Persian army in 256 and abandoned by its inhabitants; thus the synagogue was used for only 11 years and was not rediscovered for nearly two millennia. Because scenes decorating this synagogue can be found in other works of art, Jewish as well as Christian, we must assume that the models used by the artists of Dura Europos existed before 245. The elements of Hellenistic style found in these Oriental paintings, as well as the far-reaching influence of the models, prove that their place of origin could hardly have been a small frontier town on the eastern border of the Roman Empire but was certainly one of the east-Roman metropolitan centers. Themes from the synagogue of Dura Europos found in later works of art are, for example, Jacob's dream in Bethel, the exposure and finding of the infant Moses, the calling of Moses on Mount Horeb, the Exodus from Egypt, the High Priest Aaron in the Tabernacle, the anointing of David by Samuel, and the triumph of Mordecai in the story of Esther. I shall refer to some of these themes later.

The writings of Josephus Flavius may be helpful in discovering an approximate starting point for this antique Jewish art. Josephus wrote in about 100 C.E. for non-Jewish readers in Rome to whom he wished to explain the characteristics of his people. In *Bellum Judaicum* 2, 10:4, for example, he mentions that for the Jews any representation of God, man, or even an animal is forbidden. From his words it is clear that the prohibition was still strictly observed at the end of the first century C.E. Thus the appearance of a Jewish art can be pinpointed to within 100 years, for the models used at Dura Europos must necessarily have been drafted at the latest by about 200 C.E. This conclusion corresponds with the few Talmudic writings that deal with the question of images. The most important of these is the statement about Rabbi Johanan bar Nappaha (died 279) in *j Avodah Zarah* 3:3: "In the days of Rabbi Johanan bar Nappaha they began to illustrate the walls and he didn't prevent it." The practice thus prevailed during his lifetime, and even this most respected Palestinian rabbi whose authority extended far beyond the borders of his own country was unable to stop it.

The only synagogue from antiquity whose decoration with narrative scenes has been preserved is Dura Europos, but an inscription in the Great Synagogue of Sardis proves that wall paintings also existed at one time in that synagogue. The synagogue was discovered in the 1960s, and this particular inscription probably dates back to the first half of the third century. The inscription clearly mentions *zōgraphia*, the painting of figures. These probably adorned the ceiling, for the walls were covered with marble incrustations. A quotation from Rav Aḥa bar Jacob in *Yoma* 54a, which dates from the beginning of the fourth century, also proves the common practice of decorating synagogue walls with figural paintings. It reads, "Doubtless there existed painted Cherubim in the second temple." Obviously Rav Aḥa could not have reached this conclusion had he himself not seen such paintings in the synagogues. Such figural representations were quite common in Palestine and the Diaspora up to the sixth century, as the mosaic floors in the synagogues of Gaza and Beth Alpha prove.

In spite of the fact that the widespread custom of decorating synagogues with scenes from the Old Testament or with representations of single biblical figures such as David or Moses had been quite common for more than 400 years, Jews at the end of the sixth century turned away sharply from this practice as a result of a new consciousness of their own cultural, national, and religious past. This development led not only to the abandonment of the Greek language by the Jews but also to their intensified opposition to figural representation. When the Jewish iconoclasts were joined in this struggle by followers of Islam in the seventh century and by Byzantium in the eighth, they found a general consent that allowed them to strengthen and support one another against any kind of representation. Middle Byzantine art, which originates in early Byzantine models, proves beyond doubt that this artistic tradition did not perish in spite of a persecution that lasted about 120 years. However, the interval between late-antique and medieval Jewish art lasted not merely 120 years but about 600 years.

Medieval Jewish art originated not in the East but in the West. The East, remaining under the rule of Islam, was opposed to any figural representation. However, one can assume that illustrated Jewish manuscripts existed in Franconia during the Antique period—that country having been a Jewish cultural metropolis from the time of the Merovingians. It is not at all surprising that the illustrated manuscripts have not been preserved, for we know that in the mid-thirteenth century, at the time of the great dispute between Christian theologians and Jewish scholars (from 1240 to 1248, to date it exactly), no less than 20,000 Jewish manuscripts were collected from throughout the country and brought to Paris in ox carts to be burned. We may assume that among them would have been a number of illustrated Hebrew manuscripts—a particular eyesore for the Christian inquisitors, for those fanatics not only fought any heterodoxy among their own people but in their disputes with the Jews also identified and persecuted every Jewish infringement of the revealed commandments. We know from one of the writings of the Jewish apologist Joseph ha-Mekanne (Joseph the Zealot) that the creation of images was one of those concerns. Joseph ha-Mekanne, who objected to such an attack on Jewish works of art, wrote, "They argue against the plastic representation of cherubim. R. Nathan, may his soul rest in peace, answered . . . that they were only prohibited from worshipping them. How could Solomon have made the lions if they had been prohibited."[1] Joseph ha-Mekanne seems thus to justify the

works of art that existed in his own time by referring to representations mentioned in the Old Testament and by pointing out clearly that those representations had not infringed the Jewish prohibition of images.

But neither the assumption of the destruction of a great number of illustrated Jewish manuscripts in the Middle Ages nor quotations such as those above offer indisputable proof of the connection between ancient Jewish paintings and medieval Jewish manuscript illustrations. In order to give here such proof and to demonstrate the continuation of Jewish art up to the Middle Ages, it will be necessary to complement our discussion of the existing antique Jewish paintings with descriptions of illustrations in Christian manuscripts. Obviously the purpose can be fulfilled only by Christian manuscript illustrations whose archetypes had been drafted in ancient Jewish workshops and then taken over by Christian painters in search of models. Among these Christian pictures of Jewish origin we must distinguish between two different groups. In the first group we have pictures whose Jewish models can be proved by corresponding scenes either in the synagogue of Dura Europos or in some other ancient Jewish work of art. In the second we have Old Testament scenes that obviously differ from the canonic Bible text but either correspond to a Jewish Bible paraphrase, a targum, or can be explained far better by a rabbinic commentary, a midrash, than by the Bible text alone.

Among medieval Jewish manuscripts, the fourteenth-century Spanish haggadot are especially suited for such research. There we find complete sets of scenes from Genesis and Exodus available for comparison with late-antique or early-medieval illustrations, both Jewish and Christian.

If we first compare scenes from the synagogue at Dura Europos with those from Christian manuscripts and Spanish Passover haggadot, we shall see that the most conspicuous example of Jewish influence on Christian manuscripts is the scene showing Pharaoh's dispute with the Hebrew midwives (Exodus 1:15–19) (*Fig. 2.1*). At Dura Europos this scene is the first of four pictures on the west wall of the synagogue illustrating the story of Moses' childhood. Pharaoh with his scribe and a guard behind sits on a throne in front of the open gate to a town, the latter a symbol (according to the late-antique view) for the land of Egypt. The two midwives stand in front of him. Each raises her right arm in a conversational gesture, and we see that a vivid discussion is taking place. Because Pharaoh and both midwives are taking part in the discussion the scene must represent Exodus 1:18–19: "And the king called for the midwives and said unto them, why have ye done this thing, and have saved the men-children alive? And the midwives said unto Pharaoh, because the Hebrew wives are not as the Egyptian women." This scene is seldom found in Christian manuscripts and most probably indicates a Jewish influence.

The earliest Christian example of this scene is found in the so-called Ashburnham Pentateuch, or Pentateuch of Tours (Paris, Bibliothèque national, cod. nouv. acq. lat. 2334), a Vulgate text from the seventh century. A Jewish influence is assumed for part of the iconography of some of its pictures.[2] The representation on fol. 56r (*Fig. 2.2*) corresponds to the scene in Dura Europos except that the guards behind Pharaoh are missing and the open gate has been replaced by the architecture of a palace, again a symbol for the land of Egypt (as is also mentioned in the inscription above it). (A Jewish commentary may justify the existence of three men standing behind the two

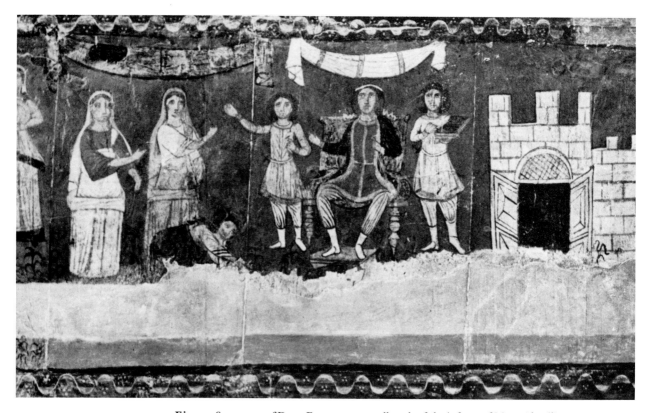

*Fig. 2.1* *Synagogue of Dura Europos, west wall, cycle of the infancy of Moses (detail), 245 C.E.:* *Pharaoh and the two midwives (photo by permission of the Yale University Art Gallery, Dura Europos Collection).*

women, but that is a subject for another discussion.) Here, too, Pharaoh's gesture as well as those of the two midwives indicates conversation, as is also mentioned in the inscription.

The next Christian example comes from the older of the two Vatican Octateuchs, cod. vat. gr. 747, fol. 72r, which dates from the eleventh century. Jewish influence for several scenes in this manuscript has been proved by a number of scholars.[3] As in the illustration in the Ashburnham Pentateuch, Egypt is represented by a palace, but the throne and Pharaoh's frontal position correspond to the Dura Europos scene. Here, too, the gesture for speech hints at a conversation taking place.

Pharaoh's conversation with the two midwives is also represented in the Anglo-Saxon Aelfric Paraphrase of the Hexateuch (London, British Library, Cotton Claudius B. IV, fol. 73v) from the early eleventh century (*color plate 1*).[4] As stated by O. Pächt, the iconography of many of the illustrations in this manuscript points to models in Eastern, pre-iconoclast cycles of Bible illustration.[5]

We again find the same scene on one of the four single leaves that probably once belonged to a psalter manuscript, New York, Pierpont Morgan Library, MS. 724, fol. 1r,[6] and in a psalter belonging to the Bibliothèque nationale in Paris, ms. lat. 8846, fol. 2r.[7] Both manuscripts may have originated in Bury St. Edmunds in twelfth-century England. The leaf of the Morgan Library psalter is of special interest because we see

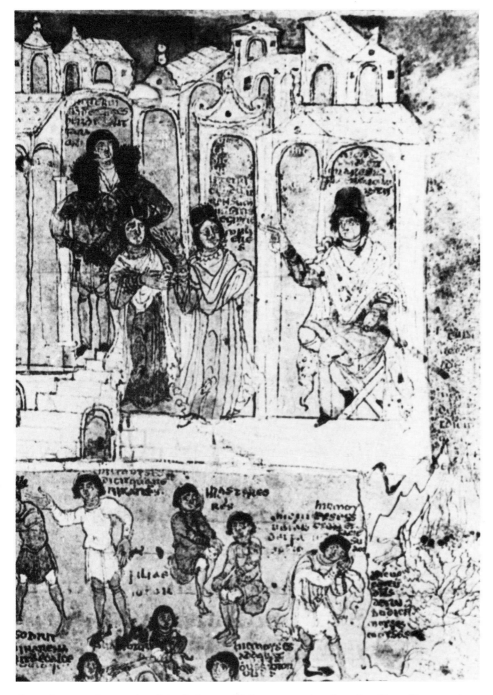

*Fig. 2.2 Ashburnham Penta-teuch (Pentateuch of Tours), seventh century (Paris, Bibl. nat., cod. nouv. acq. lat. 2334, fol. 56r [detail]): Pharaoh and the two midwives (photo Bibliothèque nationale, Paris).*

there the complete cycle of the infancy of Moses narrative found at Dura Europos but in a slightly altered form. In the upper left Pharaoh talks to the midwives while Moses' mother is about to place the child by the river. The architecture of Egypt has been omitted, and Pharaoh is turned toward the midwives so that he is in profile. The scene thus corresponds to a similar one in the Golden Haggadah (London, British Library, MS. Add. 27210, fol. 8v) from the early fourteenth century (*Fig. 2.3*) except that there

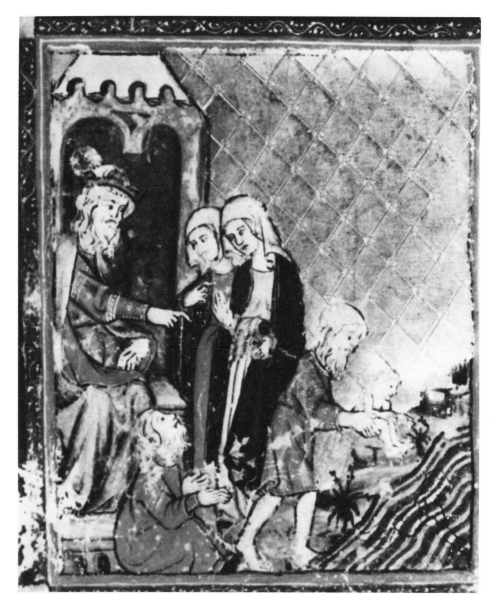

*Fig. 2.3* *Golden Haggadah,*
*ca. 1320 (London, Brit. Libr.,*
*MS. Add. 27210, fol. 8v [de-*
*tail]): Pharaoh and the two*
*midwives (photo by permission*
*of the British Library,*
*London).*

Pharaoh's gesture is modified and hints at his order that Egyptian boys be thrown into the Nile, an act that is shown as a second scene within the same frame. Thus the narrative becomes slightly altered. It is true that Exodus 1:22 reads, "And Pharaoh charged all his people, saying, every son that is born ye shall cast into the river, and every daughter ye shall save alive." But this verse is quite unrelated to Pharaoh's order to the midwives. In this picture from the Golden Haggadah the Egyptian architecture has been reduced to a canopy. The so-called Sister Haggadah to the Golden Hagga-dah, London, British Library, MS. Or. 2884, fol. 11v, also shows the same two scenes.

The close relationship of the scenes at Dura Europos to those in the two Spanish haggadot seems to prove the continuation of a tradition of representation from the third to the fourteenth century. Nevertheless, we should take into consideration the

possibility that the artist of the Golden Haggadah had a Christian and not a Jewish model at hand—in other words, that it was a Christian painter using a late-antique Jewish model who handed the model on to a medieval Jewish miniaturist. Although the scene of Pharaoh's dispute with the two midwives is comparatively rare in Christian cycles, being generally replaced by a scene showing the birth of Moses, the possibility of a Christian mediator cannot be ruled out. We have, therefore, to examine other themes of manuscript illumination in order to prove the continuation of Jewish art from late antiquity to the Middle Ages.

The first illustration of the Exodus cycle at Dura Europos, also painted on the west wall (*Fig. 2.4*), shows a scene seldom found in Christian manuscripts—the Israelites' departure from Egypt. Early Christian illuminations usually show only two of the scenes from this cycle, and they are combined into one illustration.[8] The usual arrangement of these scenes from Exodus on Christian monuments is to be found, for example, in one of the fifth-century mosaics in the nave of Santa Maria Maggiore in Rome.[9] On the right the Egyptians are leaving the city and drowning in the Red Sea; on the left the Israelites have already passed through the Red Sea, and Moses, at the end of the column of Israelites, is shown dipping his staff into the water in order to make it return to its rightful place.

At Dura Europos there are not two scenes but three, carefully separated one from another. The first, as mentioned, shows the Israelites leaving Egypt. Again, Egypt is symbolized by a wall with an open gate. The departing Israelites stand in four rows, one above the other. The men in the front row carry various household chattels; those in the second and fourth rows are armed with shields and spears. There are only 12 men in the third row, representing the princes of the 12 tribes of Israel. Moses leads

*Fig. 2.4 Synagogue of Dura Europos, west wall, Exodus cycle (detail): the Israelites leaving Egypt (photo by permission of the Yale University Art Gallery, Dura Europos Collection).*

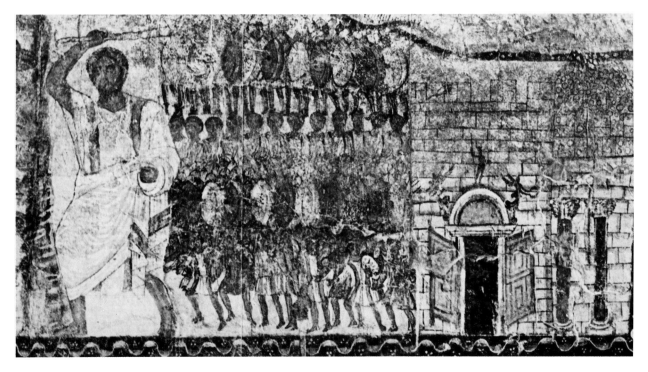

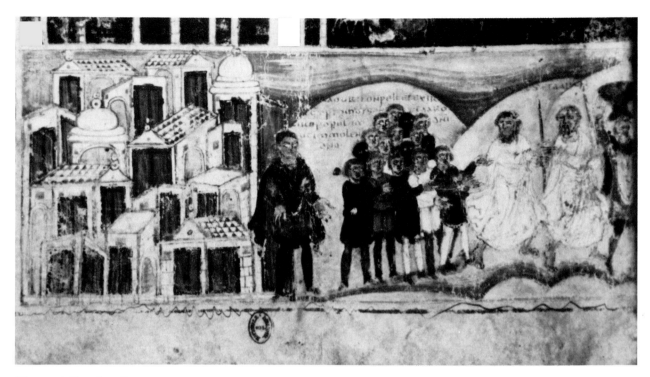

them, brandishing a clublike staff over his head in order to cleave the waters. The Aramaic inscription runs, "Moses, departing from Egypt and cleaving the sea." The second part of this inscription is repeated in the third scene of the cycle, which has the title "Moses cleaving the sea." It seems evident that the sequence of scenes in this cycle had already been confused at Dura, for between the first and third pictures we see the Egyptians drowning in the Red Sea.[10]

The Ashburnham Pentateuch, with which we are already familiar, also illustrates the departure of the Israelites from Egypt (*Fig. 2.5*). The lower third of fol. 65v shows the departure from Egypt immediately after the tenth plague. But the distribution of space here is surprising: more than a third of it is occupied by the architecture of Egypt, and in the central portion Pharaoh and his people stand in front of the walls to bid farewell to the departing Israelites. Thus little space was left for the Israelites, and only Moses and Aaron at the rear of their troops could be depicted. Besides these two one can distinguish an Israelite at the right margin carrying a golden dish on his head, which, according to the biblical text, he had probably either stolen or been given by the Egyptians (Exodus 12:35–36). We have to assume that the model for this illustration was a far longer picture strip showing the whole troop of departing Israelites, omitted here for lack of space.

The next scene in the Ashburnham Pentateuch, fol. 68r (*Fig. 2.6*), has no parallel either in early or medieval Christian works of art or at Dura Europos. Nevertheless, the fact that at Dura Europos the title of the first Exodus scene was partly repeated in the third obviously indicates that the original model contained yet another scene, probably between the first one (the departure from Egypt) and the second (the drowning of the Egyptians). But what might the lost scene have been?

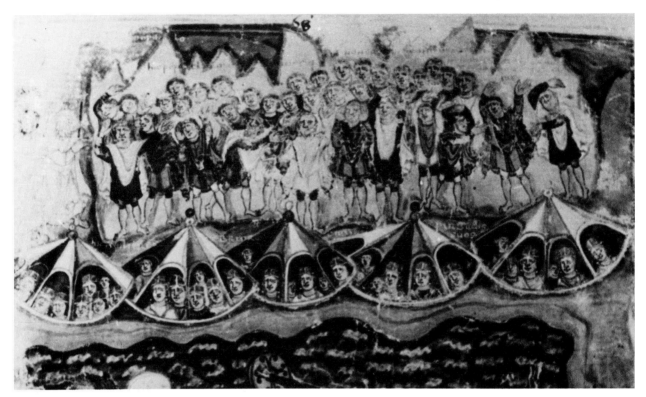

*Fig. 2.6* *Ashburnham Penta-teuch (Pentateuch of Tours), seventh century (Paris, Bibl. nat., cod. nouv. acq. lat. 2334, fol. 68r [detail], 245 C.E.: the Israelites' encampment at Phihahirot (Baal-Zephon) (photo Bibliothèque nationale, Paris).*

After the departure recorded in Exodus 12, chapter 14 tells of the encampment of the Israelites at Phihahirot, which was near Baal-Zephon on the shores of the Red Sea. There the Egyptians overtook them, and only then did Moses part the sea in order to save the Israelites from their pursuers. Fol. 68r of the Ashburnham Pentateuch shows the Israelites' encampment at Phihahirot: we see the women's tents, and behind them we see the men, their gestures expressing terror. From their postures we know that the danger they fear is approaching from the right. This danger could only have been Pharaoh and the Egyptian pursuers who overtook them at Baal-Zephon. Because space was limited in the illustration, the Egyptians were omitted. The text of the illustration confirms our assumption and repeats Exodus 14:11 in slightly different words: "[And the Israelites] said to Moses: Were there no graves in Egypt that thou should have brought us here [i.e., to Baal-Zephon] to die in the wilderness?" Then follows Moses' answer, again slightly different from the Bible text: "Have no fear, Moses answered; stand firm and see the deliverance that the Lord will bring you this day." We may assume, therefore, that the upper part of fol. 68r depicts the encampment at Baal-Zephon without showing the Egyptian pursuers approaching from the right.[11] The following, third scene on the same page shows the Egyptians drowning in the Red Sea and the Israelites safe on the eastern shore. These two representations correspond to the second and third scenes at Dura. Did the model for Dura Europos contain the scene of the Israelites' encampment at Phihahirot, whose omission at Dura caused the confusion in the titles?

We again find the same sequence of events as in the Ashburnham Pentateuch in the Sarajevo Haggadah (Sarajevo, National Museum, p. 27) from the fourteenth century

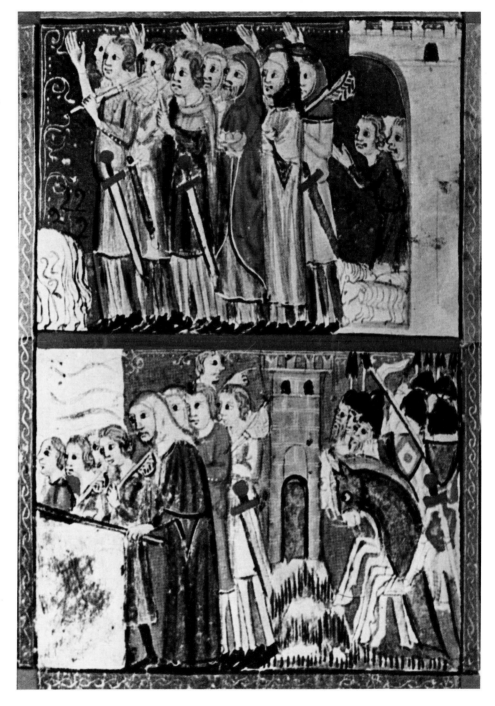

(*Fig. 2.7*).[12] The upper picture shows, on the right, the town wall of Egypt; two Egyptians stand in front of it bidding farewell to the departing Israelites. Around the Israelites (carrying swords according to the text of Exodus 13:18) are their flocks and herds. In the middle of the lower picture we find the architecture of another town, representing Baal-Zephon. While the Egyptians approach from the right, the Israel-

ites escape to the left, one of them turning back and stretching out his hand toward the pursuers. On the left is the Red Sea, with Moses standing on the shore stretching out his staff across the water. The upper part of the following page, p. 28, shows the Israelites walking through the sea; on a band in the middle, which symbolizes the sea, the Israelites march as though on dry ground. In the upper left corner we see another band with marching Israelites, a depiction that seems to accord with the description of 12 roads made through the water for the 12 tribes in Targum Jonathan to Exodus 14:12. Drowning Egyptians float in the waves between the roads. Only the crowned Pharaoh stands upright in the water at the left, saved from drowning as reported in *Pirke Rabbi Eliezer* 43.[13]

The Golden Haggadah also shows the Israelites leaving Egypt (fol. 14v).[14] Here the architecture of a town has been replaced by a castle. Pharaoh and his people stand on top of a battlemented wall, rejoicing and bidding farewell to the departing Israelites. Unlike the scene in the Sarajevo Haggadah, the fortress of Phihahirot is not shown. In the lower right-hand picture of this folio the Egyptian pursuers are represented without the Israelites; the lower left-hand picture shows the drowning of the Egyptians and the deliverance of the Israelites. A similar set of scenes is shown in the Sister Haggadah to the Golden Haggadah, London, British Library, MS. Or. 2884, fol. 16v. Yet the Hispano-Moresque haggadah, London, British Library, MS. Or. 2737, from the early fourteenth century offers a far more detailed cycle than that in the Sarajevo Haggadah. After the scene of the Israelites leaving Egypt, the next illustration, fol. 84v,[15] uses the familiar architecture of a castle to represent Baal-Zephon; the Egyptian pursuers approach from the right while the Israelites escape to the left. The title above the picture reads "BAAL-ZEPHON." The next illustration, fol. 85r, shows the pursuing Egyptians, and the following one, fol. 85v, shows Moses standing on the shore, raising his staff to part the sea. In the background the spears of the approaching Egyptians are visible.

Other fourteenth-century Spanish haggadot also show the departure of the Israelites as the first scene of the Exodus cycle, including, for example, the John Rylands Haggadah in Manchester (John Rylands Library, MS. 6, fol. 18v[16]), its so-called Brother Haggadah in London (British Library, MS. Or. 1404, fol. 6v[17]), and the Kaufmann Haggadah in Budapest.[18] The three manuscripts omit the architecture of Phihahirot and show only the Israelites with their Egyptian pursuers behind them.

The manuscripts compared here show with certainty that Jewish miniature painting in the Middle Ages, like the scenes in the synagogue of Dura Europos, depicts the departure of the Israelites as the first scene of the Exodus cycle. As we recall, the same scene is found in the Ashburnham Pentateuch. From all of this evidence we may assume a continuous tradition of Jewish art from late antiquity up to the fourteenth century, for in this instance Christian manuscripts offered hardly any suitable models for the Jewish artists of the Spanish haggadot.

When we turn to the second type of proof testifying to the existence of Jewish models for Christian manuscripts—that is, Christian Bible illustrations that differ obviously from the Latin or Greek texts and are explainable only in the light of a Jewish Bible paraphrase (a targum) or a Jewish commentary (a midrash)—we find plenty of evidence in the articles of J. Gutmann, C.-O. Nordström, O. Pächt, K. Weitzmann, and others.[19] There is, however, one particular Bible scene that, while it is in complete

harmony with the standard Bible text, seems nevertheless to prove the influence of a Jewish commentary. This scene is the meal of Joseph's brothers before they sell Joseph to the Midianite traders (Genesis 37:25–27). The meal is mentioned only incidentally in the Bible and is without importance for the course of events. In spite of this we find an exhaustive representation of it in the Cotton Genesis recension as well as in the Octateuchs and other manuscripts. Among Spanish haggadot we find the scene clearly represented—to the best of my knowledge—in only one manuscript, but this is the very same one that in another of its illustrations offers indisputable proof for the continuation of Jewish art from late antiquity to the fourteenth century—British Library, Or. 2884 (*color plate 2*). In the top half of fol. 6v Joseph, led by an angel, reaches his brothers at Dothan. In the lower right, Joseph is being thrown by his brothers into the pit, and on the left the brothers' meal is shown. The title of the illustration offers no explanation and mentions only the fact of the meal, but in *Midrash Tanḥumah* there is a commentary to Genesis 37:24. *Tanḥumah ki Tissa* 2[20] reads,

> Come and see how much Israel is loved [by God] that even their sins are turned into good. And if this is the case with regard to their sins, how much more then with regard to their merits. For example: When Jacob sent Joseph to his brothers they said to each other when they saw him: "Here comes that dreamer. Now is our chance; let us kill him" (Genesis 37:19). So they threw him into the pit. Then they said: "We shall eat and drink and then we shall draw him out and kill him." They ate and drank and finally they went thus far as to speak the blessing. Then Judah said: "We want to kill a man and to speak a blessing to our Lord? Thus we do not bless but curse, for it is said: The wicked boasts of the desires of his heart, and the man greedy for gain curses and renounces the Lord" (Psalm 10:3). "Thus we shall not kill him but sell him to the Ismaelites" (Genesis 37:27). "Then they sat down and ate" (Genesis 37:25).

The midrash was familiar to Rabbi Meir, a fourth-generation Tannaite who lived in the mid-second century, for he commented upon the topic. In *Sanhedrin* 6b Psalm 10:3 is applied to Judah in a negative sense: "Rabbi Meir said, 'The verse "the man greedy for gain curses and renounces the Lord" is only applied to Judah.'" There is also a passage from Rabbi Yehuda bar Shalom handed down from the mid-fourth century that comments upon the brothers' meal in the context of the sale of Joseph.

From these quotations we can see the importance of this scene for Jewish theology, whereas in Christian theology there is, according to L. Ginzberg,[21] no parallel in the writings of the church fathers. This is not surprizing, for the blessing before the meal, which was the cause of Joseph's deliverance, is a typically Jewish custom. That several Christian manuscripts show the meal linked with the arrival of the Midianite traders may hint at a Jewish influence. We find the scene, for instance, in the most famous representation of the Cotton Genesis recension, which is found on the third dome of the atrium of St. Mark's in Venice (*Fig. 2.8*). It was the Cotton Genesis that served as the model for the atrium mosaics in Saint Mark's. Here the relationship between the meal of the brothers and the arrival of the traders is evident. The same scene also exists in the Vatican Octateuch manuscripts.[22] In addition, both scenes are found in the Anglo-Saxon Aelfric Paraphrase, fol. 54r, and they are found together in the manuscript of Gregory of Nazianzus in Paris (Bibliothèque national, cod. gr. 510, fol. 69v[23]).

The examples offered seem to show with great probability that Jewish miniatures, models for which are available to us for the first time at Dura Europos or may be

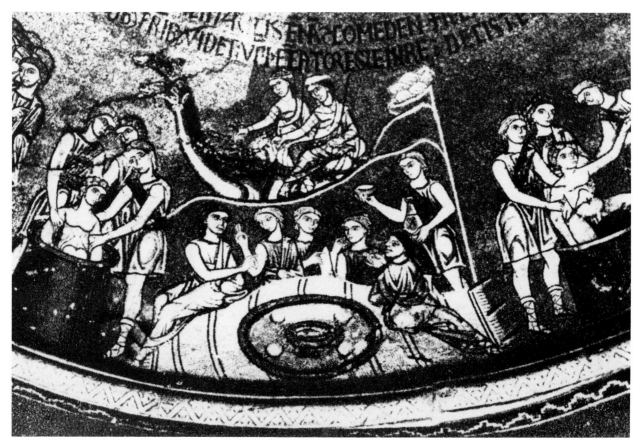

*Fig. 2.8* St. Mark's, Venice, atrium, third dome (detail), thirteenth century: the meal of Joseph's brothers.

reconstructed with the aid of Christian illustrations based on targumim and midrashim, continued to be executed from late antiquity until the Middle Ages.[24] Against this thesis one might argue that the setting up of the great collections of midrashim (e.g., *Midrash ha-Gadol*) in the Middle Ages inspired new illuminations and that models for these were sought and found in Christian workshops and manuscripts. In that case we must assume that the respective Bible motifs were originally drafted in Jewish workshops and later taken over and handed down through the centuries by Christians until a time when the Jews, knowing the relevant midrashim, rediscovered them in Christian manuscripts or workshops. Although it is difficult to imagine such a process, Christian mediation may be responsible for several Bible scenes in medieval haggadot. But a medieval Christian mediator cannot be assumed if we can prove that a motif in a medieval haggadah cannot be explained by a Jewish midrash or targum but can be explained only by late-antique concepts long forgotten by the Middle Ages.

We do, in fact, possess such a picture in the Sister Haggadah to the Golden Haggadah, London, British Library, MS. Or. 2884, fol. IV (*Fig. 2.9*). According to the title, which reads, "And breathed into his nostrils the breath of life," the picture portrays the creation of Adam.[25] This text is part of Genesis 2:7, and the complete verse reads, "And the Lord formed man of the dust of the ground and breathed into his nostrils the breath of life." But nothing like this is represented in the illustration. Adam stands in the middle of the picture in front of a little hill, facing the onlooker.

*Fig. 2.9 Sister to the Golden Haggadah, fourteenth century (London, Brit. Libr., MS. Or. 2884, fol. 1v): the creation of Adam (photo by permission of the British Library, London).*

On each side of him are three winged figures and a fourth without wings. Although the artist tried to draw the two groups symmetrically with regard to number, bearing, position, and gesture, a comparison shows that the left side is a copy of the right side and that the illustrator of the left side tried to accommodate the left side to the title above. On the right the three winged beings face Adam. The first one kneels beside him and seems to be forming Adam's left arm with both of his hands. Behind him the second winged figure touches Adam's head with his right hand. To the right a third winged figure, the only one wearing a red cape over a long violet tunic, walks toward Adam making a conversational gesture. Behind him is the fourth, wingless figure. What has this illustration to do with the creation of Adam? The Bible mentions that God formed man of dust and then breathed into his nostrils the breath of life. But the representation on the right side of Or. 2884 shows not God but three winged beings grouped around Adam in the attitudes described above. These three winged figures obviously symbolize three different stages of creation.

The threefold act of creation distinguishes this picture significantly from the Bible text obligatory for both Christians and Jews, but it does correspond to the Antique conception of man's creation in, particularly, Stoic philosophy.[26] This doctrine regarded man as consisting of *soma* (body), *pneuma* (spirit), and *psyche* (soul).[27] Thus the creation of man was presented in three different stages, as can be seen, for example, in the scenes on some Prometheus sarcophagi. In his essay "The Illustration of the Septuagint" K. Weitzmann distinguishes between the formation, the enlivenment, and the animation of man and recognizes these three stages in those Christian manuscripts and mosaics with imagery that is related to the Cotton Genesis (London,

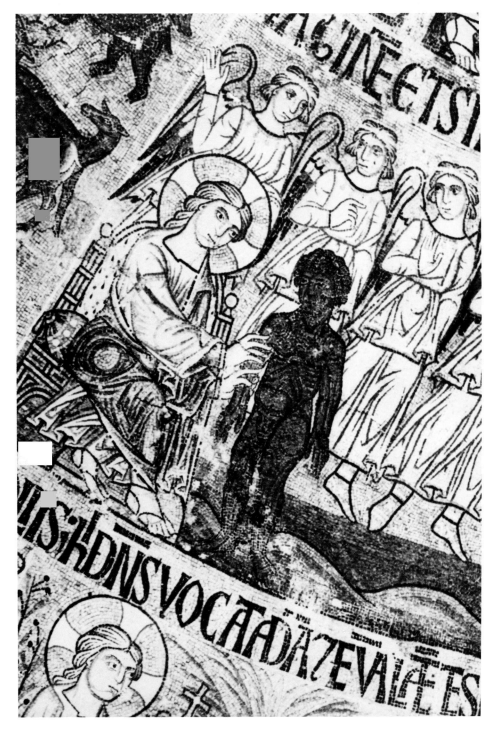

**Fig. 2.10** *St. Mark's, Venice, atrium, first dome (detail), thirteenth century: the formation of Adam.*

British Library, Cotton Otho B. VI) of the fifth to sixth century.[28] The formation of Adam's body, depicted in the mosaic on the first dome of the atrium of St. Mark's, Venice (*Fig. 2.10*), where the Creator is forming Adam's arm, corresponds to the first stage of the trichotomic anthropology. The second stage, where the Creator bestows

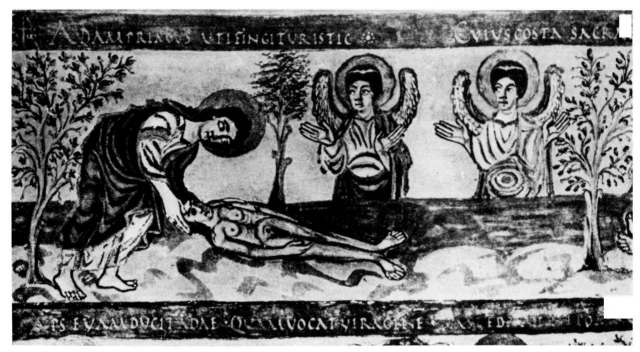

*Fig. 2.11* Grandval Bible, ninth century (London, Brit. Libr., MS. Add. 10546, fol. 5v [detail]): the enlivenment of Adam (photo by permission of the British Library, London).

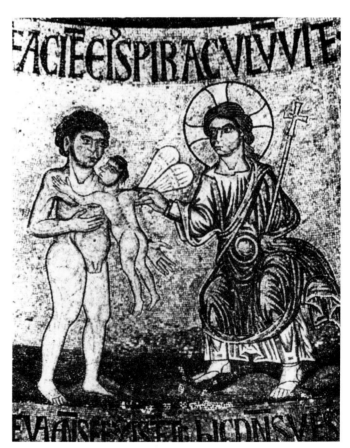

*Fig. 2.12* St. Mark's, Venice, atrium, first dome (detail), thirteenth century: the animation of Adam.

life on man by touching his head, corresponds to the creation of Adam depicted in the Grandval Bible (London, British Library, MS. Add. 10546, fol. 5v) from the early ninth century (*Fig. 2.11*). The animation of Adam, the third stage in the creation of man, is also represented on the first dome of St. Mark's, where the Creator holds a little Psyche with butterfly's wings (the butterfly being an Antique symbol for the soul) toward Adam's breast (*Fig. 2.12*). In the same essay Weitzmann considers the possibility that a Greco-Jewish book illumination was the mediator between the illustrated papyrus rolls of the classical Greek authors and illustrated Christian Bibles.

The Ezekiel cycle portrayed in the synagogue of Dura Europos, which illustrates the reanimation of the dead according to Ezekial 37:1–10, also represents reanimation by means of the same three pictorial types identified by Weitzmann as models for the formation, bestowal of life, and animation of man according to the ancient trichotomic concept. It was only within the framework of this tripartite idea of man that late antiquity could understand the act of creation. Dura Europos proves that the Jews of the third century also accepted these common ideas: They likewise could understand reanimation only according to the three stages. The text of Ezekiel 37:1–10 reads:

> The hand of the Lord was upon me, and carried me out in the spirit of the Lord, and set me down in the midst of a valley which was full of bones. . . . (5) Thus says the Lord unto these bones: behold, I will cause breath to enter into you and you shall live. (6) And I will lay sinews upon you and will bring flesh upon you and cover you with skin and put breath in you, and you shall live and you shall know that I am the Lord. (7) So I prophesied as I was commanded: And as I prophesied there was a noise, and behold a rattling, and the bones came together, bone to its bone. (8) And as I looked, there were sinews on them, and flesh had come upon them, and skin had covered them; but there was no breath in them. (9) Then he said unto me: "Prophesy unto the wind, prophesy, son of man, and say to the wind, thus says the Lord: Come from the four winds, o breath, and breathe upon these slain, that they may live." (10) So I prophesied as he commanded me and the breath came into them, and they lived, and stood upon their feet, an exceeding great army.

Thus Ezekiel 37:7–8 simply reports on the formation of the bodies according to Genesis 2:7, "Then the Lord formed a man from the dust of the ground . . . " Ezekiel 37:9 then continues, "Come from the four winds, o breath, and breathe upon these slain, that they may live." The wind therefore has to breathe upon the dead in order to give them back the breath of life. This corresponds to the second part of Genesis 2:7, "And God breathed into his nostrils the breath of life."

But what is actually represented at Dura Europos? Ezekiel the prophet is taken by the hand of the Lord and carried to a plain strewn with bones. The three corpses lying on the ground beneath a house that is tumbling down symbolize the first stage in the threefold act of creation (in Ezekiel, reanimation), the formation of man (*Fig. 2.13*). An earthquake had put the scattered bones together, and they were covered by flesh and sinew. According to the text of Ezekiel the corpses are now waiting for the wind to enliven them. But in the picture the image of the bodies is repeated, this time with a tall pagan Psyche, winged like a butterfly, touching the head of the uppermost body, as the Lord does with Adam in the Carolingian Grandval Bible. It is the bestowal of *pneuma* by the touching of the head. The third act in creation, animation, follows as

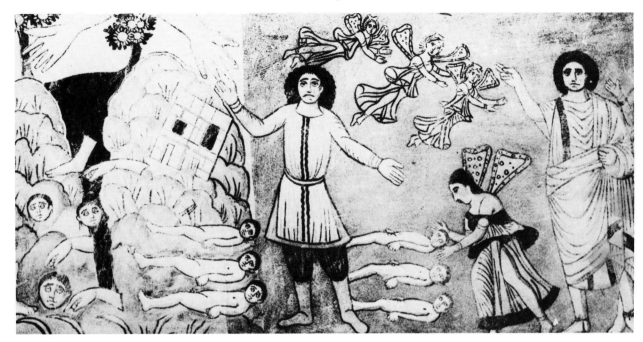

**Fig. 2.13** *Synagogue of Dura Europos, cycle of Ezekiel (detail), 245 C.E.: reanimation of the dead (photo by permission of the Yale University Art Gallery, Dura Europos Collection).*

the third scene at Dura Europos. Above the three bodies we see three little *psychai* that are fluttering down at the command of the prophet, who stands with his right arm raised in the conversational gesture. The three little souls are destined for the three bodies on the ground. They look like the little Psyche fluttering toward Adam in the representation in St. Mark's, Venice. Thus the scene of reanimation at Dura Europos corresponds to the general late-antique concept of creation through the bestowal of *soma, pneuma,* and *psyche*.

The story of the creation of Adam in Josephus Flavius (*Antiquities* I, 1:2) supports this interpretation of the picture at Dura Europos and proves that by the time of Josephus the Jews interpreted the Bible text in terms of late-antique anthropology. *Antiquities* I, 1:2, reads, "And God *formed* [my italics] a man from dust from the ground and afterwards he bestowed on him *pneuma* and *psyche*."

Paul's first Epistle to the Thessalonians is evidence that Christians also accepted these ideas. Thessalonians I, 5:23, reads, "May God himself, the God of peace, make you holy in every part, and keep you sound in *spirit, soul* and *body* . . . " [my italics]. Bishop Eirenaeus of Lyons, in the last half of the second century, commented upon this verse in the same sense (*adversus haereses* V, 6:1), and it is clear that in the first centuries of Christianity trichotomic anthropology dominated over biblical anthropology.

In the Cotton Genesis recension the original threefold creation of man is reduced to two scenes as a result of the two-phase concept of the Bible. But different representatives of this recension do not always show the same two pictures. Sometimes the

act of forming the body is combined with the act of animation, as in the mosaic in St. Mark's, or the act of bestowing *pneuma* is combined with formation of the body, as in the Carolingian Grandval Bible, where the Lord with his left hand is forming Adam's shoulder while touching Adam's head with his right hand. The examples given show the long-lasting influence of a purely pagan, ancient anthropology on Christian art, although from the end of the fourth century the trichotomic anthropology was condemned time and again by several Christian Councils. The motifs were copied from one manuscript to another and handed down through the centuries with little understanding of them, and they were never complete or in the right order.

The image of the creation of Adam in the haggadah London, British Library, Or. 2884, fol. IV (*Fig. 2.9*), originates from the same ancient anthropology, but only the figures on Adam's right correspond exactly to the late-antique archetypes. The first winged figure, modeling Adam's arm, symbolizes formation. Behind this figure a second one, touching Adam's head, represents the bestowal of *pneuma,* and a third figure, stretching out his hands in the conversational gesture, is a symbol for the bestowal of the soul. The soul is probably represented by the fourth figure, which, perhaps intentionally or through lack of space, is wingless. This figure stands at the margin of the scene and gives the impression of having arrived in a hurry.

Adam's posture is further proof of the adaptation of an Antique model for this late-medieval picture. The peculiar way in which Adam stands, with his protruding left hip much lower than his smaller right hip, has its counterpart only in Antique contraposto figures. It is not possible to suggest that the stance of this Adam was first invented in the Middle Ages.

It goes without saying that Jewish artists had to find an expedient for the representation of the Creator. There was for Jews no possibility of representing the act of creation, either by the Logos or by God himself. But Jewish targumim offered a way out of this problem. *Gen. rabbah* 8:3 to Genesis 1:26 reads, "Rabbi Ḥanina [who lived in the first part of the third century] said: In the hour He decided to create the first man He consulted his angels and said unto them: 'Let us make man in our image and likeness' (Genesis 1:26)." Targum Jonathan to Genesis 1:26 reads, "The Lord spoke to his angels who serve him and who were created on the second day of creation: We shall make man in our image and likeness." Thus for Jewish illuminators there was the possibility of symbolizing the creation of Adam by introducing angels into the scene. The Psyche in the Ezekiel cycle of Dura Europos suggests that such expedients were already being used in late antiquity. (Even as late as the twelfth century, in the Paris psalter Bibliothèque national, cod. lat. 8846, fol. 1r, seventh medallion,[29] two angels can be seen taking part in the creation of Eve by the Logos, although their gestures are not decipherable.)

It would have been absolutely impossible in the Middle Ages for an illuminator to have drafted an illustration that corresponded not at all to the text but followed instead a long-forgotten philosophy without his first having had a model at his disposal. The left part of the picture in MS. Or. 2884, fol. IV (*Fig. 2.9*), proves this impossibility, for the ancient scene of the creation of Adam was obviously enlarged in the Middle Ages (it was probably already in the haggadah that served as model for the artistically unimportant MS. Or. 2884) by repeating on Adam's left the four figures that stand on his right. By comparing the two sides we discover that, nevertheless, the left-hand fig-

ures differ sufficiently from those on the right to prove that the artist had no understanding of their original meaning.

The angel in the left foreground modeling Adam's arm is the only one that corresponds to its counterpart on the right. The angel behind does not touch Adam's head to bestow the spirit but blows through a tube onto Adam's mouth. The third angel, who ought to symbolize reanimation, does not turn toward Adam but stands at the outermost margin of the scene, obviously talking to the presumed Psyche, who faces this figure and not Adam. This interpretation is also suggested by the gestures of the two figures.

B. Narkiss assumes that the formation of the model for the illustrated haggadah took place before the thirteenth century.[30] That would mean, in our case, that the model for the scene of the creation of Adam in MS. Or. 2884 was extended by copying the right side onto the left no earlier than the fourteenth century. But our examination has shown that the archetype for this haggadah was drafted at a time when the trichotomic anthropology was still widely accepted. Yet it is impossible to presume that the medieval haggadah picture was imported from a medieval Christian illustration, because the Christian illuminators had themselves forgotten the original meaning of the different gestures and no longer copied their models exactly and faithfully. Besides, the angels hint at a Jewish workshop, for in this context a Christian illuminator would never have omitted the representation of the Creator. Thus the picture in haggadah Or. 2884, fol. IV, *Fig. 2.9*, seems to prove that its medieval Jewish artist used a late-antique Jewish model for this illustration.

Perhaps one day some lucky accident will present us with a leaf from an ancient Jewish manuscript, to have as stimulating an effect on research as the discovery of the synagogue at Dura Europos once had.

### Notes

1. See Judah Rosenthal, *Sepher Joseph hamekane* (Jerusalem, 1970), § 29, on Exodus 20:4 (in Hebrew).

2. H. L. Hempel, "Jüdische Traditionen in Frühmittelalterlichen Miniaturen," in *No Graven Images: Studies in Art and the Hebrew Bible*, ed. J. Gutmann (New York, 1971), pp. 347–61; Kurt Schubert, "Die Miniaturen des Ashburnham Pentateuch im Lichte der rabbinischen Tradition," *Kairos* 18 (1976), pp. 191–212.

3. E.g, K. Weitzmann, "The Illustration of the Septuagint," in Gutmann (*n. 2*), pp. 201–31, especially p. 229; see K. Weitzmann and H. L. Kessler, "The Frescoes of the Dura Synagogue and Christian Art," *Dumbarton Oaks Studies* 28 (Washington, D.C., 1990), p. 27 ff. A detailed review of this study by U. Schubert, *Kairos* 32/33 (1990/91), is at print.

4. C. R. Dodwell and P. Clemoes, eds., *The Old English Illustrated Hexateuch* (Copenhagen, 1974).

5. O. Pächt, *The Rise of Pictorial Narrative in Twelfth-Century England* (Oxford, 1962), p. 5; see Ursula Schubert, "Egyptian Bondage and Exodus in the Ashburnham Pentateuch," *Journal of Jewish Art* V (1978), pp. 29–44 passim.

6. K. Weitzmann, "The Question of the Influence of Jewish Pictorial Sources on Old Testament Illustration," in Gutmann (*n. 2*), pp. 309–28, especially p. 326, fig. 68.

7. *Psautier illustré (XIIIe Siècle). Reproduction des 107 miniatures du manuscrit latin 8846 de la Bibliothèque Nationale,* introduced by H. Omont (Paris, 1907).

8. At least one exception exists, namely, the sarcophagus of Aix-en-Provence (J. Wilpert, *I sarcofagi cristiani antichi* [Rome, 1929], vol. 1, pl. 97, figs. 1–3). On the front of this sarcophagus we see the Israelites, followed by the Egyptians, passing through the Red Sea; on the left face we see Moses before Pharaoh, Moses summoned by the Lord, and the Israelites leaving Egypt; and on the right face we see the miracle of the quails and the miracle of the water in the desert. The artist of this sarcophagus obviously had at his disposal a rich picture cycle, possibly of Jewish origin.

9. C. Cecchelli, *I Mosaici della Basilica di S. Maria Maggiore* (Turin, 1956), pl. 31.

10. E. R. Goodenough, *Jewish Symbols in the Greco-Roman Period,* vol. 11, Symbolism in the Dura Synagogue (New York, 1964), pl. 14; Weitzmann and Kessler (*n. 3*), pp. 38–52.

11. See Schubert (*n. 5*), pp. 42–44.

12. *The Sarajevo Haggadah,* text by C. Roth (London, 1963), p. 27 of the Haggadah (facsimile).

13. See B. Narkiss, "Pharaoh Is Dead and Living at the Gates of Hell," *Journal of Jewish Art* 10 (1984), pp. 6–13, especially pp. 8–10.

14. *The Golden Haggadah: A Fourteenth-Century Illuminated Hebrew Manuscript in the British Museum,* introduced by B. Narkiss (London, 1970), p. 53, fig. 27.

15. Ibid., p. 52, fig. 26.

16. Ibid., p. 54, fig. 29.

17. Ibid., p. 55, fig. 31.

18. *The Kaufmann Haggadah (Facsimile Edition of MS. 422 of the Kaufmann Collection),* introduced by G. Sed-Rajna (Budapest, 1990), fols. 57v and 58r.

19. Several of these are collected in Gutmann (*n. 2*); see also C.-O. Nordström, "Rabbinica in frühchristlichen und byzantinischen Illustrationen zum 4. Buch Mose," *Figura* N.S. 1 (Uppsala, 1959), pp. 24–47.

20. *Midrash Tanḥumah ki Tissa* 2, vocalized edition published by Eschkol (Jerusalem, 1972), vol. 1, p. 391. I am most grateful to Kurt Schubert for all the quotations from the midrashic literature.

21. L. Ginzberg, *Die Haggada bei den Kirchenvätern und in der apokryphischen Literatur* (Berlin, 1908).

22. E.g., cod. vat. gr. 747, fol. 58v, and cod. vat. gr. 746, fol. 116v.

23. H. Omont, *Fac-similés des Miniatures des plus anciens Manuscrits Grecs de la Bibliothèque Nationale du VI<sup>e</sup> au XI<sup>e</sup> siècle* (Paris, 1902), pl. 26.

24. In addition to the examples mentioned, see the representation of the High Priest Aaron in the Temple on the west wall of the synagogue of Dura Europos in Goodenough (*n. 10*), pl. 10, and in the Bible in San Isidoro de León (León, Colegiata de San Isidoro, fol. 50r), 960 C.E.; see John Williams, "A Castilian Tradition of Bible Illustration," *Journal of the Warburg and Courtauld Institutes* 28 (1965), pp. 66–85, especially pp. 70–72, and his *Frühe Spanische Buchmalerei* (Munich, 1977), pl. 10; and see Ursula Schubert, "Die Rabbinische Vorstellung vom Schaufrottisch und die Bibel von S. Isidoro de Leon, a.d. 960 (Real Colegiata cod. 2, fol. 50r)," *Artibus et Historiae* no. 17 (1988), pp. 83–88, especially pp, 85–87, figs. 5–7.

25. See Ursula Schubert, "Die Erschaffung Adams in einer spanischen Haggada-Handschrift des 14. Jahrhunderts (Br. Mus. Or. 2884) und ihre spätantike jüdische Vorlage," *Kairos* 18 (1976), pp. 213–17, fig. 14.

26. See Marie Simon, "Entstehung und Inhalt der spätantiken trichotomischen Anthropologie," *Kairos* 23 (1981), pp. 43–50.

27. Marcus Aurelius 12:3; see Simon (*n. 26*), p. 50.

28. In Gutmann (*n. 2*), pp. 201–31, especially pp. 225–27; K. Weitzmann and H. L. Kessler, *The Cotton Genesis, British Library Codex Cotton Otho B. VI* (Princeton, N.J., 1986), p. 52 ff, figs. 22–26.

29. Omont (*n. 7*), pls. 1 and 2.

30. Narkiss (*n. 14*), p. 59.

THÉRÈSE METZGER

# The Iconography of the Hebrew Psalter from the Thirteenth to the Fifteenth Century

Aᴌᴛʜᴏᴜɢʜ ᴛʜᴇ Hᴇʙʀᴇᴡ Psᴀʟᴛᴇʀ, like the Latin and Greek Psalters, has been thoroughly studied textually, it is rich in illustrations whose iconography has never been investigated.[1] It was therefore natural to want to look into this area more closely. The results yielded by our first inquiry into the iconography of the Hebrew Psalter are the subject of this essay.[2]

It is necessary to state at the outset that the scarcity of extant medieval illustrated Hebrew psalters makes it impossible to make separate studies of individual psalters, of psalters within complete Bibles, of psalters attached to Job and Proverbs—the other two poetical books—or of psalters attached to prayer books. However, whereas in Latin manuscripts these different types of psalter gave birth to different programs of illustrations, this was not the case with the Hebrew Psalter, and separate classifications are unnecessary. Nonetheless, the occasional illustration to isolated psalms in the prayer book or the Passover Haggadah will not be considered here because these do not really belong to the program of the illustrated Psalter but should be included in the respective programs of those two liturgical books.[3]

\*     \*     \*

The earliest illustrations to the Book of Psalms that have come down to us are in Ashkenazi manuscripts of German origin. We find them in two of the large Bibles from the second quarter of the thirteenth century, the Milan Bible[4] and the Wrocław (Breslau) Bible.[5] Both were written at about the same time, the Milan Bible in 1236–38 and the Wrocław Bible in 1237–38. In both manuscripts the illustration appears in the painted panel bearing the large gold letters of the initial word of the book, *ashrei*, and shows one figure only, that of the psalmist, King David.

In the Milan Bible the figure, wearing a gold crown and playing a gold harp with red strings, is seated under the letter *resh* of the initial word (*Fig. 3.1*). As with many of the human figures in this manuscript, this one is animal-headed—or, more precisely, lion-headed. The Milan Bible is the earliest known example of a group of manuscripts illuminated in Germany between the second quarter of the thirteenth century

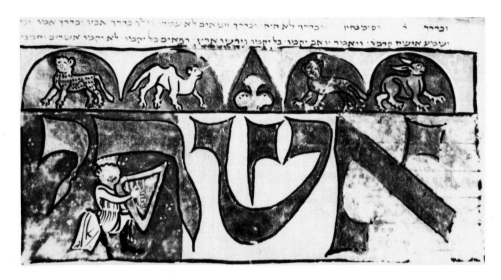

*Fig. 3.1 Milan. Bibl. Ambrosiana, Ms. B. 32. Inf.; Bible copied and decorated 1236–38 in South Germany; fol. 3r: King David, with a lion's head, seated under the letter resh of the initial word to the Book of Psalms (photo after G. Villa, Biblioteca Ambrosiana, Milan).*

*Fig. 3.2 Wrocław [Breslau], Univ. Libr., Ms. M 1106; Bible copied and decorated 1237–38 in South Germany (Franconia?); fol. 305r: King David seated under the letter resh of the initial word to the Book of Psalms (photo M. Metzger, courtesy of University Library, Wrocław).*

*Fig. 3.3 Jerusalem, Schocken Institute for Jewish Research of The Jewish Theological Seminary of America, MS. 14940; Bible copied and decorated first quarter of fourteenth century in South-West Germany; fol. 93r: King David and a second figure, most likely King Solomon, seated within a panel bearing the two initial words to the Book of Psalms (photo M. Metzger, courtesy of Schocken Institute for Jewish Research of The Jewish Theological Seminary of America, Jerusalem).*

and the second quarter of the fourteenth century in which, for reasons not satisfactorily elucidated, various devices were used to conceal all or part of the human face.[6] In the Wrocław Bible the royal psalmist is also seated playing a harp under the *resh* of the initial word, but he has a normal human head (*Fig. 3.2*), as have the other figures in this Bible.[7]

It is not until the beginning of the fourteenth century that we find another illustrated heading to the Book of Psalms, this in an Ashkenazi Bible of German origin, the so-called Schocken Bible,[8] to be dated to the first quarter of the fourteenth century. The panel (*Fig. 3.3*) bearing the two initial words of the text shows two figures: on the right, David, crowned and seated on a golden bench, is playing the harp, and a symmetrical crowned and seated figure on the left holds an upright sword. In contrast to the psalmist, this second figure is fair-haired and beardless.

It is not easy to make out the meaning of the panel. Was it intended to convey the idea of royal power and justice, made insufficiently clear by the figure of the royal musician? But the figure of a youth in royal apparel holding the sword of justice makes one think at once of Solomon, the young king full of wisdom in his judgments. Yet whereas we would have expected to find the figure of Solomon at the beginning of such books as Proverbs and Ecclesiastes—of which Solomon is considered the author—his traditional authorship of Psalms 72 and 127 does not seem enough to justify his presence at the beginning of the Psalter. Indeed, it is likely that the illuminator has yielded to the satisfaction of building a symmetrical and antithetical picture: David the king-musician and Solomon the king-judge, thus anticipating his program, which only later required the representation of Solomon.

Disappointing as it may be, a survey of German psalters of every period has not enabled us to bring to light more than three other illustrations to the Psalter text. The first illustration (*Fig. 3.4*) appears in a small volume, undated but probably written around 1300.[9] The illustration must, however, have been created somewhat later than that because it was drawn with the same ink as the initial word, which was written in the blank space left by the original hand at the beginning of the first psalm of Book II,

*Fig. 3.4 Hamburg, Staats- u. Univ.-Bibl., Cod. Hebr. 202; psalter copied in Germany ca. 1300; fol. 35v: illustration to Psalm 42, verse 2, "As the hart panteth after the water brooks . . ." (photo M. Metzger, courtesy of Staats- und Universitätsbibliothek, Hamburg).*

*Fig. 3.5 Parma, Bibl. Palat., Ms. Parm. 3095—De Rossi 732; psalter, probably copied and decorated in Germany second half of thirteenth or beginning of fourteenth century; fol. 22r: illustration to Psalm 75, verse 9, "For in the hand of the Lord there is a cup, and the wine foameth." (photo M. Metzger, courtesy of Biblioteca Palatina, Parma).*

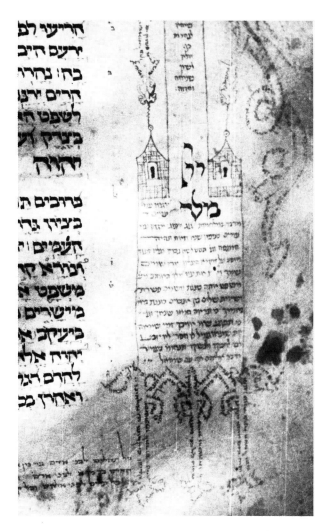

*Fig. 3.6* Parma, Bibl. Palat., Ms. Parm. 3095—De Rossi 732; psalter, probably copied and decorated in Germany second half of thirteenth or beginning of fourteenth century; fol. 34v: micrographic drawing of a triple towered building extending the length of the margin, with Rashi's commentary written within the outline. This illustrates Psalm 97, verse 8, "Zion heard and was glad, . . ." (photo M. Metzger, courtesy of Biblioteca Palatina, Parma).

Psalm 42. It shows a deer lying on the ground and bears a direct relation to the text, illustrating as it does the second verse of the psalm (RV, v. 1), "As the hart panteth after the water brooks . . ."[10]

The other two illustrations are even more limited in scope, for they illustrate not a verse but a word within a verse. The first (*Fig. 3.5*) illustrates the word *kos* (cup) in Psalm 75:9 (RV, v. 8): "For in the hand of the Lord there is a cup, and the wine foameth." It shows a cup (2.3 centimeters in height) and next to it a bird, which is irrelevant in this context. The relation of the cup to the text is confirmed by the inclusion of the drawing in Rashi's commentary to the verse next to the words *Ki kos be-yad ha-shem* (For there is a cup in the hand of the Lord). The second illustration (*Fig. 3.6*), set beside the text of Psalm 97 (Psalm 98 in the manuscript), relates to the mention of Zion in v. 8; the city is evoked by a micrographic drawing of a triple-towered building supported on pointed arches that stretches the full length of the outer margin and includes Rashi's commentary in its outline.

These two are the only illustrations in a rather large psalter of German origin prob-

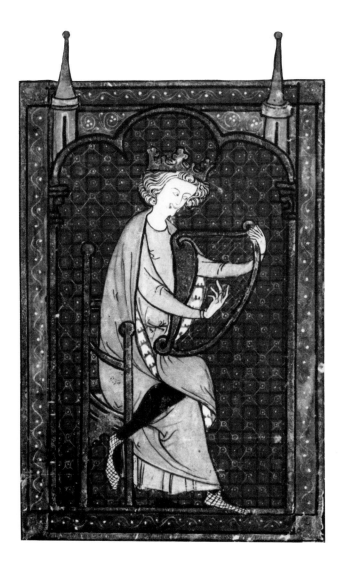

ably dating from the second half of the thirteenth or the beginning of the fourteenth century,[11] each page of which bears, framing the text, the targum, Rashi's commentary, and the *Masorah Magna.* Occasional pen-drawn motifs appear in the outer margin, and the *Masorah* is sometimes written in the form of a decorative pattern.

\*     \*     \*

No illustrated Hebrew psalter of French origin has come down to us, but we do know of a small English one.[12] It offers red and blue initial words and a tiny illustration at the beginning of Psalm 1, a pen drawing of the bust of a king playing a harp.[13] Yet it is doubtful whether we may regard this psalter as a testimony of Jewish illumination, for even if it was copied by a Jew it most probably received its original initial words and accompanying ornament—one ornament being the figure of David—from a non-Jewish hand.[14]

\*     \*     \*

Before we leave our examination of Ashkenazi manuscripts it must be pointed out that the figure of David crowned and playing a harp was not confined to illustrations of the Psalter. Indeed, the best-known representations—and, moreover, the most beautiful ones—appear in quite different contexts: in a full-page miniature that is part of a painted cycle in a French miscellany (*Fig. 3.7*), which was copied around 1280 (London, British Library, MS. Add. 11639, fol. 117v [15]); on the opening page of Book VIII of the *Mishneh Torah* in the Kaufmann collection (Budapest, Hungarian Academy of Sciences, Ms. A 77, vol. III, fol. 1r) dating from 1295–96; [16] at the beginning of the Book of Kings in a German Bible (New York Public Library, Spencer collection, formerly Frankfurt o.M., Mayer B. Goldschmidt Library, Bible, vol. II, fol. 64r) written in 1294; [17] and at the beginning of Ecclesiastes (*Fig. 3.8*) in the so-called Duke of Sussex Pentateuch (London, British Library, MS. Add. 15282, fol. 302r) dating from the first quarter of the fourteenth century.[18] It also appears in the second volume of the Ambrosian Bible (Ms. B. 31. Inf., fol. 67r [19]) at the beginning of the Book of Kings, but this representation is much less important than the figure of David on the opening page of the Psalter in that it appears only as a motif in the border of the initial-word panel. Last, a beautiful picture (*Fig. 3.9*) of David, crowned, seated on a throne, and playing the harp, was drawn before the middle of the fifteenth century in the margin of one of the last *hoshanot* (special hymns for the Feast of Tabernacles) in a German *maḥzor* (Budapest, Hungarian Academy of Sciences, Ms. A 383, fol. 189v).

<p style="text-align:center">✳     ✳     ✳</p>

Iconographic material related to the Psalter is even scantier in Sephardi than in Ashkenazi manuscripts. We find examples in only four Bibles, the Haverford College Bible written in 1266,[20] the Lisbon Bible[21] written in Cervera (Catalonia) in 1299–1300, the Dublin incomplete Bible,[22] closely related to the latter and very likely to be dated from the same year, and a much more modest volume from the Sassoon collection[23] dating probably from the last 30 years of the fifteenth century.

The Haverford Bible contains only one illustration, fol. 336r (*Fig. 3.10*), and it is in the Psalter: a golden harp, illustrating v. 3 in Psalm 150 (numbered CXLIX in this Bible), " . . . praise him with the psaltery and harp." But the prominence given to the image, coming as it does at the very end of the book and jutting out of the text in the lower margin, was certainly intended to convey the more general meaning of the musical character of the whole book and to recall also the musical instrument of its author, David the harpist.

The Lisbon Bible is one of the few decorated Spanish Bibles to contain a number of illustrations to the text, and it has no less than 23 of them. However, only one of these (in Jonah) consists of a group of active figures. Otherwise each illustration shows no more than a single, isolated figure or object. Only two illustrations are of any size—one at the end of Exodus showing the seven-branched candelabrum and another at the end of the Minor Prophets showing the candelabrum between the two olive trees in Zechariah's vision (Zechariah 4). Most of the others are tiny, marginal pictures placed beside the verse or word that they illustrate, as in the Parma psalter to which I

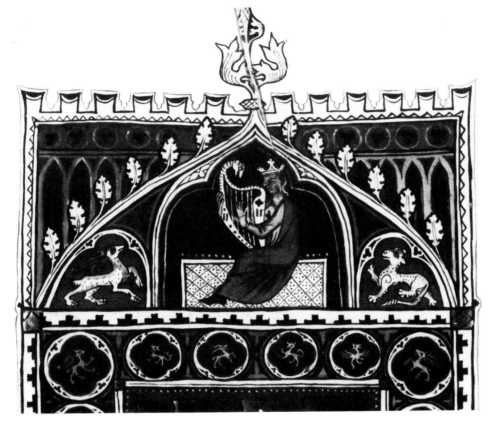

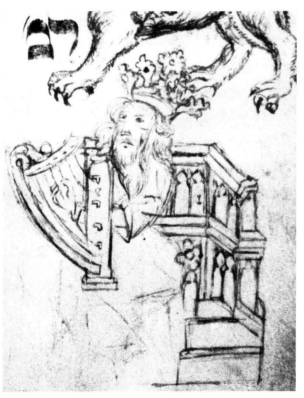

**Fig. 3.8** *London, Brit. Libr., MS. Add. 15282; the so-called Duke of Sussex Pentateuch, copied and decorated in Germany first quarter of fourteenth century; fol. 302r: King David playing the harp, at the beginning of Ecclesiastes (photo by permission of the British Library, London).*

**Fig. 3.9** *Budapest, Hung. Acad. Sc., Ms. A 383; maḥzor copied and decorated in Germany first half of fifteenth century; fol. 189v: marginal drawing of King David for one of the special hymns for the Feast of Tabernacles (photo M. Metzger, courtesy of Hungarian Academy of Sciences, Budapest).*

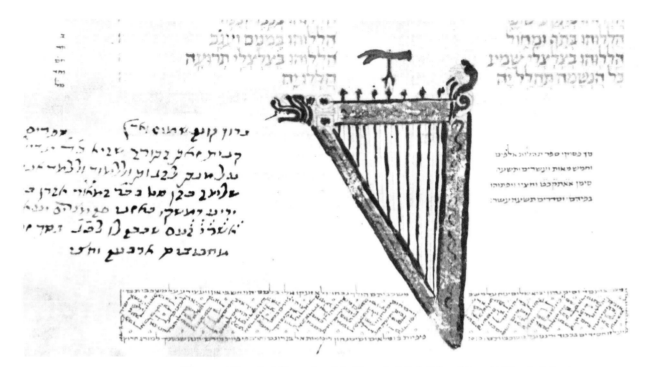

*Fig. 3.10* *Haverford [Pennsylvania], Haverford Coll. Libr., J. Rendel Harris Collection, MS. Harris 1; Bible copied and decorated in Spain in 1266; fol. 336r: illustration to Psalm 150, verse 3, "praise him with the psaltery and harp." (photo Haverford College, Haverford, Pennsylvania).*

have drawn attention (see n. 1). The six illustrations to Psalms in the Lisbon Bible belong to this category.

The first (*Fig. 3.11*) is placed beside Psalm 23 (fol. 322v) and shows a table spread with a roast chicken, two round loaves, a knife, and a gold cup. It illustrates literally v. 5 (RV, v. 5), "Thou preparest a table before me . . . my cup runneth over."

The second one (*Fig. 3.12*) (fol. 326r) illustrates the beginning of Psalm 42, v. 2 (RV, v. 1), "As the hart panteth after the water brooks, so panteth my soul after thee, O God," for we see in the margin a deer with its head raised and its mouth open.

The third one (*Fig. 3.13*) appears at the end of the Psalter (fol. 347r), where the last psalm invites us to praise God with the sound of every musical instrument, the trumpet, psaltery, harp, timbrel, stringed instrument, pipe, and cymbals. The illuminator drew two drolleries: on the right a rabbit holding a bagpipe and on the left a hybrid blowing a trumpet.

The other three illustrations are of the same kind: each illustrates one word only from the first verse of the psalm, which in all three cases gives instructions as to the appropriate tune or musical instrument:

**Psalm 56** v. 1 fol. 328v: "on the speechless dove far off" has suggested the image of a well-characterized pigeon of pink, green, and gold.

**Psalm 60** v. 1 fol. 329v: two flowers illustrate the phrase, "On the lily of testimony."

**Psalm 69** v. 1 fol. 331r: flowers and flower buds translate literally "on the lilies."[24]

*Fig. 3.11* Lisbon, Bibl. Nacional, Ms. Il. 72; Bible copied and decorated 1299–1300 in Cervera, Tudela, and Soria(?); fol. 322v: illustration to Psalm 23, verse 5, "Thou preparest a table before me . . . my cup runneth over." (photo M. Metzger, courtesy of Biblioteca Nacional, Lisbon).

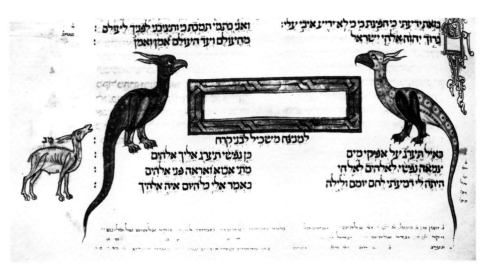

*Fig. 3.12* Lisbon, Bibl. Nacional, Ms. Il. 72; Bible copied and decorated 1299–1300 in Cervera, Tudela, and Soria(?); fol. 326r: illustration to Psalm 42, verse 2, "As the hart panteth after the water brooks, so panteth my soul after thee." (photo M. Metzger, courtesy of Biblioteca Nacional, Lisbon).

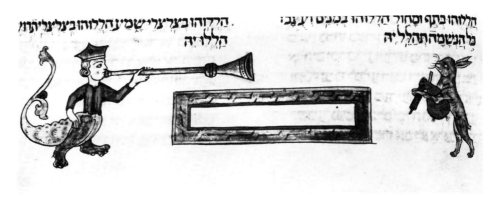

*Fig. 3.13* Lisbon, Bibl. Nacional, Ms. Il. 72; Bible copied and decorated 1299–1300 in Cervera, Tudela, and Soria(?); fol. 347r: two drolleries illustrating the injunction of Psalm 150 to praise God with the sound of every musical instrument (photo M. Metzger, courtesy of Biblioteca Nacional, Lisbon).

*Fig. 3.14 Dublin, Trinity Coll. Libr., MS. 16; incomplete Bible, copied and decorated probably 1299–1300; fol. 91r: illustration to Psalm 42, verse 2, "As the hart panteth after the water brooks . . ." (the number of the Psalm is given in the two Hebrew letters below the antlers) (photo by permission of The Board of Trinity College Dublin).*

But the unsystematic character of these illustrations must be pointed out. For even though each of the 148 numbered psalms in this manuscript has been given a painted ornament to accompany its marginal number, only six of them illustrate the text. Moreover, the relationship between text and image lacks consistency: for instance, of the three pictures of a deer (Psalms 22, 42, and 104), only that for Psalm 42 bears any relation to the text.[25] Similarly, although Psalm 45 begins with the same directions for its performance as Psalm 69, unlike Psalm 69 its ornament does not include a flower.

In the Dublin manuscript, too, a rich ornamentation winds around the number of each psalm, very often filling the whole outer margin, but in only one case is there a textual illustration. That is in Psalm 42:2 (fol. 91r), where we see a grayish-blue stag no more than 3 centimeters high (*Fig. 3.14*).[26]

The single illustration offered by the Sassoon Bible is of exactly the same kind but is less charming, for it is only a pen drawing in sepia ink and is not very elaborate. It shows (fol. 461r) streams of water and some bushes on which stringed instruments are hung and accompanies the text of Psalm 137:1–2 (RV, vv. 1–2): "By the rivers of Babylon, there we sat down, yea, we wept, when we remembered Zion. Upon the willows in the midst thereof we hanged up our harps."[27]

\*    \*    \*

The third and last group of manuscripts for us to consider is the Italian psalters, and this survey is undoubtedly more rewarding. It invites us to go back to the thirteenth century, when the most precious psalter of the De Rossi collection[28] was written and illuminated. This small volume (13 × 10 centimeters) can be dated with certainty to the last quarter of the thirteenth century and was most probably executed in Emilia.[29] It would take too long to describe this profusely illuminated psalter, where each of the 151 numbered psalms has a decorated initial word and where 75 illustrations to the text have been included in the initial-word ornament.[30] Some examples will suffice to make clear the particular type of these illustrations.

**Psalm 6**   fol. 6v (*Fig. 3.15*): above the initial word a lute illustrates v. 1 (RV, v. 1), " . . . on stringed instruments, set to the Sheminith."

**Psalm 30**   fol. 37r (*color plate 3*): on the right of the initial word is a building of several stories with a closed door, a geminate window above, an arched gallery on four slender columns, and battlements at the top; under the gallery arch is a figure with upraised hands. It is the illustration to v. 1 (RV, v. 1), " . . . a song at the Dedication of the House; a psalm of David." Only the figure at prayer indicates that the building, a typical, secular Italian one, is intended to represent the Temple.

**Psalm 34**   fol. 43r (*Fig. 3.16*): on the right a human figure dances barefoot, with disheveled hair and garment gathered up; on the left another figure, dressed in an orderly manner, is praying with eyes and hands upraised. The first illustrates v. 1 (RV, v. 1), "A psalm of David; when he changed his behavior before Abimelech, who drove him away, and he departed," and the second illustrates v. 2 (RV, v. 2), "I will bless the Lord at all times."

**Psalm 35**   fol. 45r (*Fig. 3.17*): on the right a crowned figure raises his right hand and points with the other to a shield and rondache, thus illustrating vv. 1 and 2 (RV, vv. 1 and 2), where David implores God's protection: "A psalm of David. Strive thou, O Lord, with them that strive with me: fight thou against them that fight against me," and "Take hold of shield and buckler, and stand up for mine help."

*Fig. 3.15* *Parma, Bibl. Palat., Ms. Parm. 1870—De Rossi 510; psalter copied and decorated in Italy last quarter of thirteenth century; fol. 6v: illustration to Psalm 6, verse 1, "on stringed instruments, set to the Sheminith." (photo M. Metzger, courtesy of Biblioteca Palatina, Parma).*

*Fig. 3.16* *Parma, Bibl. Palat., Ms. Parm. 1870—De Rossi 510; psalter copied and decorated in Italy last quarter of thirteenth century; fol. 43r: two illustrations to Psalm 34, verse 1, "A psalm of David; when he changed his behaviour before Abimelech, . . ." and verse 2, "I will bless the Lord at all times." (photo M. Metzger, courtesy of Biblioteca Palatina, Parma).*

*Fig. 3.17* *Parma, Bibl. Palat., Ms. Parm. 1870—De Rossi 510; psalter copied and decorated in Italy last quarter of thirteenth century; fol. 45r: illustration to Psalm 35, verses 1 and 2, "Strive thou, O Lord, with them that strive with me, . . ." and "Take hold of shield and buckler, and stand up for mine help." (photo M. Metzger, courtesy of Biblioteca Palatina, Parma).*

*Fig. 3.18* *Parma, Bibl. Palat., Ms. Parm. 1870—De Rossi 510; psalter copied and decorated in Italy last quarter of thirteenth century; fol. 65v: illustration to Psalm 48, verse 2, "Great is the Lord, and highly to be praised, in the city of our God, in his holy mountain." (photo M. Metzger, courtesy of Biblioteca Palatina, Parma).*

*Fig. 3.19* Parma, Bibl. Palat., Ms. Parm. 1870—De Rossi 510; psalter copied and decorated in Italy last quarter of thirteenth century; fol. 79v: illustration to Psalm 59, verses 1 and 2, "A Psalm of David: Michtam: when Saul sent, and they watched the house to kill him." and "Deliver me from mine enemies, O my God: . . . " (photo M. Metzger, courtesy of Biblioteca Palatina, Parma).

*Fig. 3.20* Parma, Bibl. Palat., Ms. Parm. 1870—De Rossi 510; psalter copied and decorated in Italy last quarter of thirteenth century; fol. 188v: two illustrations to Psalm 127, verse 1, showing Solomon, who is given authorship of the psalm, and a bricklayer to explain the theme "Except the Lord build the house, they labour in vain that build it." (photo M. Metzger, courtesy of Biblioteca Palatina, Parma).

**Psalm 48**  fol. 65v (*Fig. 3.18*): on the left a medieval city with its slender towers, so typically Italian, rises high above the battlemented walls. On the right is a small mound, and between the two, a human figure with griffin's head holds a phylactery on which are written the first words of v. 2 (RV, v. 1), "Great is the Lord, and highly to be praised, in the city of our God, in his holy mountain."

**Psalm 59**  fol. 79v (*Fig. 3.19*): on the right is a human figure, hand upraised, seen through the window of a small house with a closed door; in front of the house a soldier stands, shield and spear in hand; on the left another figure with lance couched is rushing at the figure in the window. The figures illustrate vv. 1 and 2 (RV, v. 1), "A psalm of David: Michtam: when Saul sent, and they watched the house to kill him," and "Deliver me . . . "

**Psalm 127** ( = 128 in the manuscript)  fol. 188v (*Fig. 3.20*): on the right is a king with upturned face and raised hands; on the left a human figure, trowel in hand, is laying the bricks or stones of a wall. The king is Solomon, to whom is given in v. 1 (RV, v. 1) the authorship of this psalm, and the picture illustrates the next sentence in the same verse, "Except the Lord build the house, They labour in vain that build it."

As in some of the first manuscripts analyzed in this essay the illustrations in this psalter are all of a very definite type: they translate in an image a single word or sentence from the text. Their structure is very simple. They do not show realistic dramas or landscapes but are, rather, a collection of signs placed together along a decorative pattern in the blank spaces around the initial words. This is a very well-known "procédé" used in Greek psalters, where the marginal pictures are, as in the psalter from the De Rossi collection, equivalent of textual glosses.

Several other psalters were decorated in a similar style during this period or a little later, at the beginning of the fourteenth century, but none of them contain even one illustration of the text.[31] We have to go to the end of the fourteenth century to dis-

cover another illustrated psalter, this one written in Perugia in 1391.[32] But its decoration develops along quite different lines. Only the initial psalm of each of the five parts of the Psalter has been illustrated.[33] Thus we have:

**Psalm 1**   fol. 10r (*Fig. 3.21*): David, the author of the book, at the bottom of the page in a quatrefoil medallion, playing the psaltery.

**Psalm 42** (= 41 in the manuscript)   fol. 54r (*Fig. 3.22*): a deer drinking at a fountain, a direct illustration of the text, as already seen.

**Psalm 73** (= 72 in the manuscript)   fol. 90r (*Fig. 3.23*): A Jew wrapped in a white *ṭallit* standing in front of a Gothic ark.

**Psalm 90** (= 89 in the manuscript)   fol. 115v (*color plate 4*): once again a Jew wrapped in a *ṭallit*.

**Psalm 107** (= 106 in the manuscript)   fol. 137v (*Fig. 3.24*): once again a Jew wrapped in a *ṭallit* but here leaning forward slightly, his arms crossed.

*Fig. 3.21  Parma, Bibl. Palat., Ms. Parm. 1711—De Rossi 234; psalter copied and decorated in Perugia in 1391; fol. 10r: King David, as the author of the book, accompanying Psalm 1, at the beginning of the first of the five parts of the psalter (photo M. Metzger, courtesy of Biblioteca Palatina, Parma).*

*Fig. 3.22  Parma, Bibl. Palat., Ms. Parm. 1711—De Rossi 234; psalter copied and decorated in Perugia in 1391; fol. 54r: illustration to Psalm 42, which begins the second of the five parts of the psalter (photo M. Metzger, courtesy of Biblioteca Palatina, Parma).*

*Fig. 3.23  Parma, Bibl. Palat., Ms. Parm. 1711—De Rossi 234; psalter copied and decorated in Perugia in 1391; fol. 90r: illustration to Psalm 73, "A Psalm of Asaph," which begins the third of the five parts of the psalter (photo M. Metzger, courtesy of Biblioteca Palatina, Parma).*

*Fig. 3.24  Parma, Bibl. Palat., Ms. Parm. 1711—De Rossi 234; psalter copied and decorated in Perugia in 1391; fol. 137v: illustration to Psalm 107, "O give thanks unto the Lord," which begins the last of the five parts of the psalter (photo M. Metzger, courtesy of Biblioteca Palatina, Parma).*

*The Iconography of the Hebrew Psalter* • **59**

What is remarkable in this series of pictures is the discrepancy between the first two and the other three. The first two, the illustrations of David and the thirsty deer, even if of widely differing emphasis (the first being a portrait of the author of the whole book and not illustrating any precise verse and the second being the illustration to just one verse), are already well-known subjects in the Psalter. But the three representations of Jews at prayer are of quite a different kind. They are reminiscent of the illustration to Psalm 112 in Ms. Parm. 1870, but in fact the analogy is only superficial. Psalm 73 is "a psalm of Asaph," and thus we would expect to see a picture of Asaph, one of the leaders of the singers appointed by David to the service of praise in the Temple (I Chron. 6:24). We would have expected the illustration for Psalm 90, which is called "A prayer for Moses, the man of God," to have represented Moses. Only the beginning of Psalm 107 allows a less precise subject because it expresses the general idea of praising and singing to the Lord. But instead of trying to show the historical figures of Asaph and Moses, the illuminator has deliberately transposed his subject matter and dealt with it in terms of images of contemporary Jewish life. The Jews with the prayer shawls that he has painted are neither Asaph in the Temple nor Moses, nor any Jew of the past praising God, but, rather, they are contemporary Jews, and one of them even prays in a medieval synagogue.

A modest, figureless, pen-drawn illustration in another psalter,[34] also copied in Perugia but at the beginning of the fifteenth century, belongs to the same iconographic trend. Psalm 30 in that psalter is not illustrated, as in Ms. Parm 1870—De Rossi 510,[35] by an evocation of the dedication of Solomon's Temple but rather by a *ḥanukkiyyah,* in this case an eight-wick oil lamp on three short legs, the very lamp that Jews of that time and place used during the eight-day festival commemorating the dedication of the Hasmonean Temple.

<p style="text-align:center">*    *    *</p>

Continuing, we find that the practice of limiting the scope of the illustration to the beginning of the five books of the Psalter was still favored during the course of the fifteenth century. We find the practice in two manuscripts that are slightly inferior in quality to the Perugia psalter and are undated but were probably written and decorated during the second half of the fifteenth century and most probably in Florence: Ms. Parm. 1714—De Rossi 385,[36] and Ms. Parm. 1718—De Rossi 672.[37]

Accompanying Psalm 1 in Ms. Parm 1714—De Rossi 385 is a small picture (fol. 1r) of a figure wearing a crown set on a hat (*Fig. 3.25*). Even though the object he holds to his breast is too indistinct to be identified as a musical instrument—harp or psaltery—the figure must be of David. In the other four books of the psalter, however, the figures enclosed in small cartouches at the bottom of the ornamental frames (Psalm 42, fol. 27v; Psalm 73, fol. 48v; Psalm 90, fol. 62v; and Psalm 107, fol 74v) are all, with the exception of a winged putto accompanying Psalm 73, completely devoid of definite attributes and thus very difficult to identify. The gesture of the figure with outstretched hands on fol. 27v (*Fig. 3.26*) is perhaps intended to depict the affliction and supplication expressed in Psalm 42. And the bearded man on fol. 62v (*Fig. 3.27*) could be Moses, to whom Psalm 90 is ascribed.

In psalter Ms. Parm 1718—De Rossi 672 the layout of the intended decoration is quite similar to that in Ms. Parm. 1714, but only the first page was executed in the

*Fig. 3.25* Parma, Bibl. Palat., Ms. Parm. 1714—De Rossi 385; psalter copied and decorated in [Florence] second half of fifteenth century; fol. 1r: illustration to Psalm 1; although the musical instrument is not clear, the figure must be King David, the author of the Psalms (photo M. Metzger, courtesy of Biblioteca Palatina, Parma).

*Fig. 3.26* Parma, Bibl. Palat., Ms. Parm. 1714—De Rossi 385; psalter copied and decorated in [Florence] second half of fifteenth century; fol. 27v: illustration to Psalm 42, to signify perhaps the affliction and supplication expressed in the psalm (photo M. Metzger, courtesy of Biblioteca Palatina, Parma).

*Fig. 3.27* Parma, Bibl. Palat., Ms. Parm. 1714—De Rossi 385; psalter copied and decorated in [Florence] second half of fifteenth century; fol. 62v: illustration to Psalm 90, perhaps portraying Moses, to whom the psalm is ascribed (photo M. Metzger, courtesy of Biblioteca Palatina, Parma).

*Fig. 3.28  Parma, Bibl. Palat., Ms. Parm. 1718—De Rossi 672; psalter copied and decorated in [Florence] second half of fifteenth century; fol. 1r: illustration to Psalm 1, showing a Jew of the period at prayer (photo M. Metzger, courtesy of Biblioteca Palatina, Parma).*

*Fig. 3.29  Parma, Bibl. Palat., Ms. Parm. 1718—De Rossi 672; psalter copied and decorated in [Florence] second half of fifteenth century; fol. 34r: illustration to Psalm 42, "As the hart panteth after the water brooks . . . " (photo M. Metzger, courtesy of Biblioteca Palatina, Parma).*

*Fig. 3.30  Parma, Bibl. Palat., Ms. Parm. 1718—De Rossi 672; psalter copied and decorated in [Florence] second half of fifteenth century; fol. 59v: illustration to Psalm 73, "A Psalm of Asaph." (photo M. Metzger, courtesy of Biblioteca Palatina, Parma).*

**Fig. 3.31** *Parma, Bibl. Palat., Ms. Parm. 1718—De Rossi 672; psalter copied and decorated in [Florence] second half of fifteenth century; fol. 76v: illustration to Psalm 90, "A Prayer of Moses." (photo M. Metzger, courtesy of Biblioteca Palatina, Parma).*

same style. The style and coloring of the following pages are much cruder and certainly of a later date. Here we have:

**Psalm 1**   fol. 1r (*Fig. 3.28*): the figure of a Jew within a medallion. The Jew is wearing a *tallit* and is standing in front of an open book placed on a lectern against a Gothic ark.

**Psalm 42**   fol. 34r (*Fig. 3.29*): the illustration is of two deer drinking at a well.

**Psalm 73**   fol. 59v (*Fig. 3.30*): it is of a man singing and playing the lute.

**Psalm 90**   fol. 76v (*Fig. 3.31*): the illustration is a kneeling figure with hands joined in prayer.

**Psalm 107**   fol. 91v: the figure is another lute player.

Thus the subjects illustrating all of the books but the first fit the text exactly: the drinking deer once again obviously illustrate v. 2 of Psalm 42; the first lute player must be Asaph; the figure at prayer, Moses; and the last lute player would convey the theme of praise of Psalm 107. The costumes and settings, deprived of any contemporary or realistic allusions, are no obstacle to these interpretations.

But as we have noted, these pictures are by a more recent hand. The program intended by the first illuminator would certainly have been quite different because he went so far as to exclude even the figure of David from the opening illustrations of the Psalter and began immediately with a representation of a contemporary Jew at prayer. That program was likely to have been very close to the one displayed three quarters of a century earlier in the Perugia psalter.

<p style="text-align:center">*    *    *</p>

In a last group of Italian Hebrew psalters, most of which were decorated during the same period as those we have just examined, the iconography undergoes yet another change. It has only one subject, David: David as the author of the Psalter; David playing the harp; David praying; David triumphant, trampling on the corpse of Goliath.[38]

The most interesting representation of David as the author of the Psalter is certainly the one in Ms. Parm. 3596, undated but probably written and illuminated between 1455 and 1465.[39] Painted at the beginning of the book (fol. 3v),[40] the figure of David is deprived of any royal insignia. We see him (*Fig. 3.32*) as a typical humanist

*Fig. 3.32  Parma, Bibl. Palat., Ms. Parm. 3596; psalter, probably written and illuminated 1455–65; fol. 3v: King David portrayed as a humanist scholar (photo M. Metzger, courtesy of Biblioteca Palatina, Parma).*

*Fig. 3.33  Jerusalem, The Israel Museum, MS. 180/51; the so-called Rothschild Miscellany, copied after 1453 most probably in North-East Italy and illuminated before 1470 in Ferrara-Padua; fol. 1v: King David portrayed as Orpheus (photo M. Metzger, courtesy of The Israel Museum, Jerusalem).*

scholar of the period sitting in an enclosed chair with a *scriptionale* affixed to it. Well provided with books and all the necessary writing equipment displayed on shelves on both sides of the chair, our scholar, knife in hand, reads a codex as if ready to correct its text. This picture offers the most complete transposition from a historical viewpoint to the representation of contemporary life that we have found in the interpretation of this subject.

Although by virtue of its subject of David playing the harp it belongs to this last iconographic series, the illustration in MS. Rothschild 24[41] (fol. 1v), to be dated between 1460 and 1470 and illuminated in Ferrara or its neighborhood, can be set apart on account of its richer and much deeper content. In this miniature (*Fig. 3.33*), David, wearing a gold crown and playing the harp, is seated on a flowered ground, not in any ordinary landscape with hilly background but in a garden planted with fruit trees, refreshed by brooks, and inhabited by hares and deer. Such a garden cannot be other than Paradise, where, from Jewish legend,[42] we know how eminent is the position ascribed to David as king and singer. Yet despite the figure's white beard and hair and his crown, the image of a harpist surrounded by animals held spellbound by his song cannot but conjure up the figure of Orpheus charming the animals with his music.

*Fig. 3.34 Parma, Bibl. Palat., Ms. Parm. 3236—De Rossi 490; psalter [Florence], second half of fifteenth century; fol. 2r: King David playing the psaltery (photo M. Metzger, courtesy of Biblioteca Palatina, Parma).*

And in an age when the spirit of the Renaissance was making its way into Jewish cultural life, there is no doubt that this humanistic treatment of the subject was intentionally contrived by the illuminator and enjoyed by the enlightened Jew who commissioned the manuscript.[43]

A second representation of David can also be set apart as different from the others in this last group. It appears in ms. hébr. 102 (fol. 41v) in the Bibliothèque nationale in Paris.[44] Placed at the beginning of the Book of Psalms, under the golden arch of the border and against a decorative black and silver background, the miniature shows David seated with the psaltery laid beside him on the green-painted ground. He reads by candlelight from a book, which he holds with both hands. Because his head has been erased we can see just the outline of his face, and it is no longer possible to know how his head was covered and whether he was wearing a crown.

<p style="text-align:center">∗　　∗　　∗</p>

However beautiful they may be, some other Italian psalters offer only a very stereotyped iconography. This fact can easily be explained by the common origin of the manuscripts, as the style of decoration in all of them points to Florence itself and for some of them to very close datings in the second half of the fifteenth century.

The superb Parma psalter, Ms. Parm. 3236—De Rossi 490, has only one illustration. This is on fol. 2r (*Fig. 3.34*) and shows the bust of David in royal apparel playing the psaltery.[45]

In the Hamburg psalter[46] there is a twofold illustration (fol. 3r). Against the background of a single landscape divided by a tree, the figure of David appears twice—on

*Fig. 3.35* Hamburg, Staats- u. Univ.-Bibl., cod. scrin. 154; psalter [Florence], second half of fifteenth century; fol. 3r: within a single landscape, the figure of David at prayer and of King David playing the psaltery (photo M. Metzger, courtesy of Staats- und Universitätsbibliothek, Hamburg).

*Fig. 3.36* Berlin, Staatsbibl., Preussischer Kulturbesitz, Orientabteilung, Ms. Hamilton 547; psalter [Florence], second half of fifteenth century; fol. 1r: four vignettes from the life of David (photo Staatsbibliothek zu Berlin, Preussischer Kulturbesitz, Orientabteilung, Berlin).

the right, with crown laid by, kneeling in prayer, and on the left, wearing the crown and playing the psaltery (*Fig. 3.35*).

The initial-word panel in Ms. Hamilton 547[47] displays (fol. 1r) four small vignettes (*Fig. 3.36*)—at the upper left, David in regal apparel and with a halo, praying to God, crown and psaltery laid on the ground; at the upper right, David in the same garments and with a halo, crown laid on the ground, sitting and playing the harp in the presence of God; at the lower left, David as a youth raising his sword in his right hand and holding Goliath's head by the hair with his left hand, trampling on the giant corpse; at the lower right, David with a halo, bearded, and with gray hair, as in the first two pictures, but now kneeling, the crown laid by, half naked and despoiled of his regal apparel as a token of humility, in the presence of God. It is an illustration of David making atonement. The four scenes take place in small, hilly landscapes.

David's victory over Goliath is the only subject to illustrate the Psalter in the Rheims manuscript[48] (fol. 4v). In a landscape with slender trees and a brook and with hills and walled cities in the distance, the young David, scrip slung over his shoulder and standing on the prone giant, swings his sword to sever Goliath's head (*Fig. 3.37*).

*Fig. 3.37 Jerusalem, The Israel Museum, MS. 180/55; Sefer "Emet" (Psalms, Job, and Proverbs) [Florence], second half of fifteenth century; fol. 4v: David's triumph over Goliath (photo M. Metzger, courtesy of The Israel Museum, Jerusalem).*

The same subject is found in the full-page miniature at the beginning of the Sotheby psalter (fol. 2v).[49] But here the young David has already severed the giant's head and, holding it by the hair, is just drawing himself upright. In the decorative border are two small painted medallions containing the figure of David at prayer.

A noticeable particularity of the manuscripts in this last group is that most of them, perhaps even all, have been illuminated by non-Jewish artists. M. Levi d'Ancona has recognized the hand of Zanobi Strozzi in the Parma psalter, an attribution confirmed by A. Garzelli.[50] Unlike M. d'Ancona, Garzelli does not recognize the hand of Antonio di Niccolo di Lorenzo in the Sotheby psalter but ascribes it instead to Mariano del Buono. A. de la Mare concurs but considers it to be an early work.[51] She also connects the Hamburg and Rheims manuscripts with Zanobi Strozzi,[52] while she sees in the Hamilton psalter a Florentine work of around 1460.[53] The Christian origin of the illustrations is betrayed, at least in the Berlin manuscript, by David's halo and the representation of God in the sky in three of the vignettes.[54]

It had generally been considered that these Florentine manuscripts were copied and decorated for Jews, but recently it has been proposed that some of them at least were commissioned by Christian humanists, mainly on the basis that the coats of arms of members of the Florentine humanist circle are included in their decoration. This remains a debatable point.[55]

Finally, we must mention a pen-drawn bust of David included in an Italian-rite prayer book that was copied and decorated at the very beginning of the sixteenth century (in 1504). This illustration of David holding a psaltery appears in the margin at the head of the Psalter.[56]

\*     \*     \*

It is obvious from this investigation that the iconography of the Hebrew Psalter cannot in any way compare in frequency or variety with the iconography of the Christian Psalter. Moreover, it is mainly characterized by the obvious absence of any tradition going back further than the Middle Ages, as is shown by the appearance of quite unconnected programs in the various areas of Jewish establishment. Thus the figure of David playing the harp is the common motif in Ashkenazi manuscripts and is of a type in use in contemporary Latin manuscripts. The scanty illustration in Spanish Bibles, although obeying tendencies similar to those manifested by the much richer series in the oldest extant Italian psalter, offers a quite different choice of subject. The Italian manuscripts are the only ones in which scenes of contemporary Jewish life are substituted for biblical subjects. Some of them also offer a consistent Davidian iconography. However, these last subjects not only are of the more common type to be found in Italian psalters, breviaries, graduals, and choir books, but they have, as we have seen, the same Christian origin. It is only in the literal illustration of the gloss type, even though it was not invented for Hebrew manuscripts,[57] and in the transposition of biblical subjects to contemporary life that an ability to find new images, some of them specifically Jewish in their content, is revealed.

\*     \*     \*

While in Princeton as a member of the Institute for Advanced Study, I examined the Hebrew manuscripts in the Garrett collection and discovered in MS. Garrett Hebrew 6 an hitherto unknown Italian representation of David crowned, seated in the foreground of a hilly landscape, and playing the psaltery. This very small manuscript contains the Pentateuch, the Psalms, an anonymous apologetical work, and selected daily and festival prayers. The final colophon, giving the date, 1524, and the names of the copyist and the first owner, is not that of the copyist of the bulk of the codex but of only the last two quires. The main part of the manuscript was certainly copied earlier, as the purely decorative initial-word panel of Genesis clearly betrays Florentine features of approximately 1460. As for the David miniature at the beginning of the Book of Psalms, it seems somewhat later and shows a North-Italian style that would locate it between Ferrara and Venice.

*Fig. 3.38 Jerusalem, The Israel Museum, MS. 180/51; the so-called Rothschild Miscellany, copied after 1453 most probably in North-East Italy and illuminated before 1470 in Ferrara-Padua; fol. 163r: illustration to Psalm 118, verse 5, "Out of my distress I called on the Lord." (photo M. Metzger, courtesy of The Israel Museum, Jerusalem).*[58]

# Acknowledgment

I wish to express my sincere thanks to all the institutions that have supplied me with photographs.

## Notes

1. The major studies of illustrated Greek and Latin psalters are so well known that the reader may well be spared a list of them. By contrast, a bibliography on the illustration of Hebrew psalters would, with two exceptions, comprise no more than a handful of isolated references to this or that miniature. The two exceptions are publications describing illustrations in the Parma psalter Ms. Parm. 1870—De Rossi 510: E. Munkácsi, *Miniatürmüvészet Itália könyvtáraiban héber kódexek* (Budapest, 1938), pp. 66–71, pls. XXV–XXX, figs. 73–94, and T. Metzger, "Les illustrations d'un psautier hébreu italien de la fin du XIIIe siècle, le Ms. Parm. 1870—De Rossi 510 de la Bibliothèque Palatine de Parme," *Cahiers archéologiques* XXVI (1977), pp. 145–62, 32 figs.

2. The subject is still new in 1991, 14 years after the Oxford conference on which this book is based, as can be gathered from the too-small selection of Hebrew Psalter manuscripts used by G. Sed-Rajna as background for the chapter on David in her publication *La Bible hébraïque* (Fribourg, 1987), pp. 115–31, and from her inaccurate statements on the iconography of the Hebrew Psalter. To ascribe, as she does (pp. 117 and 133), the paucity of Hebrew Psalter illustration to the rarity of psalters as independent volumes is to ignore the facts. I had objected in my review article "Ornamental Micrography in Medieval Hebrew Manuscripts," *Bibliotheca Orientalis* XLIII (1986), col. 184, to a similar assertion by L. Avrin about the scarcity of such independent psalters. I cannot do better than to refer once more for evidence to the index, *sub voce*, of J. B. De Rossi's catalog of his own collection, *Mss. Codices Hebraici Biblioth. I. B. De-Rossi* (Parma, 1803), vol. III, p. 216. Moreover, much used by pious Jews for the daily recitation of the Psalms, Hebrew psalters must have been rapidly damaged and have disappeared in the course of time. The fact that, in Italy, the Psalter was not infrequently bound in one and the same volume with Proverbs and Job does not seem to me to have had any special bearing on the development of the iconography.

3. In the Haggadah some of these illustrations accompany the psalms of the *Hallel* (Psalms 113–18), for example (in chronological order), Psalm 118 in the German Birds' Head Haggadah, Jerusalem, The Israel Museum—Bezalel National Art Museum, MS. 180/57, fol. 33r (reproduced in *The Bird's Head Haggada of the Bezalel National Art Museum in Jerusalem,* facsimile vol. [Jerusalem, 1965], p. 65); Psalms 113–18 in a Spanish haggadah in the same collection, MS. 181/41 (formerly MS. Sassoon 514), fols. 60r–75r; Psalm 118 in the Sarajevo Haggadah, Sarajevo, National Museum, fol. 36v of the text (reproduced in C. Roth, *The Sarajevo Haggadah,* facsimile vol. [London, 1963], fol. 36v of the text); and Psalms 113–14 in the Italian haggadah in the Schocken Institute for Jewish Research, Jewish Theological Seminary of America, Jerusalem, MS 24085, fols. 27r and 28r. Illustrations also accompany psalms in the Haggadah text within prayer books: Psalm 114 in a German *siddur* in Hamburg, Staats- und Universitätsbibliothek, Cod. Hebr. 37, fol. 32v; Psalm 118 in the so-called Rothschild Miscellanea in Jerusalem, The Israel Museum—Bezalel National Art Museum, MS. 180/51 (MS. Rothschild 24), fol. 163r (reproduced in *Encyclopaedia Judaica* (Jerusalem, 1972), vol. 13, col. 1326)—see *Fig. 3.38* in this essay for a reproduction, closer to the original size, of this very fine miniature; Psalms 113–118 in a German haggadah, Bermuda, Flörsheim Trust (formerly MS. Sassoon 511), pp. 18–26; Psalm 118 in a *siddur* of German rite but probably written in northern Italy, Oxford, Bodleian Library, MS. Lyell 99, fol. 89r; and Psalm 114 in an Ashkenazi *siddur* in Jerusalem, The Israel Museum—Bezalel National Art Museum, MS. 180/53, fols. 172v–173r.

A second series of illustrations is related to the *shefokh,* the invocation composed of verses taken from Psalms and the Book of Prophets, and in particular to Psalm 79:6. On the illustration of various psalms in the Haggadah, see M. Metzger, *La Haggada enluminée,* vol. 1 (Leiden,

1973), pp. 254 and 327–29; on the illustration of the *shefokh*, see ibid., pp. 320–21, figs. 314, 317, and 318, and J. Gutmann, "The Messiah at the 'Seder,' a Fifteenth-Century Motif in Jewish Art," in *Studies in Jewish History Presented to Professor Raphael Mahler on His Seventy-Fifth Birthday*, ed. Sh. Yievin (Merhavia, 1974), pp. 35–36, figs. 4 and 6. Psalm 19, as part of the daily prayers, is also illustrated in a German *siddur* written in 1471, Oxford, Bodleian Library, MS. Opp. 776, fol. 8v.

4. Milan, Biblioteca Ambrosiana, Ms. B. 32. Inf., fol. 3r. The most complete bibliography on this very important Bible was published by H. Striedl in *Die Zeit der Staufer, Geschichte, Kunst, Kultur, Katalog der Ausstellung* (Stuttgart, 1977), vol. 1, p. 268, no. 381; it was appended to a description of the manuscript, pp. 267–68. For a reproduction and description of this miniature see *Codici Decorati e Miniati dell'Ambrosiana: Ebraici e Greci* (Milan, 1957), part 1, *Codici ebraici*, by G. Villa, p. 28, pls. XV–XVI; see also *The Bird's Head Haggada* (*n. 3*), p. 142, pl. 28.

5. Wrocław, University Library, Ms. M 1106, fol. 305r. See C. Brockelmann, *Verzeichnis der Arabischen, Persischen, Türkischen und Hebräischen Handschriften der Stadtbibliothek zu Breslau* (Breslau, 1903), pp. 45–46, no. 1, and also the short mention by M. Garel, "Manuscrits hébreux en Pologne," *Revue d'Histoire des Textes* V (1975), p. 367 (one subject, fol. 272v, is wrongly identified as the coming of the Messiah instead of Nebuchadnezzar riding a lion). Only one page of the Bible has been reproduced: fol. 301v, with illustrations for the Book of Esther (see *Encyclopaedia Judaica* [Berlin, 1930], vol. 6, cols. 805–6). A complete study of the decoration of this Bible, *La Bible de Joseph et Meshullam Qalonymos, Ms. M 1106 de la Bibliothèque universitaire de Wrocław*, by the present author is at press.

The David illustration in Wrocław Ms. M 1106 (*Fig. 3.2*), which I showed at the Oxford conference and submitted then as an illustration to my paper, has been published recently by Sed-Rajna (*n. 2*), fig. 135. Within the same volume she has also reproduced three others of the seven illustrations (not six, as she stated on p. 164) from this Bible (her figs. 1, 145, and 174), but she has described them hastily in that she states, mistakenly, that the erased heads and upper bodies of Adam and Eve are covered by their long hair (p. 11) and that Moses holds not the Tablets but the Book of the Law (p. 95). Indeed, she has not identified the subject of this image, which shows Moses on the point of breaking the Tablets when he sees the golden calf, itself represented on the left of the image. This is the only occurrence of this subject in Jewish medieval iconography. Sed-Rajna has also overlooked the illustration at the beginning of Leviticus, fol. 100v, which shows the sacrificial lamb and bull.

6. The reader will find the most interesting insight into the much-debated question of animal-headed figures in Hebrew iconography in Z. Ameisenowa, "Animal-Headed Gods, Evangelists, Saints and Righteous Men," *Journal of the Warburg and Courtauld Institutes* 12 (1949), pp. 21–45. B. Narkiss, in his chapter entitled "On the Zoocephalic Phenomenon in Mediaeval Ashkenazi Manuscripts" in *Norms and Variations in Art: Essays in Honour of Moshe Barasch* (Jerusalem, 1983), pp. 49–62, has usefully put together the various interpretations proposed and the textual sources pertinent to the debate, but omissions and serious misreadings of the pictures mentioned mar his analysis of the main and best-known cases of distorted human faces. For instance, all the instances of featureless faces that he mentions are, in fact, partly or completely erased faces (in Munich, Cod. Hebr. 5; in Milan, B. 30. Inf.; and in Oxford, MS. Laud 321). And none of the supposedly entire faces in the Worms *Maḥzor*, which he deals with, are in their original state (which remains problematic), as all have been erased and partly completed by later hands. More recently. M. Rosenthal, in "'Mach dir kein Bildnis' (Ex. 20, 4) und 'Im Ebenbild erschaffen' (Gen. 1, 26f)," in *Wenn der Messias kommt*, ed. L. Kötzche and P. von der Osten-Sacken (Veröffentlichungen aus dem Institut Kirche und Judentum, vol. 16), (Berlin, no date [1985]), pp. 77–103, although relying too often on Narkiss's doubtful readings, offers a stimulating and controversial new hypothesis.

7. However, the face in the Wrocław Bible is now blank, as the features, eyes, nose, and mouth, have been scraped off by a later hand. Other faces in this Bible have also been scraped (fols. 1v, 272v, and 301v), and on fol. 1v Adam and Eve have been almost completely erased. Iconoclastic scraping and erasing by pious hands of whole figures, faces, and even of mere

foliage scrolls and decorated panels, are not uncommon in Hebrew illuminated manuscripts. One of the saddest examples of such rigorist treatment is Cod. Hebr. 5 in Munich, Bayerische Staatsbibliothek; see T. Metzger, "Le manuscrit enluminé Cod. Hebr. 5 de la Bibliothèque d'Etat à Munich," in *Mélanges E.-R. Labande* (Poitiers, 1974), pp. 550–51.

8. Jerusalem, Jewish Theological Seminary of America, Schocken Institute for Jewish Research, MS. 14940, fol. 93r. See J. Leveen, *The Hebrew Bible in Art* (London, 1944), pp. 86 and 87, pl. XXIX (reproduction of fol. 1v of the Schocken Bible), and B. Narkiss, *Hebrew Illuminated Manuscripts* (Jerusalem, 1969), p. 102, pl. 31 (also a reproduction of fol. 1v). The latter has the wrong shelf mark—MS. 14840—and that number has unfortunately found its way into most later publications. Neither author mentions the illustration at the beginning of the Psalter.

9. Hamburg, Staats–und Universitätsbibliothek, Cod. Hebr, 202, fol. 35v. See M. Steinschneider, *Catalog der Hebräischen Handschriften in der Stadtbibliothek zu Hamburg* (Hamburg, 1878), p. 5, no. 25. Steinschneider suggests the fifteenth century as a likely date, but codicological features and original decoration of the manuscript make an earlier date, that is, the end of the thirteenth century or beginning of the fourteenth, much more probable. Steinschneider makes no mention of the decoration of this psalter.

10. Biblical references are given according to the Hebrew version, but when verses are quoted in English translation the text is taken from *The Holy Bible,* revised version, indicated as RV, and corresponding references to this version are given.

11. Parma, Biblioteca Palatina, Ms. Parm. 3095—De Rossi 732, fols. 22r and 34v. See De Rossi (*n. 2*), vol. II, p. 142, who does not mention the decoration, and G. Tamani, "Elenco dei manoscritti ebraici miniati e decorati della 'Palatina' di Parma," *La Bibliofilia* LXX (1968), p. 85, no. 98, who mentions the masoretic decoration but not the illustration.

12. Oxford, Bodleian Library, MS. Bodl. Or. 621. See A. Neubauer, *Catalogue of the Hebrew Manuscripts in the Bodleian Library and in the College Libraries in Oxford* (Oxford, 1886), p. 18, no. 112. Contrary to Narkiss (*n. 8*), p. 29, this psalter of English origin belongs to a group of psalters that can be dated to the first half of the thirteenth century. Some of these psalters do include French glosses, but it has been definitely established that this French element is Anglo-Norman and that these psalters must be of English origin; see R. Loewe, "The Mediaeval Christian Hebraists of England," *Hebrew Union College Annual* XXVIII (1957), pp. 219–24, and relevant bibliography, p. 252. It is unfortunate that, in his endeavor to build up an early thirteenth-century French school of Jewish illumination, B. Narkiss (*n. 8,* p. 29) has not been more felicitous in identifying and selecting the other manuscripts he has made use of here: the Bible he used, which is in two parts (one in Cambridge, University Library, MS. Add. 468, and the other in Cincinnati, Hebrew Union College—Jewish Institute of Religion, MS. 13), is, in fact, a Spanish Bible and was certainly not decorated before the fifteen century. The script in this manuscript has been correctly identified as Sephardi by S. M. Schiller-Szinessy, *Catalogue of the Hebrew Manuscripts Preserved in the University Library* (Cambridge, 1876), vol. 1, pp. 19–21, no. 14; by J. Bloch, *The People and the Book* (New York, 1954), pp. 34–35 and 38, no. 7; by D. S. Berkowitz, *In Remembrance of Creation: Evolution of Art and Scholarship in the Medieval and Renaissance Bible* (Waltham, Mass., 1968), p. 17, no. 23; and by T. and M. Metzger, *La vie juive au moyen âge, illustrée par les manuscrits hébraïques du XIIIᵉ au XVIᵉ siècle* (Fribourg/Paris, 1982), Catalogue, p. 304, no. 28. Narkiss, in *Hebrew Illuminated Manuscripts in the British Isles,* part 1 (Jerusalem/London, 1982), has now placed this Bible with the Sephardi manuscripts (see pp. 161–62, no. 50) but without giving any explanation or pertinent bibliography. However, his qualification of the manuscript as Franco-Spanish is quite unfounded. The haggadah in Hamburg (Hamburg, Staats- und Universitätsbibliothek, Cod. Hebr. 155) follows the Italian rite and was illustrated in Italy in the fourteenth century.

Some decorated manuscripts of north-French origin dating from as early as the first half of the thirteenth century are still extant, but none of them have been mentioned by Narkiss. We would mention, for example, Berlin, Staatbibliothek, Preussischer Kulturbesitz, Orientabteilung, Ms. or. qu. 9, and Vatican, Biblioteca Apostolica Vaticana, cod. vat. ebr. 14, both copied by the same scribe. However, due to inconsistencies in indicating the date in the colophons of these two manuscripts, they have until now been dated from 1333 and 1339, respectively (see

M. Steinschneider, *Verzeichniss der hebraeischen Handschriften* (Die Handschriften-Verzeichness der Königlichen Bibliothek zu Berlin, vol. II) [Berlin, 1878], pp. 22–23, no. 43, and H. Cassuto, *Bybliothecae Apostolicae Vaticanae . . . Codices Vaticani Hebraici*, codices 1–115 [Vatican City, 1956], pp. 17–19). Historical and codicological evidence make a considerably earlier dating likely, that is, 1233 and 1239 (see N. Golb, *History and Culture of the Jews of Rouen in the Middle Ages* [Tel-Aviv, 1976], pp. 120–44, and M. Beit-Arié, *Hebrew Codicology* [Paris, 1976], p. 25).

However, although it is very richly illuminated, Vatican, Biblioteca Apostolica Vaticana, cod. vat. ebr. 468, copied in La Rochelle in 1215, cannot be included in the group of early thirteenth-century illuminated French manuscripts because the style of decoration shows clearly that the decoration was added in Spain around 1380. The discrepancy between the date and place of the copy and of the decoration has been overlooked by L. Mortara Ottolenghi, "La Bibbia di La Rochelle," in *Les Juifs au regard de l'histoire, Mélanges en l'honneur de Bernhard Blumenkranz* (Paris, 1985), pp. 149–56, who mistakes the Bible for "*il più antico manoscrito ebraico miniato certamente localizzato e datato della Diaspora occidentale*" (the oldest illuminated Hebrew manuscript precisely placed and dated in the western Diaspora).

A final point with regard to an early thirteenth-century French school of Hebrew illuminated manuscripts should be mentioned. The list published by G. Sed-Rajna in "Les Manuscrits enluminés" in *Art et archéologie des Juifs en France médiévale* (Toulouse, 1980), pp. 183–84, even if it includes the two Rouen Pentateuchs cited earlier in this note, presents the same errors to which I have drawn attention because the author, as she herself acknowledges, largely bases her list on the one in Narkiss (*n. 8*).

13. Other illustrations, including some animal and human heads, one a woman's (fol. 2r), others men's (fols. 2v, 4r, and 40v), and one a king's (fol. 39v), bear no relation to the text.

14. See Loewe (*n. 12*), p. 224. All the Anglo-Norman psalters, even those not purposely written for non-Jewish use, came very early into Christian hands and received their Latin or French glosses from those same hands.

15. Reproduced in G. Margoliouth, "An Ancient Illuminated Hebrew MS. at the British Museum," *Jewish Quarterly Review* XVII (1904–5), plate facing p. 193; H. Galliner, *Jüdisches Gemeindeblatt für Berlin*, January 23, 1938, p. 9; Z. Ameisenowa, "Die hebräische Sammelhandschrift Add. 11639 des British Museum," *Wiener Jahrbuch für Kunstgeschichte* XXIV (1971), fig. 28; J. Gutmann, *Hebrew Manuscript Painting* (New York, 1978), in color, pl. 20; and T. and M. Metzger, "Les enluminures du Ms. Add. 11639 de la British Library, un manuscrit hébreu du Nord de la France (fin du XIIIᵉ siècle—premier quart du XIVᵉ siècle," *Wiener Jahrbuch für Kunstgeschichte* XXXVIII (1985), p. 282, fig. 5. For a thorough analysis of this figure, see T. and M. Metzger, "Les enluminures," pp. 71, 81, 84, and 85.

16. Surely the fact that David conceived the idea of building the Temple, and the fact that his psalms accompanied the services, could explain the choice of this illustration for the beginning of a book dealing with the Temple service.

17. See G. Swarzenski and R. Schilling, *Die illuminierten Handschriften und Einzelminiaturen des Mittelalters und der Renaissance in Frankfurter Besitz* (Frankfurt, 1929), p. 74.

18. Reproduced in *Encyclopaedia Judaica* (Jerusalem, 1972), vol. 5, between cols. 1324 and 1325.

19. Reproduced in *Codici Decorati e Miniati dell'Ambrosiana* (*n. 4*), pl. XI.

20. Haverford (Pennsylvania), Haverford College Library, MS. Harris 1. The Bible is described in R. W. Rogers, "A Catalogue of Manuscripts (Chiefly Oriental) in the Library of Haverford College," *Haverford College Studies* XLII (1890), pp. 29–32, and in Berkowitz (*n. 12*), p. 12 , no. 14, and pl. 14. Neither the illustration nor the most important decorated pages are mentioned in either description.

Berkowitz has followed Rogers's incorrect reading of part of the colophon. The Bible was not "written and delivered" to four persons, as assumed by Rogers, but was "copied with the *Masorah*" for one person only, Joshua son of Zeraḥiah son of Shaltiel.

The sequence of the Hagiographa is not "unique in its confusion," as stated by Berkowitz, but follows the order given in the Babylonian Talmud, *Bava batra*, 14b, which was largely accepted in medieval Spain (see T. Metzger, *Les manuscrits hébreux copiés et decorés à Lisbonne dans les dernières décennies du XVᵉ siècle* [Paris, 1977], pp. 187–89). The Bible has been exhibited

(see exhibition catalog, *Legacies of Genius: A Celebration of Philadelphia Libraries: A Selection of Books, Manuscripts, and Works of Art,* ed. Edwin Wolf 2nd [Philadelphia, 1988], p. 105, no. 70, with a reproduction of p. 336r).

21. Lisbon, Biblioteca Nacional, Ms. Il. 72. The most complete bibliography for this manuscript is given in T. Metzger, "Les Objets du Culte, le Sanctuaire du Désert et le Temple de Jérusalem dans les Bibles Hébraïques Médiévales Enluminées, en Orient et en Espagne," *Bulletin of the John Rylands Library* 52 (1969–70), pp. 406–7. See also the short description by Narkiss in *Hebrew Illuminated Manuscripts* (*n. 8*), pl. 6 and p. 52. My own monograph on this sumptuously decorated Bible is to be published and two articles have already appeared: "Josué ben Abraham ibn Gaon et la masora du Ms. Iluminado 72 de la Biblioteca Nacional de Lisbonne," *Codices Manuscripti* XV (1990), 5th fasc., pp. 1–27, 20 figs., and "L'illustration biblique dans la bible hébraïque Ms. Iluminado 72 de la Bibliothèque nationale de Lisbonne," *Revista da Biblioteca Nacional* (Lisbon), S.2, 5 (2) (1990), pp. 61–100, 26 figs.

22. Dublin, Trinity College Library, MS. 16. See T. K. Abbott, *Catalogue of the Manuscripts in the Library of Trinity College, Dublin* (Dublin/London, 1900), p. 2, no. 16.

23. The volume, MS. 1210, is not described in D. S. Sassoon, *Ohel Dawid: Descriptive Catalogue of the Hebrew and Samaritan Manuscripts in the Sassoon Library, London* (London, 1932); it is, however, mentioned in T. Metzger, "La Masora ornementale et le décor calligraphique dans les manuscrits hébreux espagnols au moyen âge," in *La paléographie hébraïque médiévale*, Colloques internationaux du CNRS, no. 547, September 11–13, 1972 (Paris, 1974), p. 112.

24. However, the flowers are of the rose type. The Hebrew word *shoshan* (lily) seems to have been understood by medieval Jews as designating a rose because each time it is illustrated in the thirteenth-century Italian psalter Ms. Parm 1870—De Rossi 510 (partly described below), or in German *maḥzorim* from the thirteenth to the fifteenth century, it is represented by a more or less stylized rose. In fact, although the instructions for performing Psalm 56 are unlikely to be anything other than the incipit of a song whose melody was borrowed for this psalm, it remains uncertain whether "on the lily of testimony" (Psalm 60) and "on the lilies" (Psalm 69) are likewise the incipits to songs or refer instead to some unidentified musical instruments. It is this latter meaning that has been chosen in the Christian versions of the Psalms.

25. In this manuscript Psalms 75 and 76 have been joined together and two psalms have been numbered 81. Thus, if the image for Psalm 104 (= 106) (fol. 339v) were connected with the text, it would be with Psalm 102 (= 104) because the stag depicted is holding a long leaf in its mouth and one of the themes of Psalm 104 is the power of the Lord to provide for every creature on earth. However, the image of a hart that accompanies Psalm 22, which also chews a stylized tendril, has no possible connection with the text.

26. This manuscript offers only two other illustrations to the text: for the Book of Joel (fol. 68v), a locust and the vine and fig tree that it devours, and at the beginning of Zephaniah (fol. 76v), where the different created beings are mentioned, a series of 13 animals—a giraffe, a lion, a bear, a fox, a fish, an ox, a camel, an elephant, a snake, two birds, two felines (panthers or leopards) or perhaps dogs, and two monsters. The meanings proposed by Narkiss for the other two motifs (fols. 69v and 73r) that he identifies as textual illustrations (*n. 12,* p. 32, no. 4)—he overlooks the illustration to Psalm 42—are rather forced.

27. In his description of the Egyptian Synagogue Bible, afterwards in the collection of the Mosseri family, R. Gottheil, in "Some Hebrew Manuscripts in Cairo," *Jewish Quarterly Review* XVII (1904–5), pp. 621–25, no. 7, has listed (p. 623) "an illustration of the royal singer at his harp." Z. Ameisenowa, in her description of the same Bible in "Eine spanisch-jüdische Bilderbibel um 1400," *Monatsschrift für Geschichte und Wissenschaft des Judentums* LXXXI (1937), pp. 193–209, states also (p. 195), "*Der harfenspielende Dawid eröffnet das Buch der Psalmen*" (David playing the harp opens the Book of Psalms), but she does not reproduce this miniature in her article. Although both authors described this Bible as Spanish, only an examination of the manuscript could confirm its Spanish origin, and its whereabouts have been unknown since World War II (on this problem see T. Metzger, "La représentation du copiste dans les manuscrits hébreux médiévaux," *Journal des Savants* [1976], pp. 36–37, note 9).

28. Parma, Biblioteca Palatina, Ms. Parm. 1870—De Rossi 510. See Metzger (*n. 1*), note 1, pp. 145–46, for the relevant bibliography.

29. L. Mortara Ottolenghi proposes in "Un gruppo di manoscritti ebraici romani del sec. XIII e XIV e le loro decorazione," in *Studi sull'Ebraismo Italiano* (Rome, 1974), pp. 145 and 153, that it should be attributed to a Roman school, but even if the Emilian style of illumination that characterizes its decoration had largely spread to the Roman region, its coloring does not compare with the warmer and lighter colors of this group of Roman manuscripts. Furthermore, in the opinion of the specialists, the fragments of musical notation contained in two of its illustrations precisely exclude Rome as its place of origin and, on the contrary, point to a region north of Rome, to Emilia or Tuscany.

30. All are analyzed and 32 are reproduced in my monograph cited in note 1. The eight subjects described and reproduced here have been chosen intentionally from among those not reproduced in the monograph in order to complete the series of illustrations. U. and K. Schubert, in *Jüdische Buchkunst* (Graz, 1983), pp. 97 and 121 and fig. 16, propose quite a different meaning for the illustration to Psalm 83 (fol. 118v) from mine (*n. 1*, p. 155), to which they do not refer. Where I see a Jew crying to God for help against His enemies, they see a monk inciting soldiers to murder Jews, and they therefore invest this picture with an anti-Christian, polemical significance. However, the very fragile basis of their interpretation lies in their misreading of the "monk's" haircut and clothes. In fact, no tonsure is visible, and the hooded garment is quite similar to those worn by the unquestionably Jewish figures on fols. 107v and 126r (see Metzger [*n. 1*], p. 154, fig. 16, and p. 155), the first holding out a book on which the first two Commandments are written and the second praising God's mercy.

31. Examples include the psalters in the Bibles Ms. Parm. 2151–2152–2153—De Rossi 3 and Modena, Biblioteca Estense, Cod. α J. 1. 22.

32. Parma, Biblioteca Palatina, Ms. Parm. 1711—De Rossi 234. See De Rossi (*n. 2*), vol. I, p. 146, no. 234, who mentions the decoration but not the illustrations, and Tamani (*n. 11*), p. 82, no. 86, who describes the illustrations simply as "*figure umane.*"

Parma, Biblioteca Palatina, Ms. Parm. 2052—De Rossi 667, originally a complete Bible from which the Pentateuch has now been lost, offers as its sole illustration a small, crowned figure seated in a canopied cathedra. The illustration is in the left half of the initial-word panel of the Book of Psalms (fol. 259r) (not, as stated by Tamani [*n. 11*], note 62, p. 72, "*nel margine superiore,*" in the upper margin). The paint has flaked from the lower part of the image and nothing remains of a musical instrument, contrary to Tamani's description (note 62, p. 74) of "*Davide con la cetra*" (David with the zither). De Rossi (*n. 2*), vol. II, p. 125, mentions neither the illustrations nor the blue and red pen-drawn decoration. Tamani (*n. 11*), note 62, p. 74, failed to notice the discrepancy between the date, 1280, given for the copy in the colophon and the style of the painting and decoration, which can hardly have been executed before the second half of the fourteenth century for the former and possibly even later in the fifteenth century for the latter. The discrepancy was pointed out by M. Metzger in "L'aide et les risques qu'offrent le décor et l'illustration pour dater et localiser les manuscrits hébreux médiévaux," in *La paléographie hébraïque médiévale*, Colloques internationaux du CNRS, no. 547, September 11–13, 1972 (Paris, 1974), p. 122.

33. It is noticeable that even though the first psalm in each of the five books of the psalter Ms. Parm. 1870—De Rossi 510 was given, as was usual, more important decorative treatment, none were illustrated.

34. Parma, Biblioteca Palatina, Ms. Parm. 1726—De Rossi 1126, fol. 31v. De Rossi (*n. 2*), vol. III, p. 71, no. 1126, mentions the decoration but not the illustration. He gives a precise date, 1407, but the second letter (erased) of the Hebrew date is no longer securely legible. Tamani (*n. 11*), p. 79, no. 78, gives the same date as De Rossi and, like De Rossi, does not mention the illustration. The Psalms are followed by the five *megillot*. The blue and red pen-drawn decoration stops before the end of the Psalms.

35. The illustration for Psalm 30 in Ms. Parm. 1870—De Rossi 510 was discussed earlier in this essay and is shown in *color plate* 3.

36. Parma, Biblioteca Palatina. See De Rossi (*n. 2*), vol. II, pp. 15–16, no. 385, who mentions not only the decoration but also the image of David at the beginning. However, the date he proposes, "*sec. XIV vel init. XV*," is too early. V. Antonioli Martelli describes the decoration and illustrations in V. Antonioli Martelli and L. Mortara Ottolenghi, *Manoscritti Biblici Ebraici Decorati* (Milan, 1966), p. 60, no. 15; she rightly dates the manuscript to "*secolo XV, prima del XVI*" and quotes Levi d'Ancona's attribution of the illumination, "*alla cosidetta scuola del Torelli*" (to the so-called school of Torelli). Tamani (*n. 11*), p. 83, no. 91, mentions the decoration and says of the illustrations, "*figure di uomini*" (men's figures). He adopts the date proposed by Antonioli Martelli. In fact, no satisfying parallels can be found in the Florentine manuscripts so far published, either for the border (e.g., the large pink flowers in profile) or for the heads and busts in the cartouches and the two putti. The last do not look like Torelli's work.

37. Parma, Biblioteca Palatina. See De Rossi (*n. 2*), vol. II, p. 126, no. 672, who mentions the decoration and is right in dating it to the fifteenth century. Tamani (*n. 11*), p. 83, no. 90, indicates "*figure umane*" in the decoration and adopts De Rossi's dating. L. Mortara Ottolenghi, in *Arte e cultura ebraiche in Emilia-Romagna,* the catalog of the exhibition in Ferrara, September 20, 1988–June 15, 1989 (Milan/Rome, 1988), p. 187, no. 35, briefly describes the manuscript and on p. 173 assigns the miniature on fol. 1r to Francesco d'Antonio del Chierico. No identity has yet been proposed for the later, second hand.

38. In contrast to medieval Latin psalters, where this last subject was frequently illustrated, none of the extant Ashkenazi or Sephardi psalters offer any such picture. The absence of illustrations of David's fight against Goliath is possibly because of the predominance of literal illustration in these two types of psalter. As David's fight against Goliath is not mentioned in the Psalter, it is quite normal not to find it illustrated there. We find it partly illustrated, with gloss-type pictures of David's sling and Goliath's sword, in the margins of the very text that relates the event, I Samuel 17:40–51, in a Sephardi Bible, Paris, Bibliothèque nationale, ms. hébr. 20, fol. 170r.

When this subject appears in Ashkenazi manuscripts, it is always in different contexts: in the late thirteenth century it was included in a series of full-page miniatures in the London French miscellany (London, British Library, MS. Add. 11639, fol. 553v) and on the opening page to Book VII of a *Mishneh Torah* (Budapest, Hungarian Academy of Sciences, Ms. A 77, Vol. II, fol. 118r); in 1309 it was included at the end of Ecclesiastes in a German fragmentary volume (London, British Library, MS. Add. 9405–9406, vol. 1, fol. 11v); in the third quarter of the fifteenth century it was included in two haggadot, the so-called Second Nuremberg Haggadah (Jerusalem, Jewish Theological Seminary of America, Schocken Institute for Jewish Research, MS. 24087, fol. 40r) and the Yahuda Haggadah (Jerusalem, The Israel Museum—Bezalel National Art Museum, MS. 180/50, fol. 39r); and it was added at the very end of the fifteenth century in a fourteenth-century *maḥzor,* Erlangen, Universitätsbibliothek, Ms. 2601, fol. 84v.

39. This manuscript contains the Psalter, Job, Proverbs, and the liturgy for circumcisions and weddings. See P. Perreau, "Catalogo dei Codici Ebraici della Biblioteca di Parma non descriti del De-Rossi," in *Cataloghi dei Codici Orientali di Alcune Biblioteche d'Italia* (Florence, 1878), Appendix, p. 195, no. 2, who dated it correctly to the fifteenth century but underestimated the quality of the illumination in writing "*fregi e miniature assai mediocri*" (rather mediocre borders and miniatures). Tamani (*n. 11*), p. 81, no. 84, mentions "*illustrazioni a piena pagina con figure umane*" (full-page illustrations with human figures) and dates the manuscript as late as "*sec. XVI,*" a date that the style of illumination makes quite unlikely. For her part, L. Mortara Ottolenghi, in her short article "I manoscritti ebraici in Italia," *Ariel* (1975), special issue in Italian, reproduces one of the miniatures showing the circumcision, fol. 268v, but strangely and quite wrongly dates it to the end of the fourteenth century (see p. 70 and caption to fig. 4).

The illustration at the beginning of the Psalter was reproduced and described in my study "La représentation du copiste dans les manuscrits hébreux médiévaux" (*n. 27*), fig. 13 and p. 49 (in footnote 30 I wrongly ascribed Tamani's incorrect dating to Perreau). See also T. and M. Metzger (*n. 12*), Catalogue, p. 313, no. 229 and p. 105, fig. 146, for a color reproduction, and L. Mortara Ottolenghi, "The Illuminations and the Artists," in *The Rothschild Miscellany* (London, 1989), p. 145, fig. 9, who gives references in note 6 to her own articles but ignores the others.

40. The text begins, fol. 4r, on a beautifully decorated page.

41. Jerusalem, The Israel Museum—Bezalel National Art Museum, MS. 180/51. See B. Narkiss, *Hebrew Illuminated Manuscripts from Jerusalem Collections,* The Israel Museum exhibition catalog no. 40 (1967), no. 18. The miniature on fol. IV is reproduced in C. Roth, ed., *Jewish Art: An Illustrated History* (London, 1961), p. 416, fig. 208, with the indication, "executed in N. Italy, late 15th century." For an analysis of some of the minatures in this manuscript see Metzger (*n. 3*), p. 501, *sub voce,* and my article above (*n. 27*), pp. 41–47, with a bibliography on p. 42, footnotes 21 and 22.

The miniature has also been reproduced and described in B. Narkiss and G. Sed-Rajna, *Index of Jewish Art,* vol. III, card no. 4, but the description is incomplete and inaccurate, as unfortunately is true with so many of the numerous illustrations in this index. For an enlarged color reproduction see Sed-Rajna (*n. 2*), p. 129, fig. 136.

T. and M. Metzger have reproduced 22 of the illustrations in the Rothschild manuscript in *La vie juive au moyen âge* (*n. 12*); see *La vie juive,* Catalogue, p. 307, no. 79, for the references. A facsimile of the manuscript has been published, entitled *The Rothschild Miscellany* (London, 1989), the colors of which, while often fairly accurate, are completely spoiled by the disastrous reproduction of the painted gold: blobs and large, awkward strokes of dull olive-green paint are supposed to reproduce the extremely refined and delicately radiating golden highlights of the original.

The style of the Rothschild manuscript illumination has been thoroughly studied by U. Bauer-Eberhardt, as reported in "Die Rothschild-Miscellanea in Jerusalem, Hauptwerk des Leonardo Bellini," *Pantheon* XLII (1984), pp. 229–37. This author ascribes the whole decoration to Leonardo Bellini, Jacopo's nephew and a well-documented illuminator of the Bellini family who worked in Venice and Padua between 1457 and 1469, and contends that the Hebrew manuscript should be considered as one of Bellini's last works and his most important. Indeed, very close affinities are apparent between several miniatures attributed to Bellini and those in the Rothschild manuscript, especially within the figures, details of the landscapes, and some of the animals, but the pen-drawn and painted floral decoration in the manuscript is more often somewhat different from Bellini's in the type of floral motif and in the type of pen work. So, were Bellini to be taken as the painter of if not all at least part of the illustrations, most of the decoration at least would have to be by another hand. However, a close examination of most of the manuscripts where the hand of Bellini can be most surely recognized does not lead, in our eyes, to an unquestionable identification of the principal artist of the Rothschild Miscellany as Bellini himself (differences appear in the treatment of hair and faces, for instance) but to an artist very close to him, working in the same circle, using the same models and submitted to the same Ferrarese stylistic influences.

Recently, Mortara Ottolenghi (*n. 39*), passim and pp. 242–46, claimed that the various artists at work on the Rothschild Miscellany belonged to the Cremonese workshops of Bonifacio Bembo and Cristoforo de Predis, and she even recognized in some miniatures the hand of both of those artists. But, carefully investigated, the similarities and identities she points to in the works of the Cremonese workshops and the Miscellany prove entirely unconvincing. For more details see our forthcoming review article about the Rothschild Miscellany facsimile and its companion volume.

42. See L. Ginzberg, *The Legends of the Jews,* vol. IV (Philadelphia, reprinted 1968), pp. 114–15.

The picture of fruit trees growing by brooks may have been suggested by the text of Psalm 1:3: "And he shall be like a tree planted by rivulets of water, that yieldeth its fruit in its season . . . ," but by adding various animals to this landscape, the painter developed what may have been at first no more than a pictorial gloss into a much more significant image, that of Paradise.

43. As is well known, the Orpheus model was used to represent David in the synagogue of Dura Europos and, later, the synagogue of Gaza (on this question see the contribution by Paul Corby Finney, "Orpheus-David: A Connection in Iconography Between Greco-Roman Judaism and Early Christianity," *Journal of Jewish Art* 5 [1978], pp. 6–15). But, obviously, there is no possible link between an Italian miniature of the second half of the fifteenth century and those

early examples of Jewish art, and the sources of the image must be sought in trends of fifteenth-century cultural life.

44. See H. Zotenberg, *Catalogues des manuscrits hébreux et samaritains de la Bibliothèque impériale* (Paris, 1866), p. 11, no. 102, where the contents of the volume (*haftarot* and holy writings), the name of the scribe (a well-known one, Aryeh ben Eliezer Halfan—see A. Freimann, "Jewish Scribes in Medieval Italy," in *Alexander Marx Jubilee Volume* [New York 1950], pp. 247–48, no. 44), and the date of completion (11 *Marheshvan* 5242 = 1481) are given but nothing is said about the sparse pen-work decoration or the miniature—the only one in the manuscript—which is now described for the first time. The date of completion gives a *terminus post quem* for the miniature, and its style and the fact that the scribe worked between 1478 and 1494 in Ferrara, Cremona, and Isola della Scala (between Verona and Mantua) point to this part of northern Italy as the most likely origin of the illumination. We judged the miniature to be too badly damaged to be worth reproducing.

45. Parma, Biblioteca Palatina. See De Rossi (*n. 2*), vol. II, p. 60. He mentions the decoration and miniature ("*Davidem cum cythara*" = zither), and dates the manuscript, correctly, to "*sec. XV*." Antonioli Martelli (*n. 36*), p. 59, no. 14 and pl. IV, describes the miniature, confirms its date, and mentions its assessment by M. Levi d'Ancona as of "*tipo fiorento del tardo rinascimento*" (Florentine style from the late Renaissance) executed by the illuminator Zanobi Strozzi himself. Tamani (*n. 11*), p. 80, no. 83, gives the date "*sec. XV*" and for fol. 2r mentions "*motivi floreali e . . . figure di uomini e di animali*" (floral motifs and . . . figures of men and animals)! A. Garzelli in *Miniatura fiorentina del Rinascimento, 1440–1525: un primo censimento* (Florence, 1985), p. 20, also assigns this psalter, which she erroneously calls "*Bibbia*" (Bible), to Zanobi Strozzi and dates it to 1450–55.

46. Hamburg, Staats- und Universitätsbibliothek, Cod. Scrin. 154. See Steinschneider (*n. 9*), p. 45, no. 120; he suggests "*XV J?*" as a date and mentions the miniature, "*Zu Anfang f. 3 colorirte Vignette, König David*" (a painted miniature of King David at the beginning of fol. 3r). This psalter is followed by the prayers for the High Holydays (New Year, the Day of Atonement, and the Feast of Tabernacles). Until now no attribution had been proposed for this illuminated page. I owe to A. de la Mare the suggestion that it could be attributed to Zanobi Strozzi.* The badge in the lower border is now illegible.

47. Berlin, Staatsbibliothek, Preussischer Kulturbesitz, Orientabteilung, Ms. Hamilton 547. The manuscript contains David Kimhi's commentary, which is written in a smaller script and intercalated between the biblical verses. See *Catalogue of the Magnificent Collection of Manuscripts from Hamilton Palace* (London, 1882), prepared for an intended sale at Sotheby, Wilkinson and Hodge, p. 92, no. 547; the four miniatures and border are ascribed to Girolamo dai Libri in spite of their obviously Florentine characteristics. The sale did not take place, and with the exception of about half a dozen copies the catalogs were purposely destroyed. I have been able to consult the copy in the Orientabteilung, Berlin.

The manuscript was included in the exhibition *Synagoga* held in Recklinghausen, in Frankfurt o.M., and in Amsterdam in 1960–61. The same short description appears in the three catalogs under B.19, no. 89, and no. 18, respectively. Fol. 1r is reproduced in the Frankfurt catalog as pl. 55 and in the Amsterdam catalog as pl. 18.

The iconography of this page has been discussed by E. S. Saltman in her interesting article "The 'Forbidden Image' in Jewish Art," *Journal of Jewish Art* 8 (1981), p. 51, with a color reproduction, p. 50, fig. 15. However, several points in her analysis need correction. First, the clearest evidence that the decoration was intended for this particular Hebrew psalter is not, as suggested by Saltman, its layout (which affords useful but secondary evidence) but the fact that the page is part of the first quire of the codex, forming a single sheet with fol. 10, and that the entire text was already copied when the decoration on this and the other pages was executed.

---

*I have pleasure in expressing my warmest thanks to Professor A. de la Mare for the precious information she so kindly gave me by letter about the Florentine group of manuscripts (see *nn. 46–49*).

Furthermore, Saltman has incorrectly identified the psaltery in the first miniature as a meaningless shield, when it is this musical instrument, in conjunction with the crown, that clearly identifies the praying figure as David. There is no reason to interpret the picturesque tower bridge on the right as the "city of David" and even less as the then-unbuilt Temple. Finally, God is not pointing to one of the "castles" in the background but at David himself.

It must be noted that David's apparel in the scene on the lower right is identical in shape and color to his apparel in the scene of his victory over Goliath except that it is now left loose instead of tucked up under a belt, as would have been convenient in violent action. In our opinion this kind of sleeveless tunic, open at both sides, girded with a large folded belt, is different from the gray, girdled tunic worn by penitent monks, which is also sleeveless but not necessarily open at the sides (see the monk kneeling at the foot of the cross in the large central panel of *The Thebaid* by Paolo Uccello).

Nevertheless, a scene of penitence is, as I have already suggested, not out of place in a pictorial summary of King David's life, for penitence was an essential episode in it after Uriah's death and Nathan's rebuke (II Samuel 10). Repentence is also a frequent theme in David's Psalms. Moreover, Saltman is wrong to assert that penitence is secondary in Judaism. On the contrary, penitence, although not conceived as ascetic practice but as repentence, prayer, and fasting, is a keystone of Jewish religious life, and with prayer and fasting it is one of the three necessary conditions for divine forgiveness (see the Day of Atonement service).

Last, no special significance is to be attached to the absence of the divine figure from the battle scene between David and Goliath, for in Christian as well as in Jewish iconography the divine figure is traditionally absent from it. Moreover, Saltman's interpretation of this absence completely contradicts the biblical text (I Samuel 17:45–47). David, the youth who defeats the heavily armed Goliath with his shepherd's sling and pebble and who uses his enemy's sword only to sever the head of the mortally wounded giant, cannot be and never has been considered as a warrior and, as such, incurring God's displeasure. On the contrary, he is the symbol of the overwhelming power of God's help on the side of the righteous against evil.

Mortara Ottolenghi (*n. 39*), p. 147, note 5, quotes the Hamilton manuscript and gives an incorrect reading of the coat of arms in the lower border. We know it is not Sassetti's because it bears a bend gules and Sassetti's arms bear a bend azure between two fillets or, as was pointed out to me by A. de la Mare, who would herself recognize in this psalter the hand of an as yet anonymous Florentine artist active around 1460, whose hand she has identified in many manuscripts not reproduced in Garzelli (*n. 45*). Garzelli, moreover, has conflated this artist's work with that of another under the name "Maestro della Farsaglia Trivulziana" (*n. 45,* vol. I, pp. 36–37, and vol. II, figs. 42–52).

48. Jerusalem, The Israel Museum—Bezalel National Art Museum, MS. 180/55. The manuscript contains Psalms, Job, and Proverbs. See a short mention of its miniature in Narkiss (*n. 8*), p, 39. Fol. 4v is reproduced in *Encyclopaedia Judaica* (Jerusalem, 1972), vol. 8, col. 1283, with the imprecise date of the "mid-15th century." For a considerably enlarged color reproduction see Sed-Rajna (*n. 2*), p. 123, fig. 143. A. de la Mare would ascribe the illustration to Zanobi Strozzi. On fol. 4v the arms are no longer legible, contrary to Mortara's assertion (in her contribution to *The Rothschild Miscellany* [*n. 39*], p. 147, note 5), and Mortara has overlooked a Medici emblem—the three feathers and the diamond ring with the motto "*semper*"—in the lower border of fol. 5r.

49. See Sotheby and Co., *Catalogue of Western Manuscripts and Miniatures . . . Day of Sale, Wednesday, 9th July 1969,* pp. 55–56, no. 63, 4 figs., which includes a reproduction of fol. 2v. Narkiss (*n. 8*), mentions this manuscript. It is now in the Beinecke Library, Yale University (New Haven), under the shelf mark MS. Marston 409; see W. Cahn and J. Marrow, "Medieval and Renaissance Manuscripts at Yale: A Selection," *Yale University Gazette* 52 (1978), pp. 232–33, no. 57, and the catalog of the exhibition held at the Jewish Museum, *Gardens and Ghettos: The Art of Jewish Life in Italy,* ed. Vivian B. Mann (New York, 1989), pp. 230–31, no. 40. The Sotheby psalter contains the same three books as the Rheims manuscript and was copied in 1467. In the opinion of M. Levi d'Ancona, "The illumination is probably by Antonio di Niccolo

di Lorenzo (1445–1527)" (see sale catalog, pp. 55–56, no. 63), but Garzelli (*n. 45*), p. 207 and fig. 718, assigns it to Mariano del Buono, ca. 1478. This late dating seems to be due to an error she makes with regard to the date of the copy, which she gives as 1476 instead of 1467, as stated in the scribe's colophon. A. de la Mare agrees with Garzelli's attribution but considers it an early work.

50. See note 45.

51. See note 49.

52. See note 46.

53. See note 47.

54. Although the Hebrew Bible Ms. Plut. 1.31 in the Biblioteca Medicea Laurenziana in Florence cannot be considered in the same light as the other Hebrew manuscripts analyzed in this essay because (as is made clear in the colophon) the scribe had already converted to Christianity when he wrote it and thus it could not have been produced for Jews, we should point out that one can see in a medallion at the beginning of Psalms (fol. 251r) a small bust of David playing the psaltery. The Bible was copied in the second half of the fifteenth century (see A. M. Biscioni, *Bibliothecae Mediceo-Laurentianae Catalogus. Tomus Primus: Codices orientales complectens* [Florence, 1752], p. 25), and the illuminations have been attributed by C. Roth in Antonioli Martelli and Mortara Ottolenghi (*n. 36*), p. 38, to Francesco d'Antonio del Chierico. However, Garzelli (*n. 45*), pp. 184–85, assigns them to Francesco Rosselli, and, recognizing in the scenes of the creation on fol. 1r copies of those in the Bible of Federico da Montefeltro, the first volume of which was copied in 1477, she proposes this date as a *terminus post quem* for the illumination of Ms. Plut. 1.31. She wrongly sees in it a work commissioned by a Jewish patron, and as this Bible was obviously copied by a convert to Christianity who expresses his new faith very personally, in Hebrew, as seen in fols. 1r and 314v, it could well have been written originally for personal use or for religious rather than humanistic purposes. In no way does it illustrate any "symbiosis of secular and Hebraic civilisation" (p. 38), as Roth would have it.

55. As we have seen (notes 46–48), only the Medici emblem in the Rheims manuscript could point to this circle. But even the presence of such an emblem is not absolute proof that the manuscript was destined for a member of the Medici family, as Medici emblems are also found in books commissioned by friends of that family. A Jew having business or more personal dealings with some member of the Medici family could well have asked the artist to incorporate this emblem in the decoration of the manuscript. However, it is worth noticing that among the manuscripts of the Florentine group that we have discussed, the Yale manuscript, which was copied for a Jew, as attested by the scribe's colophon (fol. 187v), shows not the least restraint in the use of the most fashionable decoration. And of the other three, only the Rheims manuscript, the one with the Medici emblem, offers borders deprived of any nude putto. The unidentified coat of arms and the figure of God in the pictures of the Hamilton psalter leave open, for the moment, the problem of its commission and destination. In any case, the anti-Christian polemical stand of David Kimḥi's commentary on Psalms makes it an unlikely choice for a Christian humanist.

56. Parma, Biblioteca Palatina, Ms. Parm. 1739—De Rossi 561, fol. 2v. See De Rossi (*n. 2*), vol. II, p. 84, no. 561, who does not mention the illustration, and Tamani (*n. 11*), p. 112, no. 189, who, exceptionally, states its subject instead of simply describing it as "*figura umana.*"

We know of four other Italian representations of David that occur elsewhere than in psalters. One is in the form of a small figure with a gold halo playing the psaltery and is included in the initial-word panel of the Psalms in a late thirteenth-century copy of Rashi's commentary on the Bible (Florence, Biblioteca Medicea Laurenziana, Ms. Plut. 3.8, fol. 359v); on this manuscript see L. Mortara Ottolenghi, "Miniature ebraiche italiane," in *Italia Judaica, Atti del I Convegno internazionale Bari 18–22 maggio 1981* (Rome, 1983), pp. 214–16, who mentions most of the illustrations to the text but has overlooked the one for Psalms, which had already been mentioned in Metzger (*n. 7*), note 3, p. 538. The second shows a bust of David playing the psaltery and is in the central medallion in the lower floral border of the initial page of a *siddur* (Vatican, Biblioteca Apostolica Vaticana, cod. vat. ebr. 594, fol. 1r) to be dated ca. 1470 (see Mortara Ottolenghi's article, pp. 225–26 and fig. 28). The third, also showing a bust of David, with a

halo and playing the psaltery, and enclosed in a circular wreath, appears between Leviticus and Numeri in a Florentine copy of Naḥmanides' commentary on the Pentateuch (Manchester, John Rylands Library, Ryl. Hebr. MS. 8, fol. 173r), dating from about 1470–80 and illuminated by a Christian artist, probably Mariano del Buono. The fourth appears in the margin of a Passover *piyyuṭ* in an Italian-rite *maḥzor* that has not yet been fully studied (Paris, Bibliothèque nationale, ms. Smith–Lesouëf 250, fol. 129v), copied somewhat later than the period we intended to investigate here—in 1520—and decorated in the Mantuan style by different hands during two different periods, one shortly after the date of the copy and the other around 1569. The image of David belongs to this later stage in the decoration, and he appears not as the singer of God's glory but as "David rex," wearing the regalia—cloak, crown, and scepter. This *maḥzor* is mentioned in T. and M. Metzger (*n. 12*), addenda and corrigenda for pp. 298 and 312. See also C. Sirat, M. Beit-Arié, and M. Glatzer, *Manuscrits médiévaux en caractères hébraïques portant des indications de date jusqu'à 1540,* vol. III (Jerusalem/Paris, 1986), notice III, p. 69, and M. Metzger, "An Illuminated Jewish Prayer Book of the 16th Century, the Ms. Smith–Lesouëf 250 in the Bibliothèque Nationale (Paris)," in *Proceedings of the XXIIIrd International Congress for Asian and North African Studies*—Hamburg, 25th–30th August 1986, ed. A. Wezler and E. Hammerschmidt (Stuttgart, 1992), Section I, pp. 39–54, 16 figs.

57. It goes back to the oldest Greek psalters and was also used in Greek psalters written and illuminated in Italy; see my monograph on Ms. Parm. 1870—De Rossi 510 (*n. 1*), p. 161, n. 42.

58. See note 3.

HELEN ROSENAU (1900 − 84)

# The Architecture of the Synagogue in Neoclassicism and Historicism

THE AIM OF THIS CHAPTER is to present a brief survey of the changes that occurred in synagogue architecture in Europe in the late eighteenth and the nineteenth centuries and to demonstrate how the changed climate of opinion and the social position of the Jews influenced their patronage.[1] Obviously they usually had to employ Christian architects for the building of synagogues, the profession having been closed to Jews for many centuries.[2] At this time neoclassicism as a style was the medium of a small, educated Jewish minority who sought or had won emancipation, and historicism was favored by a more emancipated Jewry who possessed wealth and power and could look with hope and pride on their achievements.[3] They were ready to participate in the selection of more eclectic styles, fitting form to historical associations and contemporary function. Many of them were connected with finance and banking on a large and international scale.[4]

Germany had produced in Johann Joachim Winckelmann (1717−68) the most forceful proponent of neoclassicism, whilst Johann Gottfried von Herder (1744−1803) emphasized organic growth, the forerunner of romanticism. In the same period the Jews attained various degrees of emancipation and increased their wealth. It is against this background that synagogue architecture has to be understood. The initial and normative phase of neoclassicism, standing for a rational and serene imitation of antiquity, was followed by a movement that emphasized the historical past and the relationship between form and function; it therefore offered a wider choice of models. Historicism in architecture stood not simply for the correct imitation of a variety of past styles; it attempted rather to achieve a novel synthesis by emphasizing function and by bringing together unusual and sometimes striking combinations.

It is against this background that Jewish patronage of the arts developed, and the prevailing Jewish attitudes were frequently maintained with the help of non-Jewish

---

The editor records with sadness the death of Dr. Rosenau on October 27, 1984. Dr. Rosenau made a number of trips to the Oxford Centre after the 1977 conference, notably as a visiting scholar for Trinity Term 1978, and she became a valued and affectionate friend.

Dr. Rosenau gained a D.Phil. degree from Hamburg University in 1930 and a Ph.D. from London University in 1940. From 1951 to 1967 she held various appointments in the History of Art at Manchester University, becoming Reader in 1966. She was the author of numerous books on art and architecture.

**Fig. 4.1** *Jacob Abraham Abramson and Abraham Abramson, medal in honor of Moses Mendelssohn, mentioned in 1774.*

**Fig. 4.2** *Abraham Abramson, medal commemorating Jewish emancipation in Westphalia, 1808.*

artists. The contrast between neoclassicism and historicism is particularly clear in sculpture, as seen in the works of the Jewish medalists Jacob Abraham Abramson and his son Abraham Abramson, who adapted ancient symbols to contemporary life. An outstanding example of this adaptation is the medal dedicated to Moses Mendelssohn, which mentions his date of birth, 1729 (he died in 1786); on the obverse it shows his portrait, and on the reverse a skull surmounted by a butterfly, symbol of the soul and a reference to *Phaedon*, Mendelssohn's famous treatise on immortality (*Fig. 4.1*). An-

**Fig. 4.3** *Sir George Hayter and E. H. Baillie, testimonial for Sir Moses Montefiore, 1843 (Montefiore Endowment Committee; photo Victoria and Albert Museum).*

other example is a medal struck by the son in 1808 to commemorate Jewish emancipation in Westphalia. On the obverse the figure of the Synagogue is seen, her chains scattered on the ground, whilst on the reverse two winged figures embrace, iconographically based on Amor and Psyche but identified, respectively, as the Synagogue and the Church by the Tablets of the Law and the monogram of Christ that accompany them (*Fig. 4.2*). Enlightenment here seems to anticipate utopia, tolerance, and peace.[5]

By contrast, the monumental centerpiece presented to Sir Moses Montefiore (1784–1885) in 1843 was the work of two well-known Christian artists, Sir George Hayter and the sculptor Edward Hodges Baillie (*Fig. 4.3*).[6] The novel iconography was developed by Louis Loewe, Montefiore's secretary and companion, and places the events of Sir Moses's life in a historical context set against scenes of a symbolic nature.[7] An outstanding example is the scene (*Fig. 4.4*) of Moses Montefiore with his wife and retinue arriving in Alexandria. It shows the famous, so-called Column of Pompey in the background (in reality a memorial in honor of the Emperor Diocletian). Sir Moses in uniform is seen as a hero, based on the Napoleonic iconography developed by

**Fig. 4.4** *Sir George Hayter and E. H. Baillie, detail of testimonial (Montefiore Endowment Committee; photo Victoria and Albert Museum).*

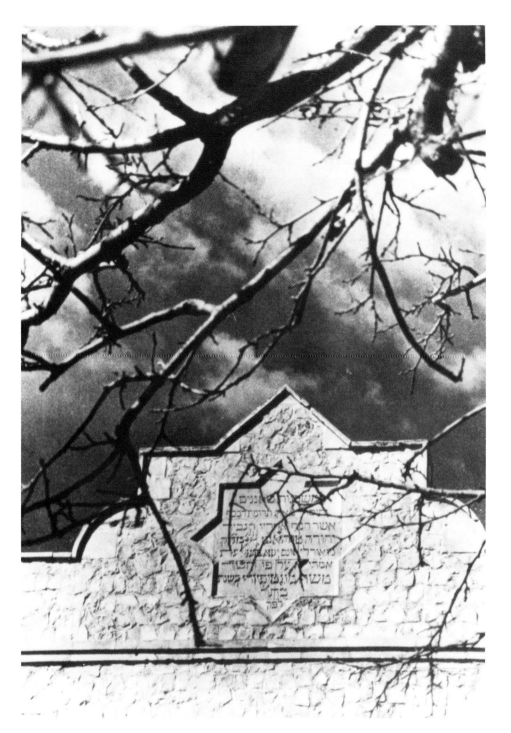

**Fig. 4.5** *Mishkenot Sha'ananim, detail of facade of original building (photo courtesy of Mishkenot Sha'ananim).*

Antoine-Jean Gros (1771–1835) and his contemporaries. Below, a panel shows animals fleeing in the opposite direction, thus holding the artistic balance.

It is interesting to note that although Sir Moses Montefiore expected there would be an undefined "Jewish Empire" at some time in the future, he did not suggest that Jews happy in their surroundings would wish to emigrate.[8] He avoided involvement

in public debate about the problems of a Jewish state (as did Moses Mendelssohn when an anonymous and secret plan was submitted to him in 1770).[9]

Moses Montefiore's famous windmill and the houses for impecunious but industrious inhabitants, Mishkenot Sha'ananim in Jerusalem, have together a picturesque quality. However, the 16 linear dwellings and two synagogues show a neoclassical regularity, and the eight-pointed star employed as a central motif—also found on other Jewish quarters in Jerusalem—emphasizes their symmetry (*Fig. 4.5*). This symmetry sets them apart from the physical arrangement of the other Jewish quarters in

*Fig. 4.6* Giuseppe Engel, bust of Alderman Sir David Salomons, Bart., MP, 1857 (photo Bodleian Library, Oxford).

**Fig. 4.7** *Stock Exchange, London (engraving) (from T. H. Shepherd,* London and Its Environs in the Nineteenth Century *[London, 1829], pl. 141).*

Jerusalem, which included squares, no doubt under the influence of the famous Venetian ghetto. When in 1875 Sir Moses voiced future plans for the erection of squares and crescents, he may well have been influenced not only by English reminiscences but also by the newly erected quarters.[10] The length of the Mishkenot, which differentiates it from similar English designs, is due to Sir Moses's desire to bring Ashkenazim and Sephardim together, literally, under one roof.

A later Anglo-Jewish example of the persistence of the neoclassical style is found in the bust of David Salomons, dated 1857, by the Jewish sculptor Giuseppe (Joseph) Engel, then resident in Rome (*Fig. 4.6*).[11] Here we may also remember in passing the neoclassical environment of the European Jews, expressed in both secular and religious buildings. An outstanding example is the Stock Exchange in London, built in 1801–2 by James(?) Peacock, a pupil of George Dance, with its impressive Tuscan columns and semicircular forecourt, a site familiar to the more opulent sections of British Jewry (*Fig. 4.7*).[12]

Let us turn now to the synagogue. In late antiquity most synagogue architecture expressed a sense of direction toward the Ark, the shrine of the Torah, and this sense was recaptured in synagogue architecture in medieval Spain and in the post-Renais-

sance period. In both cases the prototype of the Temple of Jerusalem, with its Holy of Holies, was not forgotten.[13] Exceptions to this generalization naturally exist, among them the Polish synagogues that had a centralizing focus and such non-Jewish whims as the synagogue in the Park of Wörlitz near Dessau, built by Duke Leopold Frederick Franz of Anhalt-Dessau for "his" Jews. The latter (*Fig. 4.8*) was a circular building by the architect Friedrich Wilhelm von Erdmannsdorff and was based on the so-called Temple of Vesta in Tivoli (*Fig. 4.9*). The substructure of the temple, in the form of a base with an entrance door, evokes an image of the opening to a cave.[14]

The exceptional Vienna Synagogue in the Seitenstettengasse, designed by Joseph Kornhäusel and dedicated in 1826, represents another type of design, an oval, necessitated by the exigencies of the narrow site. This synagogue is hemmed in by a variety

*Fig. 4.8* F. W. von Erdmannsdorff, Wörlitz synagogue.

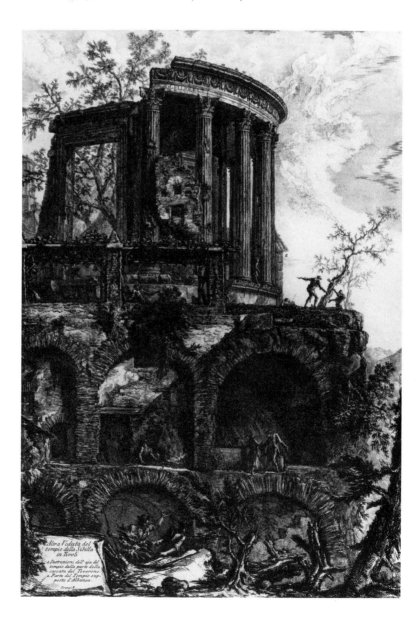

*Fig. 4.9* Temple of the Sybil, Tivoli, by Piranesi, 1761, etching (photo British Museum, Department of Prints and Drawings, H63).

**Fig. 4.10** *Jean-Jacques Le-
queu, design for synagogue,
signed Le Queu (photo Bib-
liothèque nationale, Paris).*

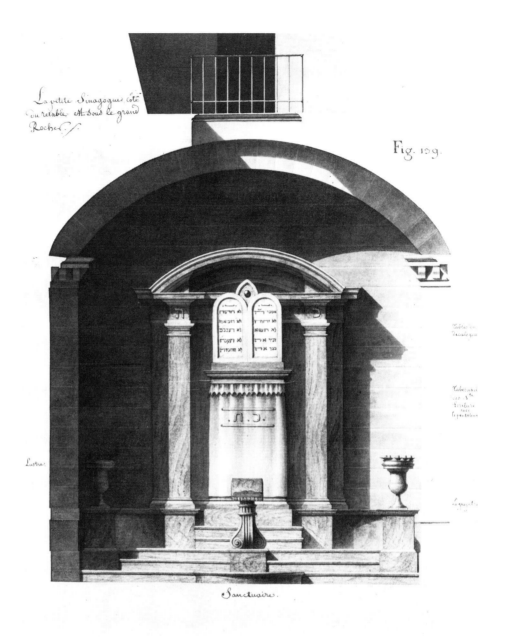

of dwellings, which saved it, like other synagogues in similar settings, from Nazi destruction.[15] Another unusual example is seen in a design by Jean-Jacques Lequeu (born 1757, died after 1824), who in his *Architecture Civile,* among a wide range of subjects of a religious, masonic, and sexual nature, drew a "buried synagogue." The drawing is now preserved in the Print Room of the Bibliothèque nationale in Paris (*Fig. 4.10*). This arrangement may be founded on the Jewish tradition, perhaps known to Lequeu, that requires a synagogue floor to have a level lower than the street in order to symbolize the verse "Out of the depths have I cried" (Psalm 130).

Having dealt with some exceptions, we now take up the main theme: synagogue architecture embodying a sense of direction. I will first mention a few neoclassical examples. The Great Synagogue in London, built in 1780 in the Adam style by the Christian architect James Spiller, was a noble building (*Figs. 4.11 and 4.12*); the sense of direction toward the Ark was immediate and pervasive. The synagogue was damaged by enemy action during World War II, left to decay further, and then demolished.[16] An outstanding example in this context is the Dusseldorf synagogue and precentor's house, designed in 1787–89 by Peter Joseph Krahe and completed by Peter Köhler (*Figs. 4.13 and 4.14*). The style was the most fashionable then available, that of C.-N. Ledoux, the great neoclassicist in Paris, who was the architect of the famous pre-Revolutionary toll houses, the *Propylées*. It will be remembered that observant Jews do not ride on Saturdays, which meant that Jewish dwellings were habitually clustered near the synagogues, thus pioneering compact planning. Another important German example is the synagogue of 1798 in Karlsruhe by Friedrich Weinbrenner,

*Fig. 4.12* Detail of the Great Synagogue, London, before destruction (photo by the author).

*Fig. 4.11* The Great Synagogue, London (from T. Rowlandson and A.-C. Pugin, The Microcosm of London, vol. 3 [London, 1809], facing p. 161).

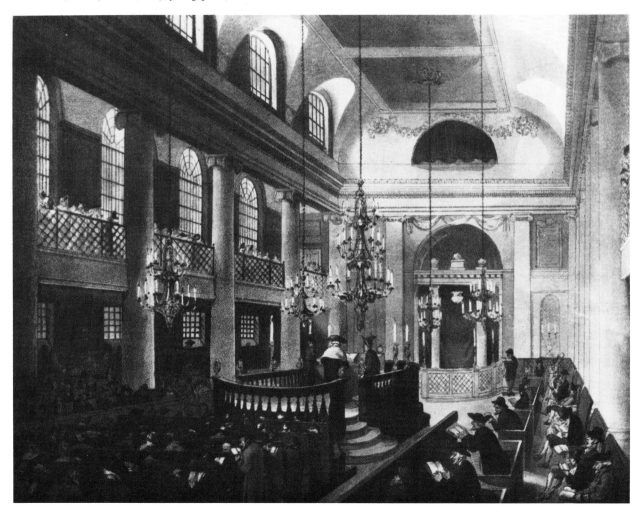

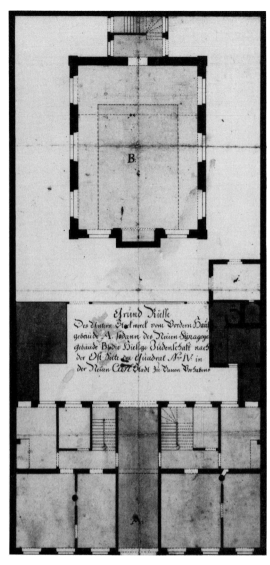

**Fig. 4.13** *P. Köhler, ground plan of the "new syna-gogue," Dusseldorf (1790), signed Peter Köhler (photo courtesy of Stadtmuseum, Dusseldorf, Inv. No. C 6558).*

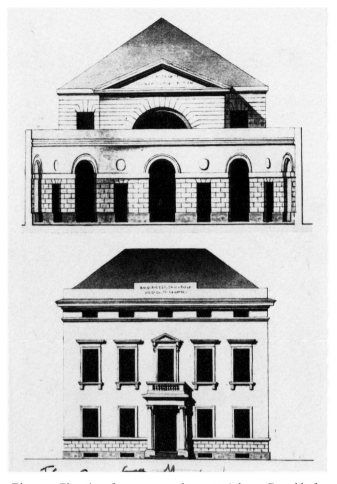

**Fig. 4.14** *Elevation of synagogue and precentor's house, Dusseldorf, signed Peter Krahe (from H. Rosenau,* Vision of the Temple *[1979]).*

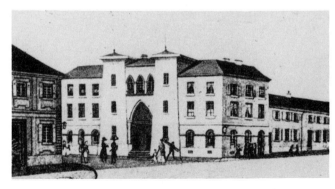

**Fig. 4.15** *Anonymous print after P. Wagner, elevation of synagogue, Karlsruhe.*

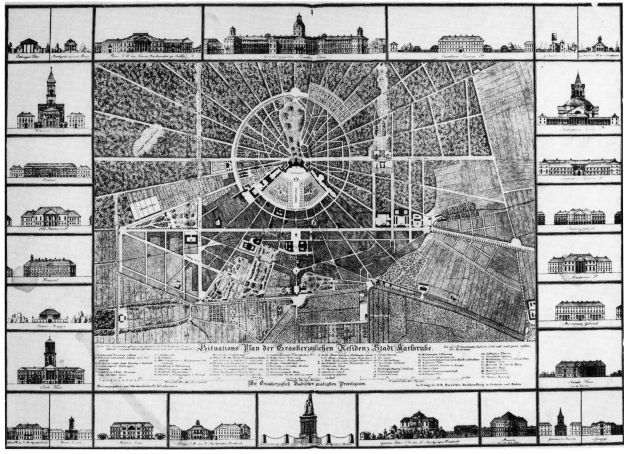

*Fig. 4.16* F. Weinbrenner, plan for Karlsruhe.

which exhibits certain Egyptian elements (*Fig. 4.15*). In this period, when a wider type of historicism was slowly developing from neoclassicism, heated discussions were taking place over whether "Egyptian-style" structures were suitable for synagogues in light of the fact that Jewish experiences in Egypt had been unfortunate in the past and, furthermore, because the Jewish Temple had stood not there but in Jerusalem. The Karlsruhe synagogue formed part of Weinbrenner's city development of 1822, and it is remarkable that it was an integrated element within it (*Fig. 4.16*).[17]

Although Paris was the center of neoclassicism, the impact of this style on Jews took place rather later. The basilical synagogue of the Rue Notre-Dame-de-Nazareth—completed in 1822—was built by P. J. Sandrié and Jacob Silveyra (*Fig. 4.17*). The latter was born in Bordeaux and was probably a Sephardi.

It was in Bordeaux itself that a "temple" synagogue of high artistic quality was begun in 1812 by Arnaud Corcelles, who was also the architect of a number of churches there, among them a Protestant "temple" with a Doric facade. This Bordeaux synagogue, now destroyed, was hemmed in by houses but bravely presented its facade to the street. The accuracy of the external view of Corcelles's synagogue shown in *Fig. 4.18* is confirmed by many other illustrations as well as by the description in the book by Auguste Bordes, a well-known Bordeaux artist. But in the interior view

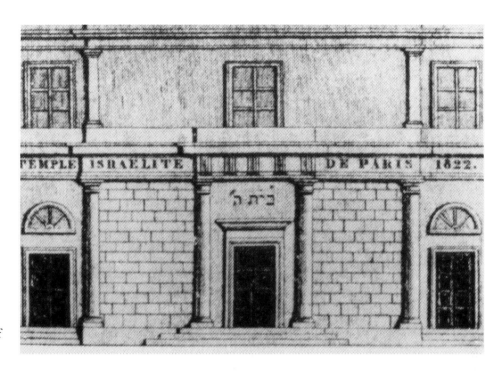

*Fig. 4.17* (above) P. J. San-
drié and Jacob Silveyra,
Temple facade, Rue Notre-
Dame-de-Nazareth, Paris
(anonymous drawing) (from
H. Rosenau, The Vision of
the Temple [1979]).

*Fig. 4.18* (below left) Old
synagogue, rue Causserouge,
Bordeaux, water color by
A. Bordes (photo courtesy of
Archives municipales de Bor-
deaux, V-DD/6, rec. 128).

*Fig. 4.19* (below right) Inte-
rior of synagogue, Bordeaux
(from H. Rosenau, Vision of
the Temple [1979])

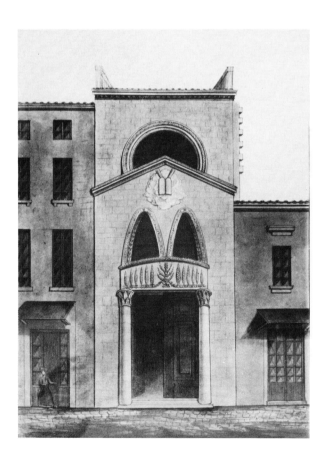

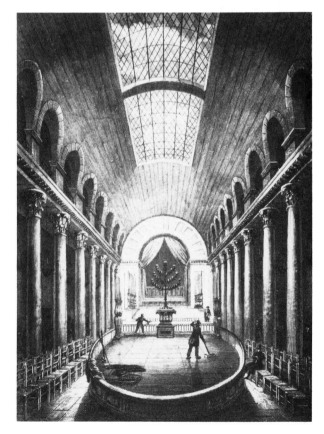

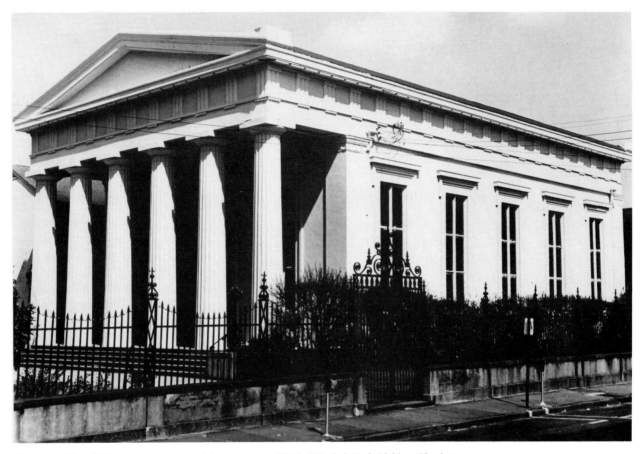

***Fig. 4.20*** *View of Charleston synagogue (photo courtesy of Kahal Kadosh Beth Elohim, Charleston, South Carolina).*

(*Fig. 4.19*) it is clear that the engraver's fantasy had taken over. The synagogue was made to look churchlike, and, for instance, chairs were substituted for benches and the appearance of the curtains of the Ark was changed. The synagogue was destroyed by fire in 1873[18] and rebuilt by P. Ch. Durand in 1882 on a different site.

The height of neoclassicism is reflected in the synagogues of Obuda, Budapest, of 1820–21, and Charleston, South Carolina, of 1841, the former showing a Corinthian, the latter a Doric, facade (*Fig. 4.20*). They are the works, respectively, of Andreas Landesherr and of C. L. Warner in collaboration with David Lopez.[19] David Lopez, like Jacob Silveyra, was probably a Sephardi Jew.

As neoclassicism reflected the Enlightenment, so the adaptation of Byzantine, Romanesque, and Moorish styles characterized nineteenth-century historicism. It should not be forgotten that Zacharias Frankel was the rabbi of the Dresden community that in 1838 commissioned the great German architect Gottfried Semper (1803–79) to erect a new synagogue in Dresden near the Elbe in a fashionable quarter outside the old city (*Fig. 4.21*).[20] It was completed in 1840 but was later destroyed by the Nazis. The building, which evoked oriental visions, made history with its central tower and twin side towers; it became the prototype for synagogue building for almost a century and

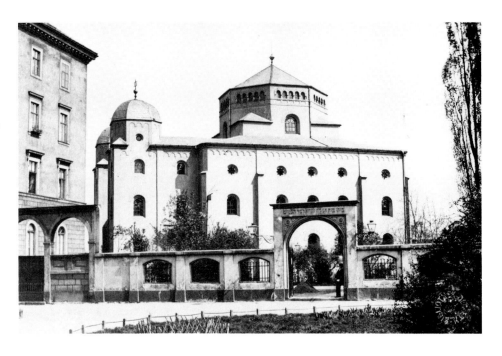

*Fig. 4.21 Synagogue Dresden (destroyed) by G. Semper; photograph of the building from the south (photo courtesy of Semper-Archiv—Institut für Geschichte und Theorie der Architektur (gta) —ETH Zurich 20-060-F-2).*

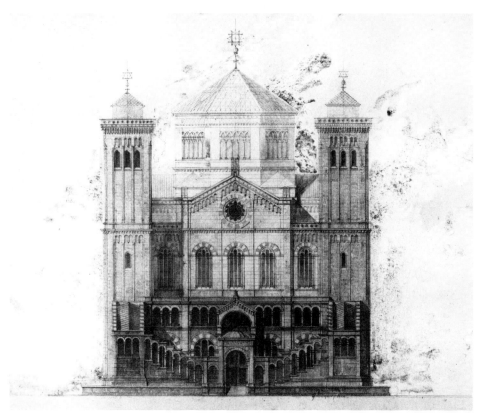

*Fig. 4.22 Design for west front of Paris synagogue by G. Semper (photo Sächsische Landesbibliothek, Abt. Deutsche Fotothek/Ludwig, no. 128 503).*

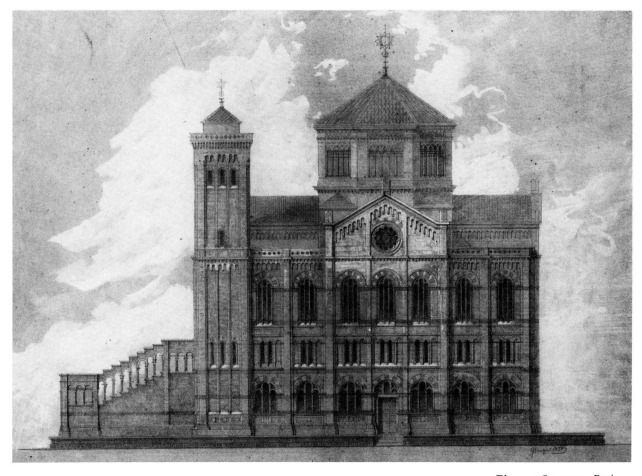

*Fig. 4.23 Synagogue Paris, elevation, signed by G. Semper (photo courtesy of Semper-Archiv—Institut für Geschichte und Theorie der Architektur (gta)—ETH Zurich 20-099-3).*

contributed to its architect's fame. As in the earlier case of Weinbrenner, who built a wooden structure, Semper had to be content with the erection of a timber ceiling, as the small Jewish congregations were still comparatively poor.

Semper, a revolutionary, had to leave Dresden in 1840, and in 1850 he tried to interest the Paris Rothschilds in commissioning the rebuilding of the synagogue in the Rue Notre-Dame-de-Nazareth but without success. Their refusal is all the more tragic because Semper's designs (*Figs. 4.22 and 4.23*) were of outstanding quality. His designs for the Dresden synagogue included the fittings, and he was, in fact, the creator of a resuscitated type of medieval *Gesamtkunstwerk* for his Jewish patrons long before Richard Wagner coined the phrase.[21]

It is in this period that Jewish architects, who had previously been deprived of any type of training in architecture, made their first, hesitant entry into the Western world. In England George Basevi (1794–1845), a convert to Christianity, and David Mocatta (1806–82) were pupils of Sir John Soane, probably the best-known English architect of his time. Mocatta was the architect of Sir Moses Montefiore's synagogue in Ramsgate in 1833 (*Fig. 4.24*) and was possibly also connected with the New Synagogue in London of 1839. He was certainly consulted about and had been on the committee for the erection of the West London Synagogue in 1866, but his chief architectural

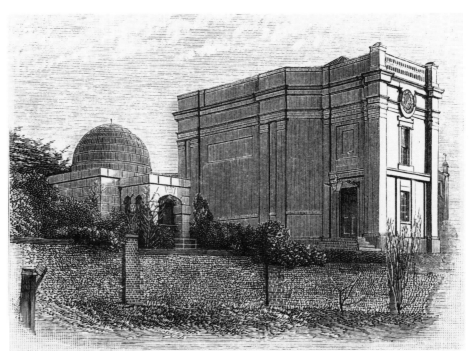

***Fig. 4.24*** *Moses Montefiore's synagogue and mausoleum in Ramsgate (engraving) (photo Bodleian Library, Oxford).*

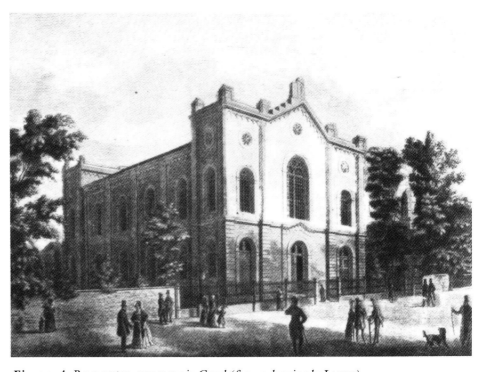

***Fig. 4.25*** *A. Rosengarten, synagogue in Cassel (from a drawing by Loower).*

interest was with railway stations, which he pioneered. However, he effectively retired from architectural activities in order to devote himself to communal affairs.[22]

A. Rosengarten (1809–93) in Germany was perhaps the most outstanding of the nineteenth-century Jewish architects. He was also a writer and thinker and published a book in Brunswick in 1857 entitled *Die Architektonischen Stylarten,* which, with the section on the modern period enlarged, appeared in London in 1876 under the English title *A Handbook of Architectural Styles.* He disclaimed the importance of Egyptian elements in the Temple of Solomon, which to him was more an example of Phoenician art. He also felt that the Moorish style was inappropriate for synagogues, but he tolerated the Byzantine and the Romanesque. Basically, his attitude toward religion and culture was universalistic, doubting as he did the possibility of a German national art due to improved communications between all countries and civilizations. In spite of his undoubted gifts he remained an assistant to the *Oberlandbaumeister* August Schuchardt when building the Cassell synagogue, which was dedicated in 1839. An austere building in a hesitant Romanesque style without a dome, it showed women's galleries, rounded arches, and roundel windows. If one compares the Cassel synagogue (*Fig. 4.25*) with Rosengarten's Hamburg synagogue of 1856–59 in the Kohlhöfen (*Figs. 4.26 and 4.27*), the influence of Semper on the latter is clearly apparent in the external dome and Romanesque arches.[23]

To return to England—no more outstanding example of historicism can be imagined than the mausoleum for Judith Montefiore erected in Ramsgate after her death in 1862 (see *Fig. 4.24*). The mausoleum evokes the so-called Tomb of Rachel near

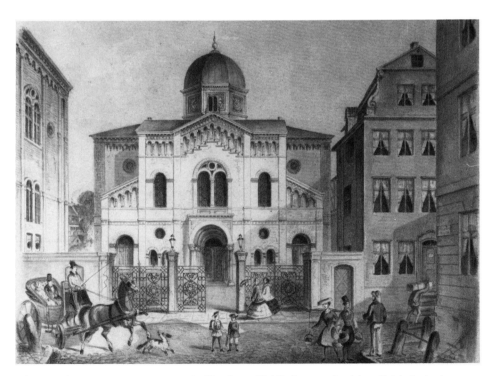

***Fig. 4.26*** *A. Rosengarten, synagogue in Hamburg, Kohlhöfen, exterior (photo Erich Andres).*

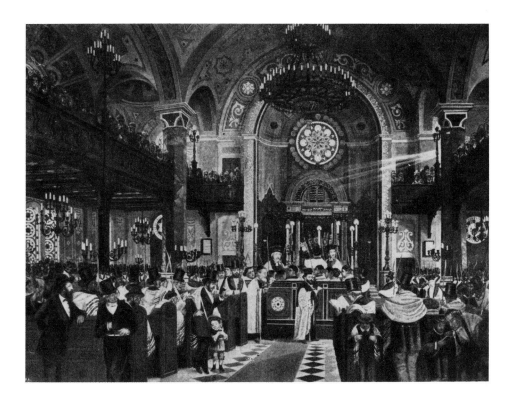

Bethlehem, which Judith wished to restore in 1839, a task completed and paid for by Moses Montefiore in 1841.[24]

A late phase of this development is seen in the St. Petersburg old synagogue, completed (according to the *Encyclopaedia Judaica*) in 1893 (*Figs. 4.28 and 4.29*). It was designed by Professor Shaposhnikov and built by L. Bakhman, the first Jew to be enrolled in the St. Petersburg Academy of Arts. Few other historical details about the building of the St. Petersburg synagogue are available, but stylistically a synthesis of Semper's influence, the Moorish, and the vernacular is apparent. The small dome here may perhaps be explained by the difficulties encountered by the Moscow congregation, who in 1891 were forced by the Russian authorities to remove the dome of their synagogue, probably because it might otherwise have suggested the appearance of a church.[25]

The evolution of synagogue architecture sketched in this chapter was based first on the Jews' struggle for emancipation and later on Jewish achievements in international finance and philanthropy. Recognition moved from small intellectual circles, as in the case of Moses Mendelssohn, to the wider fame acquired by Sir Moses Montefiore.

Classicism and historicism as artistic forms were superseded in the twentieth century by art nouveau and the so-called international style, which swept the Western world. Function was redefined in an austere and rational manner, whilst the Bauhaus rediscovered the necessary integration of arts and crafts.[26] In this evolution Jews played a significant part, looking forward rather than backward. When the ancient Temple architecture of Jerusalem was remembered, it was appreciated not so much as an architectural form but as a universal symbol.

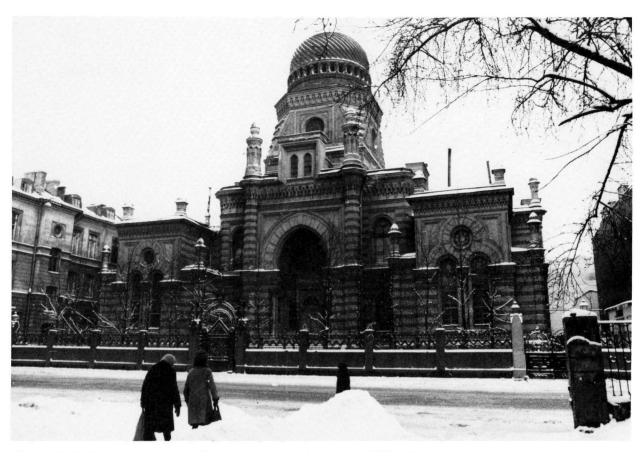

*Fig. 4.28*  L. Bakhman, synagogue in St. Petersburg, exterior (photo courtesy of Elliott Myers).

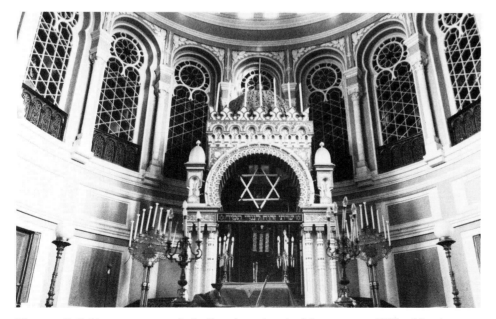

*Fig. 4.29*  L. Bakhman, synagogue in St. Petersburg, interior (photo courtesy of Elliott Myers).

# Acknowledgments

I wish to take this opportunity to record my thanks to Dr. David Patterson and the community of scholars at Yarnton Manor for their advice and cooperation and to Mr. John Cooper, Mr. J. P. Fuller, Mr. Peter Slater, Mr. K. E. Wilson, and the staffs of the Bibliothèque nationale, the Bodleian Library, the Bordeaux Archives, the British Library, and the Royal Institute of British Architects, as well as of the Wiener Library. Last, I want to thank the mayor of Jerusalem, Teddy Kollek, for his hospitality at Mishkenot Sha'ananim, which enabled me to study that and other historical sites.

## *Notes*

1. On the history of synagogues see R. Wischnitzer, *The Architecture of the European Synagogue* (Philadelphia, 1964); H. Hammer-Schenk, *Untersuchungen zum Synagogenbau in Deutschland von der ersten Emanzipation bis zur gesetzlichen Gleichberechtigung der Juden (1800–1871)*, Tübingen dissertation (Bamberg, 1974); H. Rosenau, "German Synagogues in the Early Period of Emancipation," *Leo Baeck Institute Year Book* VIII (London, 1963), pp. 214–25, and "Gottfried Semper and German Synagogue Architecture," *Leo Baeck Institute Year Book* XXII (London, 1977), pp. 237–44. Also see R. Wischnitzer, *Synagogue Architecture in the United States* (Philadelphia, 1955), and H. Rosenau, *A Short History of Jewish Art* (London, 1948).

2. M. Wischnitzer, *A History of Jewish Crafts and Guilds* (New York, 1965).

3. For an attitude toward historicism in art see L. Grote (ed.), *Historismus und Bildende Kunst* (Munich, 1965). We do not share Professor Nikolaus Pevsner's view (in Grote, pp. 27 and 116), which stresses the noncreative side of historic imitation. Professor K. R. Popper's definition of the poverty of historicism in his book *The Poverty of Historicism*, 2nd ed. (London, 1960), cannot be applied to art history.

4. On the landed gentry in England see F.M.L. Thompson, *English Landed Society in the Nineteenth Century* (London/Toronto, 1969).

5. T. Hoffman, *Jakob Abraham und Abraham Abramson* (Frankfurt, 1927); J. J. Spiess, *Brandenburgische Historische Münzbelustigungen* (Arsbach, 1768–74); A. Rubens, *A Jewish Iconography* (London, 1954). On Mendelssohn see A. Altmann, *Moses Mendelssohn: A Biographical Study* (London, 1973).

6. J. Culme, *English Nineteenth Century Silver* (London, 1977), p. 119. Also H. Rosenau, "Sir Moses Montefiore and the Visual Arts," *Journal of Jewish Studies* XXX, no. 2 (1979), pp. 233–44.

7. L. Wolf, *Sir Moses Montefiore: A Centennial Biography* (London, 1884); L. Loewe, *Diaries of Sir Moses and Lady Montefiore*, vol. II (London/Sydney, 1890), p. 182; D.A.J. Cardozo and P. Goodman, *Think and Thank: The Montefiore Synagogue and College, Ramsgate, 1833–1933* (London, 1933), passim. It is interesting to note that Sir Moses, although quite well off, was not rich when measured against outstandingly wealthy people like the Rothschilds, who could think in millions where Montefiore thought in thousands. We know from his will, published by Loewe, that his fortune consisted of about £25,000 in stocks and shares, to which should be added his house (Loewe, vol. II, pp. 349–50). On the Rothschilds see, for example, the perhaps slightly anti-Semitic but factually accurate booklet by H. Schnee, *Rothschild* (Göttingen, 1961), p. 54, on Nathan's legacies to his seven children. Nathan died on August 8, 1836, and the Rothschilds became even richer in the second part of the nineteenth century. See also R. Ehrenberg, *Grosse Vermögen, Ihre Entstehung und Ihre Bedeutung*, 2nd ed. (Jena, 1905), p. 42 ff.

8. Wolf (*n. 7*), p. 276.

9. This plan, usually attributed to the Count of Lynar, must have been of a utopian nature, as is clear from Mendelssohn's reply. There is no evidence to prove that the Count of Lynar was the author of the plan. In 1775, he was on friendly terms with Mendelssohn, and it seems most unlikely that the secretive author would have wished to renew a contact that might have exposed him as the author of the abortive plan. It is more likely that the anonymous author indeed succeeded in remaining anonymous, although no doubt the rather fruitless search for the author will continue. See Altmann (*n. 5*), pp. 424–26, quoting B. and B. Strauss in *Occident and Orient: Being Studies . . . in Honour of Haham Dr M. Gaster's 80th Birthday*, ed. B. Schindler

and A. Marmorstein (London, 1936), pp. 518–25. Count Rochus Friedrich of Lynar was born in 1708; he was, therefore, not a young man when Mendelssohn received the memorandum in January 1770. The correspondent, as we know from Mendelssohn's reply, had demanded utmost secrecy and had promised to accept Mendelssohn's judgment if the latter regarded the project as foolish or impossible to execute. This sounds rather more like a younger admirer writing to an older man and is in flat contradiction to the friendly relations Lynar started with Mendelssohn in 1775. Furthermore, the interpretation by the Strausses of the sentence in the anonymous author's letter as preferring the public good to private aims and willing to make sacrifices is far too general to single out Lynar, who had experienced difficulties of a financial nature that had caused his downfall in about 1750. These mistakes he freely acknowledged, but this can in no manner be described as making sacrifices. Furthermore, Lynar was a fairly prolific writer, and nothing in his writings, which are mostly political, shows any particular interest in Jews in general or Jewish statehood in particular. See *Des Weiland Grafen R. F. zu Lynar . . . Hinterlassene Staatsschriften und andere Aufsütze* (Hamburg, 1793–97).

10. Wolf (*n. 7*), p. 267; Loewe (*n. 7*), vol. II, p. 281. On the Venetian ghetto see D. Cassuto in *Journal of Jewish Art* III and IV (1977), pp. 40–43.

11. Malcolm D. Brown, *David Salomons House: Catalogue of Mementos* (privately printed, 1968), passim; A. M. Hyamson, *The Sephardim of England . . . 1492–1951* (London, 1951), p. 264 and passim.

12. J. Summerson, *Georgian London*, revised ed. (Harmondsworth, Middlesex, and others, 1962), p. 267.

13. H. Rosenau, *Vision of the Temple: The Image of the Temple in Jerusalem in Judaism and Christianity* (London, 1979).

14. H. Rosenau, *Leo Baeck Institute Year Book* VIII (1963), pp. 214–25.

15. E. Jamilly, "The Architecture of the Contemporary Synagogue," in *Jewish Art*, ed. C. Roth (London, 1961), pp. 756–95. Also see R. Wischnitzer, *European Synagogue* (*n. 1*), p. 178 ff.; Hammer-Schenk (*n. 1*), passim, emphasizing perhaps overmuch the assimilationist tendencies; and D. Philipson, *The Reform Movement in Judaism*, revised ed. (New York, 1967), on changes in religious practice.

16. Rosenau, *Jewish Art* (*n. 1*), pp. 38–43.

17. Rosenau (*n. 14*); R. Dorn, *Johann Peter Krahe, Leben und Werke* (Jena, 1969–71); W. Schirmer and others, *F. Weinbrenner 1766–1826* (Karlsruhe, 1978).

18. E. Brault, *Les Architectes par leurs Oeuvres*, vol. III (Paris, 1893), passim; A. Bordes, *Histoire des Monuments Anciens et Modernes de la Ville de Bordeaux* (Bordeaux, 1845); *Histoire de Bordeaux* (general editor, Ch. Higounet), vols. V and VI (1968 and 1969), passim.

19. Rosenau (*n. 13*), p. 139. The Budapest synagogue is reproduced in Wischnitzer, *European Synagogue* (*n. 1*), p. 180, and Jamilly (*n. 15*), p. 762.

20. Rosenau, *Leo Baeck Institute Year Book* XXII (*n. 1*), pp. 237–39.

21. Ibid., pp. 243–44. The reply by Semper in the letter of March 21, 1850, is addressed to the architect Wilhelm Heine (a relative, Dr. W. Herrmann has suggested, of the poet Heinrich Heine, thus adding another example to the list of Semper's numerous Jewish connections).

22. A. S. Diamond, *The Building of a Synagogue* (London, 1970).

23. Rosengarten's first name was most probably Albert, the name given in local records (R. Hallo, *Geschichte der Jüdischen Gemünde Kassel* [Cassel, 1931], passim; S. Wininger, *Grosse Jüdische National-Biographie* V [1930–31], p. 242) as well as in the British Museum catalog. Thieme-Becker's *Allgemeines Lexikon der Bildenden Künstler* is followed by R. Wischnitzer, who mentions Albrecht, for Jews a less popular name. See Hammer-Schenk (*n. 1*), note 228.

24. Cardozo and Goodman (*n. 7*), p. 52; Z. Vilnay, *The Holy Land in Old Prints and Maps* (Jerusalem, 1963)—see p. 70 for Rachel's tomb.

25. L. Greenberg, *The Jews in Russia* (New Haven and others, 1951), vol. II, p. 45; Wischnitzer, *European Synagogue* (*n. 1*), p. 208. The information on St. Petersburg was kindly supplied by Dr. H. Shukman of St. Antony's College, Oxford. See *Yevreiskaya Entsiklopediya* (St. Petersburg, after 1900), passim.

26. H. M. Wingler, *Das Bauhaus 1919–33 Weimar, Dessau, Berlin, und die Nachfolge in Chicago seit 1937*, 2nd ed. (Bramsche, 1968).

ALFRED MOLDOVAN

# Foolishness, Fakes, and Forgeries in Jewish Art

## An Introduction to the Discussion on Judaica Conservation and Collecting Today

In 1967 the late Cecil Roth of blessed memory wrote an article entitled "*Caveat Emptor Judaeus.*"[1] I feel it is fitting that Dr. Roth's stern warning be sounded again at the close of the first international conference devoted to the subject of Jewish art, and it is appropriate that this warning should emanate from the halls of Oxford where he was for so many decades a student and a teacher.

In the years since Dr. Roth's warning to the Jewish world about the proliferation of fraudulent Judaica there has been a remarkable growth of interest in the collecting of Judaica. The establishment of museums, large and small, throughout the world attests to the growing interest in this field. One has but to look at the numerous publications and catalogs of collections that have been issued in the past few years. Attendances at the many auctions held throughout the world and the sometimes staggering prices paid for these Jewish objects also attest to the continuing growth of interest in collecting Judaica.

In considering fakes and forgeries, I am not going to insult the intelligence of my audience by discussing some of the most obvious examples being foisted on a gullible public: the numerous *yads* made from lorgnette and parasol handles, the saints' crowns converted into Torah crowns, and the sugar bowls made into *etrog* boxes. The examples can go on forever. Nor am I going to deal with the very obvious fact, with which we are all familiar, that no silver objects of a Jewish ritual nature from before the Spanish Expulsion exist anywhere in the world except for a pair of *rimonim* in the cathedral treasury of Palma de Mallorca.[2] The so-called astrolabes inscribed with Hebrew lettering that purport to be of Jewish origin and use are the most common of these pre-Expulsion frauds. The object in *Fig. 5.1*, for example, was included in a major exhibition in Europe in 1972 and was described in the catalog as an eighteenth-century astrolabe, as follows,

> *Messing, 18. Jahrh. zur Berechnung der Feiertage nach dem Mondjahr, mit hebr. Ziffern, Durchmesser 8 cm.*[3]
>
> [Brass, 18th century, for calculating festivals according to the lunar year, with Hebrew numerals, diameter 8 cm.]

 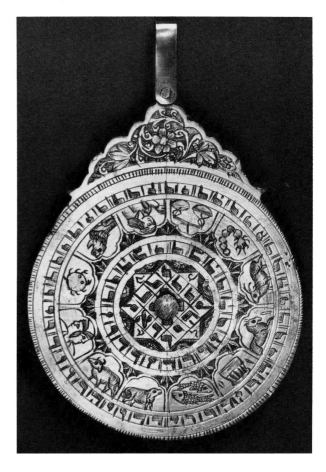

*Fig. 5.1 (photos courtesy Berlin Museum/Jewish Museum, Berlin).*

Dr. Roth, in his 1967 article, stated that he had never come across such an object. Today, to my knowledge, only three authentic Hebrew astrolabes are known—one can be found in the British Museum in London (*Fig. 5.2*),[4] one in the Chicago Planetarium, and the third in a private collection. Comparison of the object in *Fig. 5.1* with an authentic astrolabe shows that there is no similarity in construction, engraving, or style. Yet astrolabes are being sold all over the world and are displayed at exhibitions and auction galleries as being of Jewish origin and Jewish use.

I have entitled this chapter "Foolishness, Fakes, and Forgeries in Jewish Art." Before we can discuss these issues, however, we must define these terms a little more scientifically. Let us first consider what we mean by foolishness. If one were to ascribe an object improperly as being of Jewish ritual usage, and if the attribution were made in error or through ignorance, no great harm would be done once the error was discovered and the object properly reclassified and removed from the corpus of Jewish ritual objects so that it no longer remained as part of our tradition. Certainly, legitimate errors can be made. *Fig. 5.3* shows an object that appeared in a catalog published in 1908 by the Smithsonian Institution,[5] to which it was then on loan (it was withdrawn in 1924) from the Judaica collection of Hadji Ephraim Benguiat, a great authority in the world of art. The object is described in the catalog as an Indian spice box, as follows,

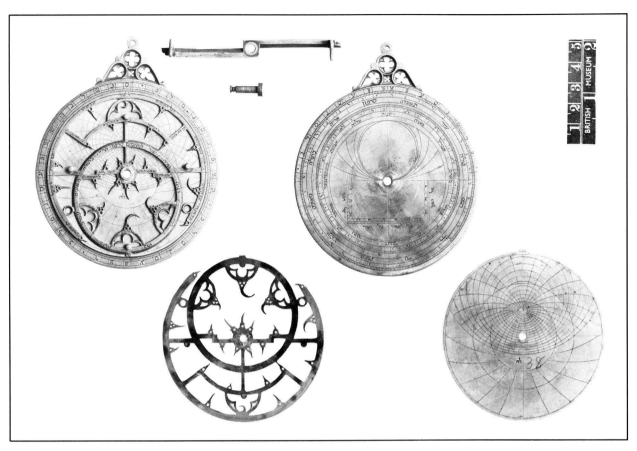

**Fig. 5.2** *Astrolabe, Spanish-Moorish, ca. 1350. Gilt brass, probably Toledo work (photo Trustees of the British Museum).*

**Fig. 5.3** *(photo courtesy of the author).*

Spice box. Made of brass in five pear-shaped compartments resting on five legs. The cover of each compartment is surmounted by a lion, while in the center stands a peacock. Measurements 5 × 4 1/2 inches.

*Fig. 5.4* shows another such object, also called an Indian spice box, which was described as

> "Hadas" for spices. India(?), 18th century.
>
> Bronze, cast and carved. Box in the form of a flower of five petals, which function as lids, on each of which there is a peacock. In the centre a large erect peacock with spreading tail. When turned the peacock secures all the lids.[6]

It also comes from a very famous collection, is well documented, well cataloged, and prominently displayed in a major museum. With this kind of imprimatur it is not surprising that I have seen two more such objects offered at auctions in the United States, similarly described as Indian spice boxes and bringing fair prices.

In order to understand this particular type of misattribution we must first ask ourselves, what is an Indian spice box? The Jewish ritual of India is patterned on the Iraqi *minhag*. In the authoritative study of the history of the Jews in Baghdad by David Sassoon, we read, "At the end of the sabbath, the shamas distributed to each member of the congregation 'Hadas' [myrtle] for the Havdalah."[7] Nowhere is there any reference to a spice box in this form of the ritual. How, then, is it that this object was described as an Indian spice box as far back as 1908? I cannot answer for Hadji Benguiat: I can merely paraphrase my mother, who stated in her simple Yiddish, "*Der*

**Fig. 5.4** *'Hadas' for spices, India (?), nineteenth century (The Israel Museum, Feuchtwanger collection, item no. 283, purchased and donated to the Museum by Baruch and Ruth Rappaport, Geneva; photo Israel Museum, Jerusalem).*

*Fig. 5.5 (Moldovan Family collection).*

*kligster mentsh ken zikh banarishn*" (Even the wisest man sometimes makes a fool of himself). *Fig. 5.5* is of an object in my possession. I purchased it in an Indian store in New York for six dollars. It is called a *tikka* box, and it is the box that holds the various shades of vermilion paste or powder used by married women in India to make the *tikka,* or spot, on their foreheads. I do not think there can be any question but that this and the two objects just described are of the same kind.

Again in the context of improper or erroneous attributions, the filigree stag in *Fig. 5.6* was described as a nineteenth-century (?)Polish silver filigree spice container in the form of a stag. This object is in the possession of a major museum in the United States, and a similar one, also described as an east European filigree spice box of stag form, is on display at another museum nearby. *Fig. 5.7* shows a similar item described in an auction catalog as an "Austrian eighteenth century filigree silver stag-form spice box."[8] But compare *Fig. 5.8*, an item from a 1968 exhibition of three centuries of Peruvian silver sponsored by the Smithsonian Institution and the New York Metropolitan Museum of Art.[9] I do not think it requires too much analysis to see the similarity in filigree work and total design between this cock and the stags in *Figs. 5.6 and 5.7*. In another illustration (*Fig. 5.9*) from a book on Peruvian silver[10] the similarities in design are again evident. Certainly no Jewish spice boxes were made in Peru, so what are these objects? These are Peruvian incense burners used by Peruvian Catholics for their religious services, and they were never intended as spice boxes for the Havdalah ceremony.

*Fig. 5.6* (above left) (photo Photographic Archives, National Gallery of Art, Washington, D.C.; © 1967, Sotheby's, Inc.).

*Fig. 5.7* (above right) (photo Photographic Archives, National Gallery of Art, Washington, D.C.; © 1967, Sotheby's, Inc.).

*Fig. 5.8* (below right) (photo courtesy of the author).

I am sure we have all seen these or similar animals and objects labeled as Jewish spice boxes. Misattributions will continue, and such objects will continue to be purchased by unsuspecting Judaica collectors until the imprimatur of authenticity is removed by deaccessioning them from museum collections and no longer displaying them as objects of Jewish ritual silver.

I would now like to move on to another area, which I have entitled "Fakery in Jewish Art." Fakes are not foolish errors but are deliberate attempts to create objects that never existed or to imitate objects that might have existed. I do not consider them totally venal, but I think one should be on guard against them.

*Fig. 5.10*, for example, is a North-African *tallit* bag of standard design made of pierced and engraved silver on a red velvet background.[11] *Fig. 5.11* is an object described in the catalog as a silver Ḥanukkah lamp from North Africa, nineteenth century. The description reads,

> the shaped back applied with engraved ajouré silver to a design of roundels containing foliated stars of David and the inscription, Solomon bar Abraham Ibn Ezra; matching base and sides with tray of compartmented oil troughs. Height 12 3/4 inches.[12]

Note carefully the silver in both of these objects. One can see immediately that every bit of silver on the so-called Ḥanukkah lamp comes from a North-African *tallit* bag. Everything has been rearranged, including cutting out and reversing the inscription so that it does not appear upside down. I do not put this object in the category of an out-and-out forgery made in North Africa: it was made for a Jew but it was not made originally as a Ḥanukkah lamp. Was the *tallit* bag taken apart and made into a Ḥanukkah lamp in North Africa, or was it taken apart and made into a lamp by some unscrupulous dealer elsewhere? I do not think we shall ever be able to solve this

*Fig. 5.9* *(photo courtesy of the author).*

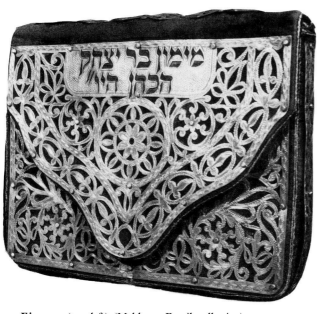

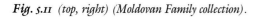

Fig. 5.10 *(top, left) (Moldovan Family collection).*

Fig. 5.11 *(top, right) (Moldovan Family collection).*

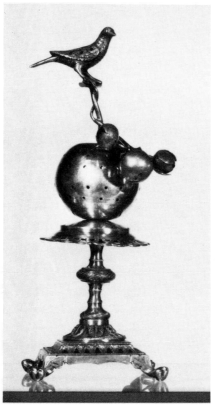

Fig. 5.12 *(bottom, left) (Moldovan Family collection; photo Photographic Archives, National Gallery of Art, Washington, D.C.).*

Fig. 5.13 *(bottom, right) (photo Photographic Archives, National Gallery of Art, Washington, D.C.; © 1967, Sotheby's, Inc.).*

problem, but it does illustrate that things are not always what they seem to be and that one should be very careful about objects that are not made of a piece.

*Fig. 5.12* is another such object, which I purchased in a famous auction, where it was described as a "French(?), nineteenth century Ajouré and parcel-gilded silver orb and bird spice container." The catalog describes it as,

> In the form of a pierced and gilded orb upon which a bird stands on a perch with a spray of fruit and flowers, supported by an *ajouré* canopy and knopped stem; on square base pierced with leaf tips on four paw feet. Height 7 1/2 inches.[13]

When I brought it home to share it with my family and proudly displayed my latest acquisition, my son, who was then barely ten years old, turned to me and asked, "But Daddy, where do the spices go?" Looking carefully at the object I noted to my chagrin that nowhere in this pierced and gilded orb was there a place or an opening in which spices could be put. This obviously was not a spice box because it could not hold anything. Then what was it? I learned very quickly that it was a toothpick holder, and I was soon to see many more such objects (see, for example, *Fig. 5.13*[14]) at other auctions and on display in various museums. The orbs in at least some of the toothpick holders had been cut in half and carefully fitted together again so that the error made with mine was not repeated. Nevertheless, these were toothpick holders and were never created as spice boxes. One could say that somewhere in Europe in the eighteenth and nineteenth centuries, Jews unable to afford custom-made spice boxes took toothpick holders and turned them into spice boxes. You may believe that. I frankly do not, and I suspect that many of these objects were turned into spice boxes merely to satisfy gullible purchasers.

It would take an entire, separate discussion to analyze properly what constitutes a valid inscription on a Jewish object. How can we ascertain whether an inscription was applied at the time of manufacture or added centuries later in order to enhance the value of an object? I would like, for the present, to deal with only one such pair of objects for which the inscriptions are suspect.

In *Fig. 5.14* we have an item described in an auction catalog as a "Wrought gilded silver stag-form Passover drinking vessel, Augsburg, XVIIth century." The description states that it is a

> well-modeled figure of a rearing stag with coral antlers and removable head forming a wine cup; an oval rustic base centring a coiled serpent flanked by two salamanders, the rim of the base inscribed, A memorial gift for Rabbi Zvi Halevi from the Congregation of Worms. Height 14 3/4 inches.[15]

At another auction five years earlier a similar object (*Fig. 5.15*) appeared that was labeled as a "Repoussé gilded silver cup in the form of a stag, Melchior Bayer, Augsburg, c. 1600" and was described as a

> vigorously modeled figure of a rearing stag the head serving as a cover; oval grassy base enlivened with snails, insects and chameleons. Height 14 1/2 inches.[16]

I would like to leave it to historians of German Jewry and students of Hebrew responsa literature to decide if a seventeenth-century German rabbi of a major city such as Worms would have used this kind of object as a kiddush cup. It seems almost inconceivable to me that such a cup would have been used ritually by any Jew of the

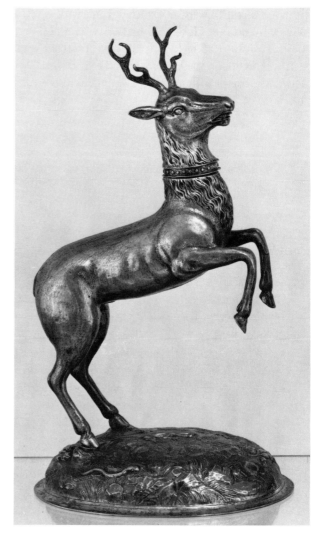

seventeenth century, much less a rabbi. A kiddush cup represents a very special ritual object in the Jewish household. It is usually chosen most carefully, and when given as a gift it is given most respectfully, in recognition of its sacred nature in a Jewish household. One would be very hard put to accept the appearance of animal-form kiddush cups or kiddush cups with any sort of unusual design, motif, ornamentation, figural representation, or the like.

I come now to what I consider to be one of the most blatant pieces of forgery in the entire field of Judaica collecting. *Fig. 5.16* is a photograph of four objects from a catalog of a major exhibition in the United States. The description in the catalog reads,

> Miniature set of ceremonial objects. Height 5 1/2, width 2 1/4 inches. These objects which when assembled appear to be an ordinary cup were probably used by the Marranos of Spain, Jews who outwardly were converted to Christianity but secretly practiced the Judaic rites.[17]

If this statement were not such a complete travesty of Jewish history it would be almost humorous. However, this cup and numerous others like it grace the collections of many unsuspecting Jews in the world today. A similar set (*Fig. 5.17*) was offered at a major auction in the United States. But this one, thank goodness, was dated around 1900 and was not described as of Marrano origin but was called a German silver Passover set, whatever that means. The catalog description continues as follows,

> Comprising cup and cover, cover incorporating incense box, the cup with Sabbath lamp base; one beaker inscribed "Why is this night different from all others," blessing over wine beaker and Hagadah safer scroll containing the Book of Esther. Each piece engraved with scrolling flowers and religious scenes, the sides mounted with gemstones and with gilt interior. Height of cup and cover 7 inches (18 cm).[18]

A similar cup is prominently displayed on an elaborate stand in the entrance to the main sanctuary of a large synagogue in a major city of the United States. It bears a long and careful description, again mentioning the Marrano nature of the cup. If these objects continue to appear in the catalogs of exhibitions sponsored by Jewish organizations, how are unsuspecting collectors to know that they are being duped?

The last item I wish to discuss involves an interesting phenomenon, the display in a major exhibition by a major museum of a ritual object that had already been described as a forgery by a world-famous authority. In 1964, in the issue of the journal *Eretz Israel* dedicated to the memory of L. A. Mayer, the world-famous art historian, the late Otto Kurz (then of the Warburg Institute of the University of London) wrote an article entitled "Forgeries of Jewish Ritual Lavers."[19] In this article he identified a set of objects known as lion-shaped aquamaniles, very common in medieval Christian

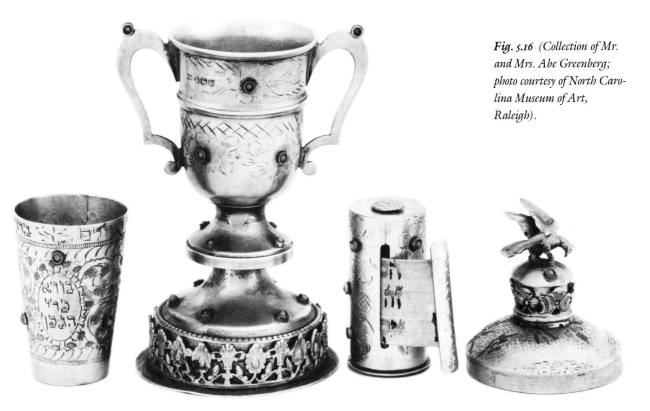

*Fig. 5.16 (Collection of Mr. and Mrs. Abe Greenberg; photo courtesy of North Carolina Museum of Art, Raleigh).*

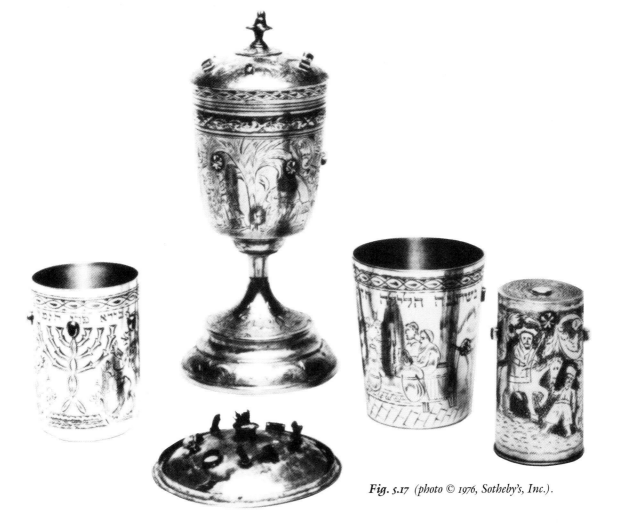

**Fig. 5.17** *(photo © 1976, Sotheby's, Inc.).*

and secular art. He identified two of these aquamaniles, one from the famous Howitt collection, sold in London in 1932 (*Fig. 5.18*),[20] and the other from the then Lee collection[21] (at present on loan from another collection to the Royal Ontario Museum, Toronto), as reproductions of an aquamanile from a treasury of silver objects from the north-German town of Lüneburg. The Lüneburg aquamanile (*Fig. 5.19*) was acquired by the Berlin Museum in 1874 as part of the treasure of that town, and it became the prototype for numerous forgeries that were soon to appear all over Europe and that were adopted by Jews and Gentiles alike.

Some years ago at a major show of Jewish ritual art held in the United States, the lion aquamanile shown in *Fig. 5.20* held a place of great prominence. It was used almost as the symbol of the exhibition: it appeared in all the advertising and television shows and became the most prominent item in that exhibition. The aquamanile was described in the catalog as,

> Silver, cast and engraved; h.9, w.11 1/2 in. Germany, early 17th century.
>
> Laver in the shape of a lion. His right fore-paw rests on a heraldic crest upon which is engraved a crowned lion rampant. A spout of 2 serpents' heads issues from the lion's mouth. His S-curve tail is supported on the back by a griffin.[22]

When I saw this object I noted its marked similarity to the photograph in Professor Kurz's article and wrote him a letter enclosing the catalog photograph and a descrip-

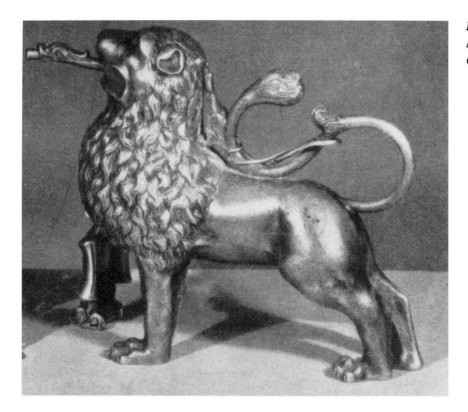

*Fig. 5.18* "Howitt collection" aquamanile (photo Christie's).

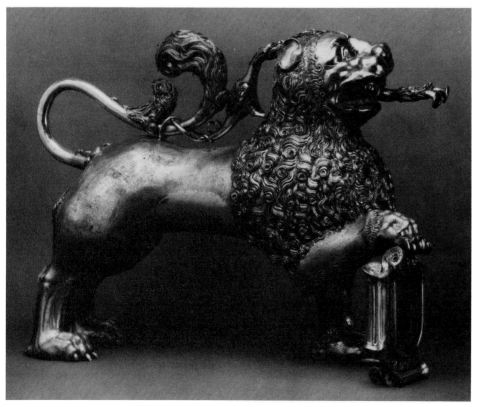

*Fig. 5.19* Aquamanile from the Lüneburg Treasury, silver, gilded. Jochim Worm (?), Lüneburg, 1540. (photo Kunstgewerbemuseum, Berlin, Inv. no. 74,390).

tion. He answered me in November 1968 as follows, "Dear Dr. Moldovan: I am deeply grateful to you for drawing my attention to the silver lion exhibited in New York. I agree with every word in your letter. The family likeness of these lions is too obvious."

I would like to end this part of the discussion by quoting the last paragraph of Professor Kurz's article, which states, "Interest in Jewish art is steadily growing. It is high time to eliminate some of the unwelcome accretions." On a positive and forward-looking note, I think that the attendance here at the first international conference on Jewish art is indicative of the great interest in, and devotion worldwide to, the subject of Jewish art. I would like to take this opportunity, therefore, to make a plea that we continue the work begun by this conference in a very specific and constructive fashion. On May 8, 1970, an article appeared in the *New York Times* with the headline "Art group is set up to judge attribution." To meet the demands of the public, who had numerous questions about disputed works of art, a non-profit making foundation was set up to coordinate scholarly and technical resources on art from all over the world and to make them available to individuals, associations, and other agencies. A representative of the foundation was quoted in the article as follows: "We expect to deal with questions of substance as they arise, not to serve as a shopping guide. I think of us as a court of appeals." If we can work to set up such a group, composed of leading scholars, collectors, museum people, dealers, all those knowledgeable in the multiple phases and facets of Jewish art, we would do a great service to the Jewish community and help preserve our Jewish heritage in an honest and ethical fashion. The Jewish

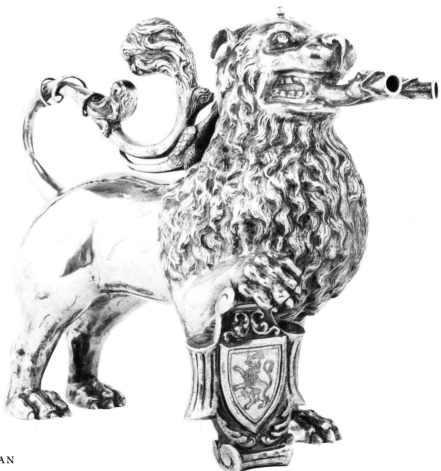

*Fig. 5.20 (The Brooklyn Museum; gift of Stephen Ensko; photo The Brooklyn Museum).*

people have for centuries been exposed to the most ruthless destruction, not only of our people but of our property, which includes our books, our ritual material in all of its forms, our buildings, our libraries, and other repositories we once had of Jewish history. The last and greatest onslaught was the Hitlerian horror, in which practically all the reminders of our Jewish past were destroyed. I think, therefore, that it devolves upon us to guard fervently those meager remnants that still remain with us and to oppose, almost as a *hillul ha-shem,* attempts to introduce false objects, which not only do not represent our legitimate past but may falsify that past for those seeking to reconstruct our history.

## Notes

1. C. Roth, "Caveat Emptor Judaeus," *Commentary* 43, no. 3 (1967), pp. 84–86.

2. See A. Kanof, *Jewish Ceremonial Art and Religious Observance* (New York, 1971), p. 226 (illust.).

3. Landesmuseum, Munster, *Jüdisches Jahr Jüdischer Brauch,* exhibition November 7–December 4, 1972, pp. 70 and 98–99 (illust.), no. 143.

4. F.A.B. Ward, *Catalogue of European Scientific Instruments* (London, 1981), no. 328.

5. C. Adler and I. M. Casanowicz, *The Collection of Jewish Ceremonial Objects in the United States National Museum* (Washington, 1908), p. 717 and pl. LXXX.

6. I. Shachar, *The Feuchtwanger Collection: Jewish Art and Tradition* (Jerusalem, 1971), pp. 109 and 110 (illust.), no. 283.

7. D. Sassoon, *Massa Babel* (Jerusalem, 1955), p. 218.

8. Parke-Bernet Galleries, Inc., Sale No. 2530 (Davidowitz), March 16, 1967, pp. 22 and 23 (illust.).

9. Smithsonian Institution, Washington, D.C., and the Metropolitan Museum of Art, New York, *Three Centuries of Peruvian Silver* (1967), p. 6: "Incense burner in the shape of a cock. Filigree with applied castings. Glass inserts. 19 × 26.2 cms., 1021 gr."

10. R. d'Harcourt, *L'Argenterie Péruvienne à l'époque coloniale* (Paris, 1927), p. 29 and pl. 4A: "Filigree incense burner in the shape of a turkey, made in Ayacucho. H. 18 cm. 1st half of 19th C."

11. Similar to one in Y. L. Bialer, *Jewish Life and Tradition* (New York, 1976), p. 85.

12. Parke-Bernet Galleries, Inc., Sale No. 2549 (Bistritzky), April 18, 1967, pp. 53 and 54 (illust.).

13. Parke-Bernet Galleries, Inc., Sale No. 2627 (Feinberg), November 29 and 30, 1967, pp. 33 (illust.) and 34.

14. Parke-Bernet Galleries, Inc. (*n. 8*), pp. 24 and 25 (illust.), described as "Ajouré silver fruit-form spice box Polish 19th c."

15. Parke-Bernet Galleries, Inc., Sale No. 2264 (Zagayski), March 18 and 19, 1964, p. 57.

16. Parke-Bernet Galleries, Inc., Sale No. 1867 (Kramarsky), January 7–10, 1959, pp. 30 and 31 (illust.).

17. North Carolina Museum of Art, Raleigh, *Ceremonial Art in the Judaic Tradition,* exhibition April 27–June 15, 1975, p. 40. Introduction and catalog notes by Abram Kanof.

18. Sotheby, Parke-Bernet, Los Angeles, Sale No. 190B, June 7–10, 1976 (unpaged, item no. 1777).

19. O. Kurz, "Forgeries of Jewish Ritual Lavers," *Eretz Israel* 7 (Jerusalem, 1964), pp. 54–55 and pls. XXIII and XXIV(1).

20. Christie's Catalog (No. 87) of the Howitt Collection of Jewish Antiquities and Ritual Art, May 9, 1932, p. 13 and illust. facing.

21. Kurz (*n. 19*), pl. XXIV(1).

22. Jewish Museum, New York, *Ingathering Ceremony and Tradition in New York Public Collections,* October 17, 1968.

BERNHARD BLUMENKRANZ (1913 – 89)

# The Case for a Central Archives of Jewish Art

## An Introduction to the Discussion on the Possibility of Establishing a Central Photographic Archives of Jewish Ceremonial Art

IN 1969, AT THE FIFTH WORLD CONGRESS OF JEWISH STUDIES in Jerusalem, I heard Ishayah Shachar put forward the idea of establishing a Central Archives of Jewish Art. In this connection he referred to a similar undertaking (though one much more limited in scope, it is true) that the Commission française des Archives juives had just brought to a successful conclusion under my direction. When Ishayah, in preparing the program for the present colloquium, asked me to introduce the discussion on the subject I willingly agreed. I shall be reporting principally on our methods as well as on the experiments we have been able to make and the results we have achieved.

I must emphasize at once that I am not an art historian, either of art in general or of Jewish art in particular. My field is Jewish history, and it is as a historian of the Jews that the evidence presented by works of art interests me enormously. Thus I have given our inquiry in France as broad a dimension as possible. I have, first of all, deliberately ignored all the limitations that would belong to *religious* art. When we discovered several so-called Roman oil lamps that were undeniably of French origin and at the same time Jewish (the motif of the seven-branched candelabra, the menorah, allowed no doubt on that score), we were not interested in whether the lamps had served to light a home or a house of prayer. Nor did it matter to us that we were not dealing in this case with works of art as such but rather with the work of craftsmen or even, if one is not guilty of an anachronism in using the term, with industrial

Bernhard Blumenkranz was born in Vienna in 1913 and died in Paris on November 4, 1989. He obtained a Ph.D. from Basle University (published 1946) and the Doctorat d'Etat from the Sorbonne in 1958. A director of research at the Centre nationale de la Recherche scientifique, he was a prolific worker in the field of Jewish studies and founded the Commission Française des Archives Juives and the journal *Archives Juives* (1967–84).

**Fig. 6.1** *Oil lamp, third cen-*
*tury* C.E., *found at the end of*
*the nineteenth century at Port-*
*du-Lys, Salignac-de-Pons,*
*Charente-Maritime (Musée*
*de Cognac; photo Musée de*
*Cognac) IAAJF 011-01-05.*

products. What was most important for us was their correct dating and provenance. As historians it was important to know that the objects came from the south of France (one from the southwest, two from the southeast) and dated from the first century B.C.E. to the first century C.E., the third century (*Fig. 6.1*), and the end of the fourth to the beginning of the fifth century, respectively.

In order to leave no doubt about our purpose in the minds of those interested in our survey we gave it the title Inventaire d'Art et d'Archéologie des Juifs en France.[1] The questionnaire, which is included as an appendix to this chapter, shows clearly that our inquiry was concerned with place names (rue des Juifs, de la Juiverie, de la Synagogue, and so forth) and cult buildings (synagogues, ritual baths, ovens, cemeteries), ancient as well as modern. Jewish art, by our definition, included not only those things produced *by* Jews (even if the content had no Jewish character, or even if, at the extreme, it had a Christian character—as from the nineteenth century has sometimes

been the case) (see *Fig. 6.2*), but also those things that were produced *for* Jews even though by non-Jewish artists (as is particularly frequent in architecture). *Fig. 6.3* is an example of the latter.

When considering artists to include in a survey, one is inevitably faced with the problem of what date limit to choose. To have tried to include all contemporary artists and all their works would have swelled our records in a physically intolerable manner. This is particularly true for a country like France, but the same thing would happen with regard to the United States or Israel and many other countries besides. We were guided by convenience in setting the beginning of the twentieth century as the chronological limit of our inquiry (two of the most recent works in our inventory are shown in *Figs. 6.4 and 6.5*), thus avoiding the claims of the numerous artists who would have wanted to appear in such a record—not to mention all those who perhaps would have refused to appear in it. Equally it meant that we avoided claims possibly even more insistent than those of the artists themselves—the claims of their widows or widowers. The injustice of this limit is obvious, and I freely admit that the solution was one of convenience. But faced with the thousands of artists and their tens of thousands of works (if we had wished to include the twentieth century as well) what criteria for selection should we have chosen? Should an artist have appeared in an exhibition or, better still, have had a one-man show? Should the artist have been entitled to a mention or, better still, been the subject of an article in a periodical or a textbook? One would simply shift the problem without reaching objective criteria. Does this parochial sheet have the same weight as that illustrious review with its international readership? One should note in passing that some textbooks (for ex-

*Fig. 6.2* *"Jesus ascending Calvary," drawing by Henri Levy (1840–1904) (Musée Magnin, Dijon, MMG 1938–676; © photo RMN) IAAJF 005-07-71.*

**Fig. 6.3** *"Synagogue interior," drawing by Godefroy Durand, nineteenth century (Musée de Cognac; photo Musée de Cognac) IAAJF 003-06-69.*

ample, specialized dictionaries) enjoy a largely usurped reputation, for although dead artists may appear in them without the extraction of a fee from their descendants, living artists for the most part are included only if they pay a fee (a double fee if the notice is to be accompanied by a photograph)! Is a one-man exhibition mounted at the artist's expense equal to appearing in an exhibition like the Biennale, where an independent jury makes its selection from a vast number of candidates?

We must now consider the recipients of our survey, namely, those who own the

*Fig. 6.4* "A Philosopher," etching by Edouard Moyse (1827–1908?) (Bibl. nat., Paris; photo Bibliothèque nationale) IAAJF 045-04-82.

objects and the works that we seek. Two major groups can be discerned. First there are the groups or individuals who put such objects and works of art to daily use. Then there are the public collections and private collectors for whom these same pieces are often no more than objects of ethnographic curiosity or aesthetic appeal. One realizes immediately that the first group is made up of Jews—individuals, families, and groups, the latter represented principally by congregations and religious associations, that is, the synagogue, but also by institutions and charitable associations (old people's homes, hospitals, fraternal societies, and migrant associations [*Landsmannschaften*]), cultural associations, and even political associations. Unusual discoveries are particularly to be made in synagogues. In one we found Torah ornaments signed by

"Maurice Meyer, goldsmith to the Emperor"; in another we found some seats of pure Empire style that were in danger of being sold in a flea market because they had been replaced by modern and more "functional" furniture. Apart from cases like this last one, the danger of witting destruction does not occur in the Jewish community—the sacred nature of the objects assures their preservation even when no longer in use, if only by means of storage in a *genizah,* the storeroom for worn-out sacred objects. Persistent search for such synagogue *genizot* often produces interesting discoveries. We were told only recently of a large number of *mappot* (Torah binders) hidden away in the remote attic of a Lorraine synagogue. One ought also to investigate whether an official in a community does not have items from the synagogue lodged in his home because he otherwise fears for their safety. Finally, one should be wary of acquisitions produced by recent migrations: French experience points to the frequent appearance of objects of North-African provenance, often at places where North-African Jews have not settled.

Among public and private collections the situation is virtually reversed: the archeological or purely artistic value of the objects is usually well established, but their Jewish nature is often ignored. This criticism does not apply, of course, to those museums that possess a wealth of Judaica and have curators who, even if they are not perfectly up to date in this field, will nonetheless know where to go and who to ask for information about an article. Noteworthy examples in France in this connection are the Cluny Museum in Paris with its Strauss-Rothschild collection, the Museum of Lorraine in Nancy with its Wiener collection, the Museum of Alsace in Strasbourg with the prestigious deposits of the Société d'histoire des Israélites d'Alsace et de Lorraine, the Basque Museum in Bayonne with its Jewish room, and the Musée judéo-comtadin

in Cavaillon. Nor does it apply to the private collectors specializing in Judaica, all of whom are without exception among the finest connoisseurs in this field and of whom France might well be proud.

When, however, a solitary Jewish object lands in a public or private collection where there are no others like it, it often remains unnoticed because its true significance is not understood. In order to avoid this possibility we supplied our respondents with a *descriptive* list of Jewish objects, grouped according to *materials,* to facilitate identification. It is probable that we owe the discovery of a number of extremely precious objects to this precaution. This was certainly the case with one of the Roman lamps decorated with the menorah mentioned earlier in this chapter, which in spite of its great antiquity and remarkable beauty had never been exhibited before, or even mentioned in any study, but had remained locked up in the storeroom of the museum concerned. Another example is the medieval Ḥanukkah lamp brought to light by our inquiry whose presence in a French collection strengthens the hypothesis of its French origin.

These modest examples drawn from our inquiry in France demonstrate already all the benefits to be expected of the Central Archives of Jewish Art. Thanks to the wealth of material available for comparison, undated objects and objects whose origins are unknown will be correctly placed in time and space. One deplores, justifiably, the proliferation of fakes in Jewish art: here again, comparison with a large number of objects of the same type but of assured authenticity will help to solve disputed cases. Finally, a wider controversy has raged for many years, namely, is there a Jewish art? And if the answer is yes, what are its characteristics? The reply, nay the replies, to this double question will be easier when supported by the unimaginably rich material that will have been gathered within the Central Archives.

It is appropriate to ask at this point whether the Archives we envisage would not be a useless repetition of other projects already set up. This danger certainly does not exist in the case of the *Index of Jewish Art,* for which both the ambitions and limitations have been clear since the appearance of the first installment in 1976. In their introduction (pp. 7 and 8) Bezalel Narkiss and Gabrielle Sed-Rajna present the project as complementary to the Princeton *Index of Christian Art* and, like it, limited to the consideration of *iconographic* elements. For that reason the project has started with the manuscripts that permit "the largest number of illustrations in comparison with other elements of Jewish art." But whereas the Princeton Index stops at the fourteenth century, the editors of the *Index of Jewish Art* wish to go as far as the sixteenth century. This limit is manifestly inadequate because the richest harvest of Jewish works of art comes to us from the seventeenth, eighteenth, and nineteenth centuries (if, as we have already proposed, we set aside the twentieth century as being *too* rich).

There is a parallel scheme for works of art other than miniatures, also under the direction of Bezalel Narkiss, at the Diaspora Research Institute of Tel-Aviv University. In the absence of any publication about this project (or at least, through my ignorance of any publication) I am unable to say anything about the range of themes, chronologies, and areas that has been considered.

The task of determining the range and standards of the Central Archives of Jewish Art with which we are concerned here would devolve upon its managing committee. From our experience in France I would suggest as an example worth following the

"pre-inventory" of the Inventaire Général des Monuments et des Richesses Artistiques de la France, which was established by law in 1962. The first system of documentation that organization adopted was so exacting that it was impossible to imagine a successful outcome, in spite of the considerable number of people engaged in the task. However, the pre-inventory adopted thereafter allows sufficiently rapid progress for one to foresee completion in the not-too-distant future but for the fine detail. If this example were to be followed, the Central Archives of Jewish Art would be based first of all and above all on a wealth of photographic record. All manuscripts and early printings would not only be recorded miniature by miniature or illustration by illustration but any purely decorative elements and the obverse and reverse of the bindings would also be noted. All three-dimensional objects, including funerary art, which should not be neglected, would be shown from all sides. Descriptions should provide all the necessary objective data—materials(s), size, marks, stamps or signatures, techniques and methods of production, present location (with inventory or catalog number), past location(s), exhibitions, sales, and so forth. The bibliography will carefully gather together old drawings, engravings, and photographs and thus reveal intervening amputations or restorations.

Establishing these parameters would be the task of a managing committee, but the collection of the records cannot be carried out by a central body. This task, if it is to be speedy and effective, must be entrusted to regional corresponding bodies. These organizations, while devoted to international cooperation, will be equally careful to complete their own records, for their part in the common enterprise will allow them to take advantage of the data bank thus set up. Last, and still on a practical level, the example of the Princeton *Index of Christian Art,* which today can be consulted in Rome or Utrecht as well as at its headquarters in the United States, shows that the researcher in Israel or America will not necessarily have to take the road for Oxford in order to consult the Archives. Thanks to modern means of reproduction it will be possible at little cost to place complete sets of the central records in a number of other centers for Jewish studies.

<div align="center">*    *    *</div>

I would like to end, as I began, on a personal note. On August 26, 1977, the day after the conference ended, I once again had the pleasure of Ishayah Shachar as my attentive audience while I reported to him the most encouraging progress of the conference and the very favorable reception given to *his* project for a Central Archives of Jewish Art—a project I had so willingly defended. On September 19, Ishayah Shachar died.

The Oxford Centre has since then made clear its firm intention of carrying out this project, which was so dear to Ishayah Shachar's heart, as an appropriate tribute to his memory. It is my fervent wish that this modest communication may contribute to that end.

### Note

1. The meeting of the Inventaire d'Art et d'Archéologie des Juifs en France, arranged by the Commission Française des Archives Juives, was supported by a grant from the Memorial Foundation for Jewish Culture.

# COMMISSION FRANÇAISE
# DES ARCHIVES JUIVES

**ARCHIVES NATIONALES**
87, Rue Vieille-du-Temple—PARIS (3ᵉ)

Dear Sir or Madam,

The French Commission for Jewish Archives is at the present time conducting a vast inquiry with a view to drawing up a double inventory:

1. of Jewish objects in public and private collections;
2. of Jewish archeological remains (including place names).

In addition to the strictly scientific objective, which by itself has already justified our enterprise, there is also an eminently practical aim—to furnish ourselves with the necessary documentation for a large exhibition which we plan to hold in Paris in . . . on the theme "Fifteen Centuries of Jewish Life in France."

We should be most grateful to you if you would help by telling us as much as possible about the collections in your care and the region with which you are so familiar.

Jewish objects are generally not well known: thus we are taking the liberty of attaching to this letter a descriptive list according to materials, which might sometimes allow the identification of objects whose true significance has escaped detection. A second list gives the names of the principal Jewish painters, sculptors, engravers and ceramists of the 19th and early 20th centuries: we should be equally obliged if you would tell us if you possess any of their works.

For greater simplicity we have gathered these—and several other—headings into the questionnaire attached, which we should be grateful if you would complete and return to me at the following address:

**Commission Française des Archives Juives**
(Inventaire d'Art et d'Archeologie)
Archives Nationales—87, Rue Vieille-du-Temple—Paris 3

In thanking you in advance for your valuable contribution, please be assured etc.

President, **Commission Française des Archives Juives**
B. BLUMENKRANZ

## COMMISSION FRANÇAISE

## DES ARCHIVES JUIVES —

## Inventaire d'Art et d'Archéologie

**ARCHIVES NATIONALES**
87, Rue Vieille-du-Temple — PARIS (3e)

# Questionnaire

1. **Name of museum or collection:**
   **Address and telephone number:**
   **Name of director** (or, where appropriate, **Head of Department** concerned):

2. **Jewish objects in your possession—Please give:**

   —Description of object
   —Inventory number
   —Date of acquisition, provenance
   —Materials and dimensions
   —Origin and date
   —Any mentions in catalogs or studies
   —Exhibitions in which it has been included

   Are you able to provide a photograph (or, failing that, to authorize the taking of a photograph)?
   (If there are several objects to list, please attach additional sheets.)

3. **Christian works of art or relics relating to the Jews**
   (description as above).

4. **Works by Jewish painters, sculptors, engravers and ceramists**
   (description as above).

5. **Public or private collections in your locality or region that are likely to possess objects or works belonging to groups 2–4.**

6. **Jewish archeological remains (synagogues, ritual baths, cemeteries and inscriptions, etc.) in your locality or region.**

## COMMISSION FRANÇAISE
## DES ARCHIVES JUIVES—
## Inventaire d'Art et d'Archéologie

**ARCHIVES NATIONALES**
87, Rue Vieille-du-Temple—PARIS (3ᵉ)

## Research of Jewish Objects

In general we are looking for all objects of a Jewish character or decorated with one of the traditional symbols: six-pointed star, seven-branched candelabra, palm frond, citron, or showing Jewish life.

In addition we are looking for all objects having the following characteristics:

### I—METAL OBJECTS

A) *Gold or Silver work for the Torah Scroll*
—Ornament in the form of small towers with bells covering the two projecting rods of the Torah scroll (*Rimonim*);
—Crown intended to be placed on the Torah: inside it comprises two parallel spindles on which two rings move (*Keter* or *Atara*);
—Torah breastplate for decorating the Torah scroll: from it hang bells and a small chain of about 0.80 meters (*Tass*);
—Torah pointer for following the reading: a pointing index finger at the end of a rectangular arm (about 0.25–0.40 meters) and, at the other end of the arm, a small chain (*Yad*).

B) *Lamps*
—Eternal light: small hanging lamp with chains; generally of colored glass (*Ner Tamid*);
—Synagogue chandelier;
—Candlestick with 4 vertical branches and sometimes a spice drawer (*Havdalah* lamp);
—Lamp for oil or candles comprising 9 cups or candle holders (8 plus 1): There are two principal forms:
   1. Wall bracket with a metal backplate of various shapes but often triangular, and having at the base 8 small cups for oil, the ninth being placed either to the side or above;
   2. Candlestick with 8 symmetric cups or candle holders, the ninth being placed on the axial stem (*Ḥanukkah* lamp or *Ḥanukkiyyah*);
—Hanging lamp frequently in the form of a 6, 7 or 8 compartmented star suspended by chains, and a drip cup for the oil below (Sabbath lamp);
—Taper holder for vigil candles used during the Day of Atonement service.

C) *Cups, Goblets and Bowls*

The different cups are very often in the form of chalices.

—Benediction cups, frequently decorated with representations of towns (*Kiddush* cups);

—Cup for the Prophet Elijah;

—Circumcision cup;

—Circumcision cupel often bearing a motif showing the sacrifice of Abraham or the circumcision of Isaac;

—Marriage cup;

—Burial society cup.

D) *Boxes and Cases*

—Spice box frequently in the form of a tower, a fish or fruit with an openwork reservoir for the spices (*Besomim* box);

—Box to hold the citron in the form of a citron or other citrus fruit (*Etrog* box);

—Cylindrical case on a handle, often chased, for the Scroll of Esther (*Megillah*);

—Wall case (3 to 30 cm) intended to be placed on the doorpost, inside which is a small roll of parchment (*Mezuzah*);

—Amulet holder, in the form of a locket in which a small roll of parchment is placed;

—Phylactery box, in the form of a cube set on a square base (*Tefillin* box);

—Torah case, either cylindrical or with panels (one of them attached by hinges), to contain the Torah (*Tik* or *Nartik*);

—Alms box.

E) *Ablutions*

—Wash basin and jug for the *Kohanim;*

—Wall fountain;

—Ewer for mortuary toilet;

—Fountain for cemetery.

F) *Tableware*

a) Dishes and Plates

—for the Passover (*Pesaḥ*) ceremony, often decorated with scenes depicting the Exodus from Egypt, or Passover ceremonies. The plates are often divided into 6 compartments (*Seder* plate);

—for Passover, 3 plates one above the other, for the unleavened bread;

—for the Feast of Esther (*Purim*);

b) Cutlery

—Different knives (for slaughtering, for the Sabbath bread, etc.);

c) Cooking Utensils

—Cake molds for the Feast of Esther;

—Rolling pins with patterned edges or small metal combs for making the unleavened bread.

G) *Circumcision*

—Requisites for the circumcision ceremony, a kit containing pincers to hold the foreskin, a scalpel and a flask of astringent.

H) *Various*

—Different seals, individual, community, or for a particular office;

—Medals, commemorative or relating to a particular office;

—Wedding rings: their settings are generally of a somewhat architectural shape and highly worked;

—Marriage belt, in the form of 2 belts held together by a little chain.

## II—CHINA, PORCELAIN, GLASS

—Plates (see **I—METAL OBJECTS**—F) Tableware—a) Plates);

—Cups for blessings—marriages—burial societies, etc.;
—Stained glass.

## III—WOOD

*Synagogue furniture*
A) —Cupboard to hold the Torah scroll (the Holy Ark), often decorated with the Tablets of the Law (*Aron ha-Kodesh*);
　—Lectern for the officiant;
　—Book rest for the reading of the Torah (*Bimah*);
　—Chair, called the Prophet Elijah's chair;
　—Box with compartments for books and religious objects.

B) *Various*
　—Decorated hut walls for the Feast of Tabernacles (*Sukkot*);
　—Circumcision bench;
　—Mallet used for summoning the faithful to the synagogue;
　—Rattle for the Feast of Esther;
　—Child's spinning top.

## IV—WAX

—Plaited wax candles for the ceremony at the close of the Sabbath (*Havdalah*).

## V—TEXTILES

A) *Vestments*
　—Sacerdotal;
　—Skull caps;
　—Jerkin in white linen of rectangular shape with an opening for the head and fringes at the four corners (*Arba Kanfot* or *Talliṭ Katan*);
　—Shroud of white linen (*Sarganess*);
　—Prayer shawl (silk or linen), white with blue or black bands and fringes (*Talliṭ*).

B) *Curtains and Linen*
　—Curtains, usually richly embroidered, covering the Holy Ark (*Paroḥet*);
　—Wedding canopy (*Huppah*);
　—Torah mantle, always made of precious cloth (*Meïl*);
　—Bindings of linen, embroidered or painted with motifs, often naive, for fastening the Scrolls (*Mappah*);
　—Cloth for the lectern (frequently of tapestry);
　—Small purse with three compartments for unleavened bread;
　—Tablecloths, mats, dusters, cushion covers.

## VI—LEATHER AND HIDES

—Phylacteries for prayer (*Tefillin*). They comprise two sets of leather thongs, one made up of two thongs of about a meter long, the other a single thong of about two meters with a slip knot;
—A large, single shoe for the refusal of the "levirate" (*Ḥaliẓah*).

## VII—STONE

　—Tombstones;
　—Commemorative stones;
　—Various seals (see above **I—METAL OBJECTS**—H) Various);
　—Cooking stones for unleavened bread.

## VIII—HORN

—Ram's horn (*Shofar*) used at the High Holydays.

## IX—BOOKS, MANUSCRIPTS, PAPER CUT-OUTS

—Books, for study, prayer, ritual prescriptions, etc.;
—Torah scrolls;
—Scrolls of Esther;
—Calendars;
—Pictures with prayers (also in the form of posters);
—Pictures, often of cut-out paper, used to indicate the East (*Mizrah*);
—Marriage contracts (*Ketubah*);
—Playing cards;
—Archival documents, either printed or in manuscript.

## X—CHRISTIAN ART

All representations of Judaism or of Jews contemporary with the date of execution of the work (do not include biblical scenes);

Catholic relics dealing with supposed ritual crimes.

## COMMISSION FRANÇAISE

## DES ARCHIVES JUIVES—

## Inventaire d'Art et d'Archéologie

**ARCHIVES NATIONALES**
87, Rue Vieille-du-Temple—PARIS (3ᵉ)

### *Jewish Painters, Engravers, Sculptors, and Ceramists in France up to the Beginning of the Twentieth Century*

| | |
|---|---|
| Painter | AARON, Michel-Joseph, born in Geneva |
| Sculptor | ADAM-SALOMON, Antony Samuel (1818–81) |
| Painter | ADLER, Jules (born Luxeuil, 1865–1957) |
| Painter | ALCAN, Eugène (1811–ca. 1898) |
| Painter and Sculptor | ASTRUC, Zacharie (1835–1907) |
| Painter | AXENFELD, Henri, born in Odessa |
| Painter | BACCHI (BACHY), Raffaele (1716–67) |
| Painter and Engraver | BARON, Henri Charles Antoine (1816–85) |
| Painter | BERNARD, Delphine (1825–64) |
| Sculptor | BERNSTAMM, Léopold Bernhard (1859–1939) |
| Sculptor | BERNSTEIN-SINAIEFF, Leopold |
| Sculptor | BLOCH, Elisa (1848–1905) |
| Painter | BLUM, Maurice, born in Bordeaux |
| Painter | BORCHARD, Edouard, born in Bordeaux |
| Sculptor | BRACH, Malvina (1842–1922) |
| Painter | BRANDON, Jakob Emile Edouard (1831–97) |
| Painter | CARO-DELVAILLE, Henry (1876–1926) |
| Painter | COSSMANN, Maurice (1821–90) |
| Painter | DIAS, Félix (1794–1817) |
| Painter | FICHEL, Benjamin-Eugène (1826–95) |
| Painter | FICHEL, Jeanne, née Salomon |
| Painter | MLLE. FORMSTECHER, born in Paris |
| Painter | GONZALEZ, Eva (1849–83) |
| Painter | HADAMARD, Auguste (1823–86) |
| Sculptor | HANNAUX, Emmanuel (born 1855) |
| Painter | HEILBUTH, Ferdinand (1826–89) |
| Painter | HERMANN, Léo (born 1853) |

| | |
|---|---|
| Painter and Engraver | HIRSCH, Alexandre (1833–1912) |
| Painter and Engraver | HIRSCH, Alphonse (1843–84) |
| Painter | JACOBBER (JACOB-BER), Moïse (1786–1863) |
| Sculptor | LEVY, Albert (born 1864) |
| Painter and Engraver | LEVY, Alphonse (1843–1918) |
| Painter | LEVY, Emile (1826–90) |
| Engraver | LEVY, Gustave (1819–94) |
| Painter | LEVY, Henri Leopold (1840–1904 or 1905) |
| Painter | LEVY, Henri-Michel |
| Painter | MAYER, Constant (born 1832) |
| Painter | MAYER, Léon |
| Painter | MAYER, Léopold |
| Painter | MICHEL, Léon-Henri (after 1895) |
| Painter | MOYSE, Edouard (born 1827–1908?) |
| Painter | PEREIRE, P.-E. |
| Ceramist | PETIT, Jacob (1796–1868) |
| Painter | ROTHSCHILD, Baronne Charlotte Nathaniel de (1825–99) |
| Engraver | RUDINOFF (MORGENSTERN), Willibald Wolf (born 1866) |
| Painter | SALZEDO, Paul (1842–1909) |
| Engraver | SOLCHI, Emile-Arthur (born 1846) |
| Painter | ULMANN, Benjamin (1829–84) |
| Painter | WEISS, Adolphe (born 1832) |
| Painter | WORMS, Jules (1832–1914) |

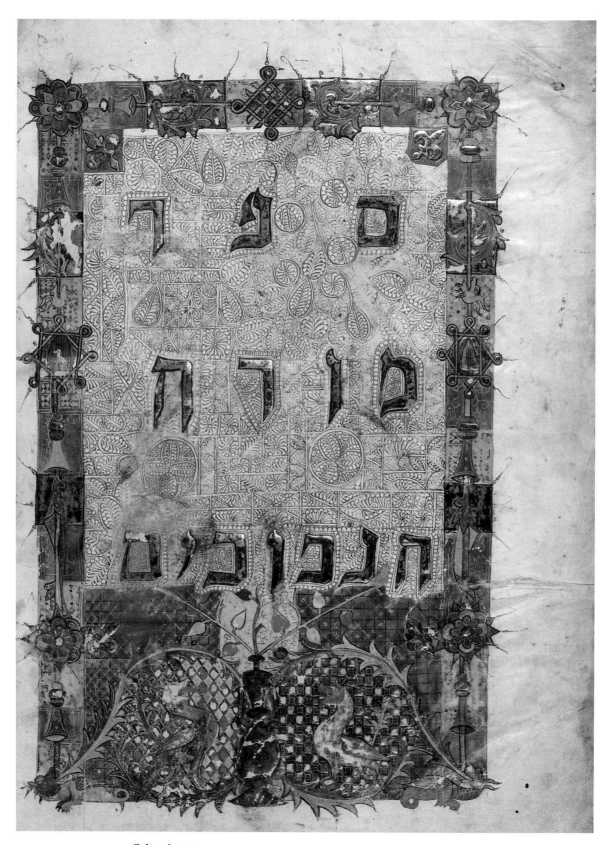

*Color plate 6*

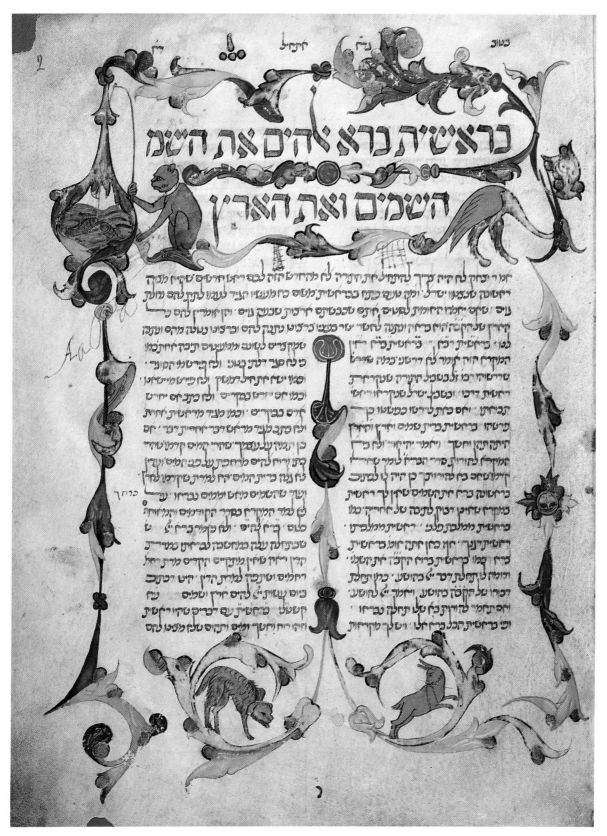

Color plate 7

**Color plate 8** *Oxford, Bodleian Library, MS. Opp. 776 (Catalog No. 20);* siddur *written and decorated in Germany c. 1471; fol. 8v: initial panel to Psalm 19 (in morning prayers) showing a man at prayer with musicians and singers (photo Bodleian Library, Oxford). Miniature measures c. 33 × 57 mm.*

---

**Color plate 5** *Oxford, Bodleian Library, MS. Kenn. 3 (Catalog No. 1); Ashkenazi Pentateuch with Targum Onkelos,* megillot *and* haftarot, *copy finished in 1299; original decoration contemporary, second stage later in the 14th century; fol. 178r: beginning of Deuteronomy, architectural panel for the initial word of the book. Only the central motif in the lower* Masorah *belongs to the first stage of the decoration; the tall hat and foliage on the right hide traces of the columns that supported the original word panel. Traces of a bird resting on the left pinnacle of the portico can still be seen behind the crenellations (photo Bodleian Library, Oxford).*

**Color plate 6** *Oxford, Bodleian Library, MS. Laud. Or. 234 (Catalog No. 10); Maimonides' "Guide of the Perplexed" (*Moreh ha-Nevukhim), *copied and decorated in Spain in the second quarter of the 14th century; fol. 7v: title of the book in large letters on a filigree panel within a frame of Italian inspiration, although the diaper pattern within the two scrolls is of a French type (photo Bodleian Library, Oxford).*

**Color plate 7** *Oxford, Bodleian Library, MS. Can. Or. 81 (Catalog No. 11); Rashi's commentary on the Pentateuch, written in Pescia (Italy) in 1396; fol. 2r: beginning of the work. Typical Italian decoration of the period bearing no relation to the text within it (photo Bodleian Library, Oxford).*

## THÉRÈSE METZGER & MENDEL METZGER

# *Introduction to the Catalog of the Bodleian Library Exhibition*

T HE BODLEIAN AND COLLEGE LIBRARIES at Oxford house over 3,000 Hebrew and Samaritan manuscripts, making them the largest collection in Great Britain, with most of the manuscripts acquired between the seventeenth and the end of the nineteenth century.[1] The scholars whose collections were purchased by or bequeathed to the Oxford Libraries during that period had been mainly interested in the texts, so that the Libraries can now boast of manuscripts in nearly every branch of Jewish literature. Indeed, so minor stood the decoration in the eyes of the scholars that it was more often than not hardly noticed and, when noticed, was commented on in the most cursory if not deprecatory fashion—one of the best examples of this outlook being provided by A. Neubauer's catalog of the Oxford collections, published in 1886.[2] During the nineteenth century and even up to and beyond the middle of the twentieth only a small number of medieval illuminated Hebrew manuscripts were acquired by non-Jewish private or public collections on the basis of the quality, or at least the curiosity, of their decoration or their ancient bindings.[3] So the wealth or dearth of illuminated manuscripts in the collections built up during those periods is more often due to chance than to choice. And the Oxford collections are no exception to the rule. In any case, put together, the Hebrew illuminated manuscripts that were part of the various collections acquired by the Oxford Libraries now form a most valuable ensemble.

However, when compared with other series of manuscripts, Latin, Greek, and so on, the number of Hebrew manuscripts that have survived time and destruction is so few that one must not be surprised at the even smaller number of illuminated ones. Taking into account nearly every and any kind of decoration or illustration, rich or poor, of higher or lower quality,[4] the number of medieval illuminated Hebrew manuscripts in the Oxford collections totals less than 150.

The collections can count few Middle Eastern examples, a larger number of Sephardi and Italian ones, whereas Ashkenazi volumes constitute about half the total. Biblical manuscripts are more numerous than liturgical manuscripts, and both greatly outnumber all the other categories put together. Among biblical manuscripts the Ashkenazi and Sephardi are roughly equal in number, the Italian ones being much fewer; among liturgical volumes the number of Ashkenazi manuscripts ranks high above both the Sephardi and the Italian.

With the notable exception of the much-praised Sephardi Bible MS. Kenn. 1 (No. 4),[5] and the well-known, giant thirteenth-century Ashkenazi *maḥzor* MS. Laud or. 321, the illuminated Hebrew manuscripts in the Oxford collections, unlike those in other collections, have up until now been known to only a handful of scholars, and it is only in the publications of those scholars that decorated pages from some of them have been reproduced.

The Oxford collections cannot boast the possession of Sephardi Bibles with images of the sanctuary implements comparable to those in the British Library, but the range of their Sephardi biblical volumes with micrographic decoration from the thirteenth to the end of the fifteenth century (Nos. 3 and 5) is of great value. The weakest point of the collections, again in contrast to the British Library, is in the field of the Passover Haggadah; in the Oxford collections there is no example with a biblical cycle and/or full range of ritual illustrations. However, Oxford offers a worthy decorated *Moreh Nevukhim* (No. 10).

Oxford can be proud of the number and quality of Ashkenazi decorated Bibles and liturgical books in its collections: large size volumes with micrographic decoration, smaller and rarer ones with pen-drawn or painted ornament (Nos. 1 and 2) or illustrations, and huge and middle-size *maḥzorim* and smaller *siddurim* with not only painted or ink decoration but a fairly good number of illustrations as well (Nos. 13–20). Its decorated or illustrated Ashkenazi legal, ritual, and ethical texts are equally remarkable (Nos. 8 and 9).

As for the smaller number of Italian manuscripts, they nonetheless offer some fine quality and rather rare pieces, ranging from a thirteenth-century decorated Bible or an even rarer fourteenth-century decorated and illustrated Rashi's commentary on the Pentateuch (No. 11) to an exceptional *Arba'ah Turim* (No. 12), fine biblical volumes (Nos. 6 and 7) of the fifteenth to the early sixteenth century, and more modest but nonetheless attractive liturgical ones (Nos. 21 and 22) of the fifteenth century.

Within the necessary limits of the number of exhibits it was not possible to do justice to every feature of the Oxford collections.[6] On the whole, preference has been given to painted decoration over pen and ink or plain micrography, as this is more pleasurable to the eye. Still, it is our hope that this choice will give a not-too-unfaithful picture of the diversity and quality of decoration to be found in the most remarkable pieces of these collections, not unworthy jewels to be set in a crown of excellence.

### Notes

1. On the history and formation of Hebrew manuscript collections, see the excellent survey by B. Richler, *Hebrew Manuscripts: A Treasured Legacy* (Cleveland/Jerusalem, 1990), pp. 58–84; on collections in Great Britain, see Richler, pp. 72–74 and 138–39. A brief account of the formation of the Bodleian collection is given by A. Neubauer in the preface to his *Catalogue of the Hebrew Manuscripts in the Bodleian Library* . . . (Oxford, 1886), pp. v–vi.

2. Other significant examples would be M. Steinschneider's catalogs of the German collections.

3. Such was the case for most of those Hebrew manuscripts that entered, for instance, the Sussex and Hamilton collections. The first one was acquired by the British Museum in 1844 and the second by the then Königliche Bibliothek und Kupferstichkabinett in Berlin in 1882. A

few isolated manuscripts may well have been purchased for their miniatures, such as the London Miscellany, MS. Add. 11639, acquired by the British Museum in 1839, or the Haggadah ms. 732, acquired in 1859 by the Duc d'Aumale for his collection (later the Musée Condé, Chantilly).

It is worth recalling that interest in decoration and miniature painting in medieval Hebrew manuscripts was not initiated before the end of the nineteenth century, and interest was sparked mostly through the publication of D. H. Müller and J. von Schlosser's pathbreaking work, *Die Haggadah von Sarajevo* (Vienna, 1898), with an appended essay by D. Kaufmann, the first survey of Jewish book art ever published. Although prepared earlier, next to be published was the sumptuous album by V. Stassof and D. Günzburg, *L'ornement hébraïque* (Berlin, 1905), which revealed an unsuspected hoard of ornament in medieval Middle Eastern Hebrew Bibles.

4. But omitting those volumes in which poorness of execution and paucity of decoration occur together.

5. The numbers are those in the exhibition catalog that follows.

6. None of the manuscripts from the College Libraries were exhibited.

Manuscripts selected and described by
THÉRÈSE METZGER & MENDEL METZGER

# *Catalog of Illuminated Hebrew Manuscripts Exhibited in the Bodleian Library, August–September 1977*[1]

In Conjunction with the Conference "The Visual Dimension: Aspects of Jewish Art" Organized by the Oxford Centre for Postgraduate Hebrew Studies (with support from the Tarbuth Foundation)

### *Biblical Texts*[2]

1. **MS. KENN. 3** (Neubauer No. 2325)[3]

Pentateuch with Onkelos; *megillot* and *hafṭarot* with *Masorah Magna* and *Parva*.

297 leaves (two fol. 54 but no fol. 202; fols. 296–297 later addition); 263 × 182 mm, biblical text and targum 116/132 × 161/167 mm, with *Masorah Magna* 197 × 161/167 mm.[4]

*Masorah Magna* completed in 5059 (= 1299) by an anonymous hand for Samuel ben Moses ha-Levi, and *Masorah Parva* copied for the same by Joseph ben Isaac in the city of קריניא or קרצייא (not identified). The two scripts are different (see colophons, fol. 239v).

**Codex:** Ashkenazi characteristics.

**Decoration:** the original decoration, entirely German in its vivid reds, blues, greens, and yellows, is now present only from fol. 219v onward. The original decoration of the Pentateuch was replaced at a very early date either by removing the first leaf of a book (fols. 1, 100, and 132) or by erasing the first painted panel and marginal ornament (fols. 54(ii)r and 178r); the substituted decoration, although it betrays a French influence, was certainly executed in northern Italy (as hinted at by the characteristic crenellated walls, fols. 1v and 100v).

**Open page** *(color plate 5)*: fol. 178r, Deuteronomy; substituted panel with, on the right, traces of the original architectural frame.

2. **MS. SELD. A sup. 106** (Neubauer No. 130)

Ecclesiastes, Esther and *hafṭarot;* originally a Pentateuch with *megillot* and *hafṭarot* (see colophon, fol. 120r), *Masorah Magna* and *Parva* (only fols. 2r–14r).

*Fig.* 1

120 leaves; 136 × 97 mm, biblical text 72/75 × 48/50 mm, with *Masorah Magna* 110 × 48/50 mm.

Written by David ben Isaac.

**Codex:** German characteristics.

**Decoration:** German illumination; first half of the fourteenth century; occasional ornamental *Masorah*.

*Fig. 2*

**Open page** *(Fig. 1)*: fol. 11v, beginning of Esther; colors, red, olive green, yellow, pink, blue-gray, gray, white, and blue with gold leaf on the letters.

### 3. MS. KENN. 2 (Neubauer No. 2323)

Complete Bible with *Masorah Magna* and *Parva,* preceded by a list of the Commandments according to their order in the Pentateuch.

428 leaves; 306 × 240 mm, biblical text 195 × 145 mm, with *Masorah Magna* 232 × 145 mm.

It has until now been generally thought that the *Masorah* was written by Joshua ben Abraham ibn Gaon in Soria, where in 1306 he executed the drawing of the Temple, a fragment of which is bound in at the beginning of the Bible (fols. 1–2). Joshua has also been credited with the writing of the main text.

In fact, comparison of Joshua's writing and scribal habits in manuscripts where he has signed the *Masorah* (Lisbon, Biblioteca Nacional, Ms. Il. 72, Paris, Bibliothèque nationale, ms. hébr. 20, and Dublin, Trinity College Library, MS. 16) with those of the *Masorah* in MS. Kenn. 2 does not corroborate this view. However, the decorative patterns of the *Masorah* and the rest of the decoration do indicate that MS. Kenn. 2 was produced in the same circle as Joshua's manuscripts. MS. Kenn. 2 is similar to Oxford, Bodleian Library, MS. Opp. Add. 4° 75–76.

**Codex:** Spanish characteristics of the period but not of the most common type.

**Decoration:** decorative frames, full-page ornamental panels, smaller panels at the end of books, indicators for the *parashiyyot* and ornamental *Masorah* with gold leaf and paint often completing the patterns. Typical Spanish-Jewish Bible decoration of the early fourteenth century.

**Binding:** Turkish or Venetian, in the Persian style, from the end of the sixteenth or the beginning of the seventeenth century; restored.

**Open page** *(Fig. 2)*: fols. 19v (not illustrated)–20r, ornamental *Masorah* and indicator for *Parashat lekh lekha;* colors, small lozenges of blue, green, and red between crossed bars of gold leaf.

### 4. MS. KENN. 1 (Neubauer No. 2322)

Complete Bible with both *Masorah* and, at beginning and end, D. Kimḥi's *Sefer Mikhlol*.

460 leaves: 453 + 7 fols. with duplicate numbers; 292 × 240 mm, biblical text 175/178 × 144/146 mm, with *Masorah Magna* 223/227 × 144/146 mm.

Written by Moses ben Jacob ben Zabarah for Isaac ben Solomon de Braga in 5236 (= 1476) at La Coruña (Corunna) (colophon, fol. 438r).

Decorated by Joseph ben Ḥayyim (colophon in zoomorphic letters, fol. 447r).

**Codex:** Spanish characteristics.

Original tooled box-binding, in the Mudéjar style and technique; restored.

**Decoration:** the whole program—the ornamental frames, full-page decorative panels, smaller painted panels, marginal decoration at the beginning or end of each book, ornamental indicator for each *parashah* and letter-number for each psalm, and zoomorphic letters—has been borrowed from the superb Lisbon Bible, written in 1299–1300 in Cervera and most probably illuminated in Soria—hence, in spite of some influence from the style of fifteenth-century miniature painting and various borrowings from the contemporary decorative vocabulary, the archaizing aspect of most of this decoration. On the whole the shapes are rather awkwardly stylized and the colors garish, but the general effect is powerfully decorative.

Illustrations to the text: two full-page miniatures showing the Temple implements (fols. 120v–121r), several marginal motifs, e.g., the red cow (fol. 88v), Balak (fol. 90r), Pinḥas (fol. 92r), David enthroned (fol. 185r), and Jonas (fol. 305r).

**Open page** *(Fig. 3)*: fols. 442v–443r: wars of hares and dogs, and cats and mice, within ornamental frames to the *Sefer Mikhlol*.

*Fig. 3A*

**5. MS. OPP. ADD. 4° 26** (Neubauer No. 30)

Pentateuch with *hafṭarot, megillot, megillat Antiochus, Masorah Magna* and *Parva*.

240 leaves; 227 × 170 mm, biblical text 135/139 × 106/108 mm, with *Masorah Magna* 169/173 × 106/108 mm.

Written by Moses ben Jacob ben Moses ibn Khalif (or Khalef) in 5240 ( = 1480); this scribe copied two other Bibles, one in 1472 in Seville and the other in 1473. *Masorah* written by Samuel ben Joshua ben Joseph (colophons, fol. 239v).

**Codex:** Spanish characteristics.

Fig. 4

**Decoration:** "carpet pages," decorative frames and marginal ornament are drawn with lines of minute writing. This Bible is a very fine example of this specifically Jewish type of book ornament as practiced in Spain in the fifteenth century. Once belonged to Don Samuel Abrabanel the Prince (fol. 239v), born in Lisbon in 1473, died in Ferrara in 1547, who acquired it in Italy.

**Open page** *(Fig. 4)*: fols. 140v (not illustrated)–141r, ornamental *Masorah*.

*Fig. 5 (facing)*

**6. MS. CAN. OR. 62** (Neubauer No. 26)

Pentateuch with Onkelos and Rashi, five *megillot* with various commentaries, *haftarot*.

275 leaves; 305 × 220 mm, biblical text 158/167 × 104/106 mm, marginal texts vary.

Written by Berakhiel ben Ḥiskia Raphael Ṭrabot for Abraham Raba in [5]232 ( = 1472) (colophon, fol. 190r).

**Codex:** Italian characteristics.

**Decoration:** Italian illumination of the Ferrara school of around 1470. One illustration (fol. 1r) to the text.

**Open page** *(Fig. 5)*: fol. 1r, beginning of Genesis; in the right margin at the top of Rashi's commentary, an illustration to Genesis III:6: Adam and Eve under the Tree of Good and Evil—Eve kneeling in front of the seated Adam offers him the forbidden fruit, while coiled around the tree the serpent with the woman's head whispers in Eve's ear. The stag in the upper roundel and the virgin with the unicorn in her lap have no special Jewish meaning here but have been borrowed from contemporary Italian decoration. The artist is likely to have been non-Jewish, as evidenced by the unusual shape of the initial-word letters. Colors, pink, blue, red, and green.

**7. MS. MICH. ADD. 34** (Neubauer No. 134)

Ecclesiastes, with a short commentary by Abraham Farissol.

58 leaves; 194 × 141 mm, 123 × 78 mm.

Written by Farissol himself for Elḥanan ben Abraham in 5281 ( = 1521) (fol. 52r).

**Codex:** Italian characteristics. Original sixteenth-century binding.

**Decoration:** ornamental frame to the first page and painted initial-word panel; initial word in gold. Usual Italian illumination of Ferrara at this period.

**Open page** *(Fig. 6)*: fol. 1r, first page of the work; colors, pink, blue, green, and lilac on gold ground. The coat of arms in the lower border either has been erased or was not executed.

## *Non–Biblical Texts*

**8. MS. ARCH. SELD. A. 5** (Neubauer No. 864)

Moses of Coucy's *Sefer Mizvot Gadol*.

331 leaves (first and last leaves are later additions); 358 × 259 mm, 242 × 167 mm.

Written last half of the fourteenth century.

**Codex:** Ashkenazi characteristics.

**Decoration:** middle of the fourteenth century; the coloring (predominantly red but with entwined arches of blue, yellow, and green and splashes of gold leaf) is German rather than French.

**Open page** *(Fig. 7)*: fol. 217r, first page of the second part of the work, with fantastic architectural frame.

**9. MS. ARCH. SELD. B. 2** (Neubauer No. 569)

Maimonides's *Mishneh Torah;* books vii–xi missing.

510 fol. 450 × 342 mm, 293 × 190 mm.

Written by Solomon (name indicated by dots on several pages, e.g., fol. 471v), probably in the first half of the fourteenth century.

**Codex:** German characteristics.

*Fig. 6*

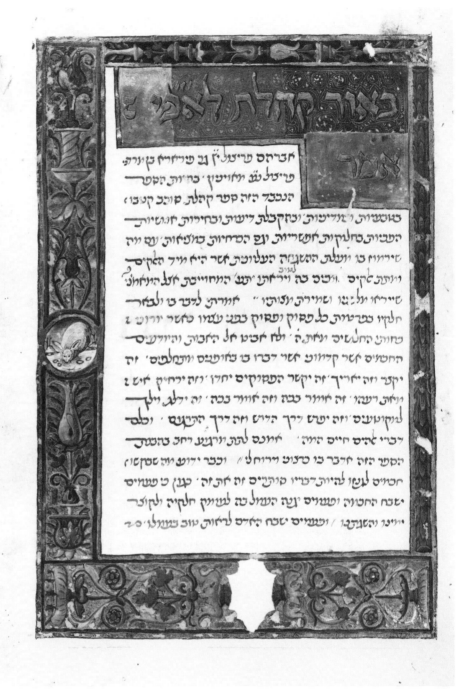

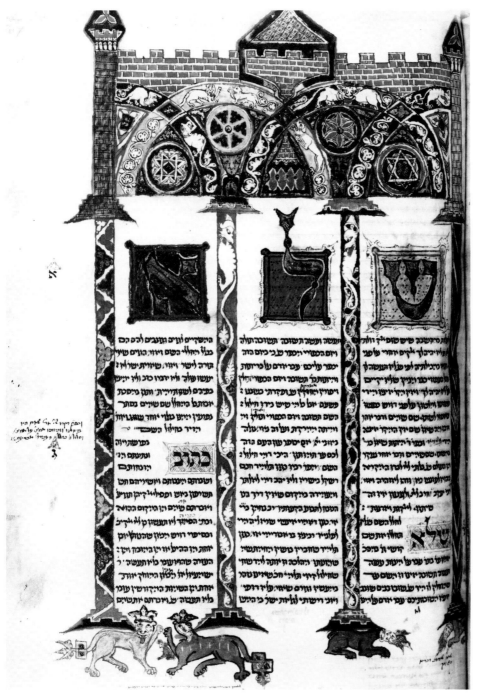

*Fig. 7*

*Fig. 8*

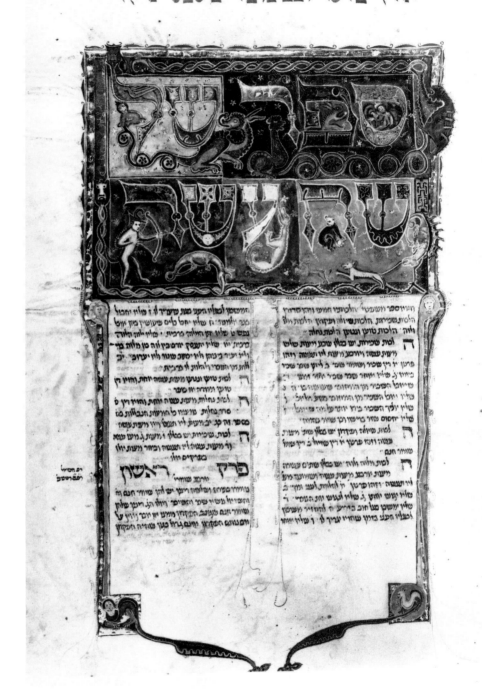

**Decoration:** three pages (fols. 362r, 411r, and 469v) with very richly decorated panels for the monumental initial words to books xii, xiii, and xiv and a smaller, simpler panel on fol. 325r. German illumination of high quality from the second half of the fourteenth century.

**Open page** *(Fig. 8)*: fol. 411r, beginning of book xiii; rectangular zones of lilac, blue, and pink above; pink, lilac, and blue below.

### 10. MS. LAUD OR. 234 (Neubauer No. 1250)

Maimonides's *Moreh Nevukhim* in the Hebrew translation by Samuel ibn Tibbon.

216 leaves (the first six are later additions); 287 × 215 mm, 178/185 × 120/123 mm.

Written before 5116 (= 1356) (when money was lent on it in the town of Huesca), probably in the second quarter of the fourteenth century.

**Codex:** Spanish characteristics.

**Decoration:** Spanish illumination showing some French and Italian features; very delicate coloring but rather rigid and angular forms.

**Open page** *(color plate 6 and Fig. 9)*: fols. 7v–8r, title page and foreword by the translator; typically Spanish association of painting and pen-drawn filigree.

### 11. MS. CAN. OR. 81 (Neubauer No. 189)

Rashi's commentary on the Pentateuch.

191 leaves; 300 × 227 mm, 188 × 139 mm.

Written in Pescia by Meir ben Samuel of Provence for Daniel ben Samuel the physician in [5]156 (= 1396).

**Codex:** Italian characteristics.

**Decoration:** Italian illumination; stylized scroll ornament, fantastic creatures, and charming naturalistic details but usually bearing no relation to the text. Some illustrations to the text: the bull and the sheep given as burnt offerings (fol. 96r), the seven-branched candelabrum (fol. 132v) (after a Spanish model), and hanging lamps (fols. 132r, 137r) evoking the service of the menorah.

**Open page** *(Fig. 10 and color plate 7)*: fols. 1v–2r, first page of the book with coat of arms of the original owner and, fol. 1v, lower right, an inscription by another owner in small cursive writing; notice the monkey fishing to the left of the initial words.

### 12. MS. CAN. OR. 79 (Neubauer No. 711)

Jacob ben Asher's *Tur Even ha-Ezer* (laws affecting women, marriage, etc.) and *Ḥoshen Mishpat* (civil law).

453 leaves; 300 (307) × 247 mm, 202 × 153 mm.

Written in [5]198 (= 1438) by Moses of the Beit-El family from Provence and the city of Avignon (colophon, fol. 453v).

**Codex:** Italian characteristics.

**Decoration:** North-Italian illumination of around 1440, possibly executed in the Veneto; the colors are somewhat cold and even dull, but volumes and forms are vigorous. Illustrations at the beginning of each book; book 2, fol. 135v, the head of Justice has been erased. In spite of slight differences in this miniature (probably due to the slightly larger figures), we do not think that it is by another hand.

**Open page** *(Fig. 11)*: fol. 2v, a Jewish wedding, the bride and groom stand under the *ḥuppah* formed by the *ṭallit* laid over their heads; colors, red, blue, pink, and yellow on green ground.

*Fig. 9*

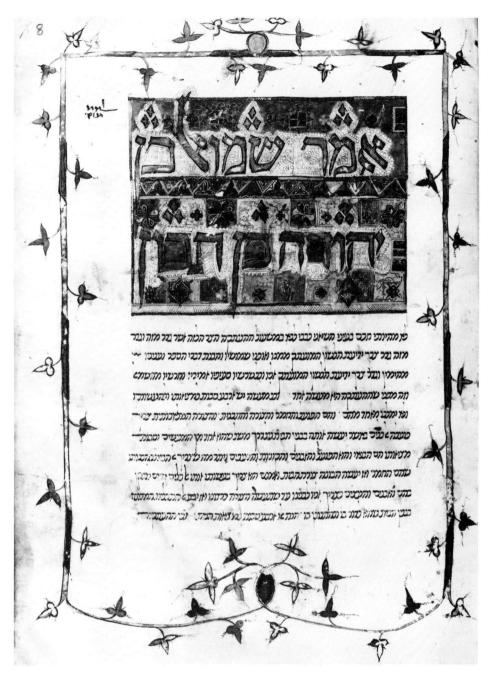

### Prayer Books

**13. MS. MICH. 617** (Neubauer No. 1033)

*Maḥzor* (first part) (incomplete at the beginning and with some lacunae) with the prayers for the special *Shabbatot*, Passover, and Pentecost.

132 leaves; The first folio of the first quire, probably blank, and the last folio of the fourth quire (lacuna in the text between fols. 30 and 31) are missing. Fol. 40, second

*Fig. 10*

שלׁי הנׁשׁ נׁמר
שמו׳ והרומׁא דיּן יּשׁרו

folio of the sixth quire, is not original; glued to the widow of fol. 45, it has been copied and decorated by different hands. Fols. 37–38, blank, are a later addition; 400 × 295 mm, 300 × 190/200 mm.

Written in Germany in 1258 (see colophon in the second part, MS. Mich. 627).

The miniatures in this codex show the characteristics, both in color and style, of late

Fig. 11

Romanesque, early Gothic south-German art of ca. 1250–60.

**Open page** *(Fig. 12)*: fol. 11r, initial word *zekhor* for the Sabbath when the reading is the *Parashat zakhor;* the illustration shows several armed zoomorphic figures taking up battle positions, perhaps symbolizing the war between Israel and Amalek, which is recalled in the ritual on this special Sabbath. The miniature also includes a hunter with bow and arrows and two animals. Colors, green, yellow, or white figures on a bipartite pink and blue ground.

*Fig. 12*

**14. MS. MICH. 627** (Neubauer No. 1035)

*Maḥzor* (second part) (some lacunae) with the prayers for the New Year, Day of Atonement, and Feast of Tabernacles.

174 leaves (fol. 1, glued to fol. 8 and copied by a different hand, and fol. 100 are not original; two folios are missing from the tenth quire [lacuna in the text between fols. 79 and 80] and one folio from the eleventh quire [lacuna in the text between fols. 81 and 82]); 400 × 295 mm, 300 × 190/200 mm.

Written in Germany in 1258 by Yehuda ben Shemuel, called "Saltman" (see colophon, fol. 174r).

*Fig. 13*

The miniatures in this volume are of the same style (German, ca. 1250–60) as the first volume (see No. 13 above).

**Open page** *(Fig. 13)*: fol. 48r, initial word *Kol* (*Nidrei*); beginning of evening prayers for the Day of Atonement. A portal with decorated pillars and a lintel enclosing various animals and birds painted in green and golden-yellow on a lilac ground and within a large scroll; the miniature bears no relation to the text.

Fig. 14

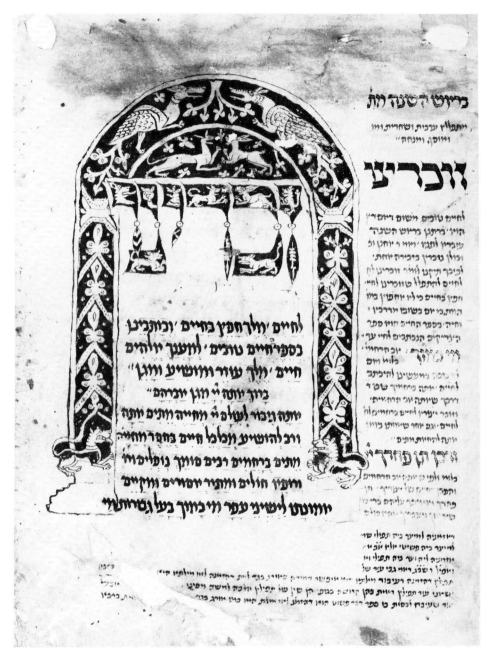

## 15. MS. CAN. OR. 1 (Neubauer No. 1104)

*Siddur* (second volume only, the first is missing), beginning with the New Year's service and including the *hoshanot* followed by the *ma'arivim* for the three festivals, Passover Haggadah, rules for the calendar, etc.

133 leaves; 250 × 190 mm, *siddur* text 155 × 90 mm, with marginal commentary 210 × 130/140 mm.

Written and decorated in Germany (Würzburg? The length of time that elapsed between the date [1256] of the legal documents in this *siddur* and the likely period of

*Fig. 15*

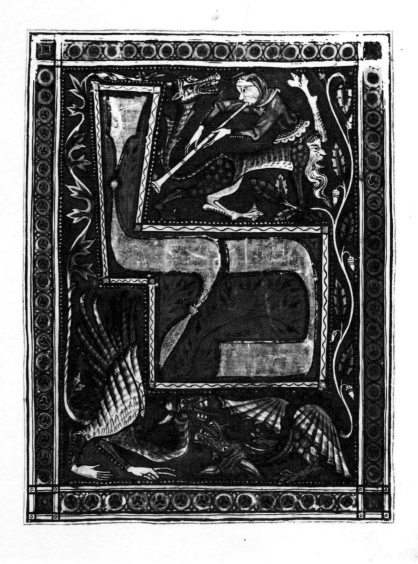

its copying makes it uncertain whether it was copied in the same place, Würzburg, as the documents) at the beginning of the fourteenth century (see fols. 91v–92v, the calendars for 1295–1351 and 1304–13).

The decorative, pen-drawn patterns of plants and animals "reserved" on an ink ground that we see in this manuscript are common in German Hebrew manuscripts from the last half of the thirteenth century.

**Open page** *(Fig. 14)*: fol. 1v, initial word *zokhrenu* for the *Amidah* for New Year. The letters of the initial word contain animals and stylized plants similar to those in the Romanesque arch framing the opening text of the volume.

### 16. MS. MICH. 619 (Neubauer No. 2374)

*Maḥzor* (one part only, containing the prayers for the New Year and the Day of Atonement; another part is in the Kaufmann collection, Hungarian Academy of Sciences, Budapest (Ms. A 384), and the third part is in the British Library (MS. Add. 22413).

293 leaves (but fols. 1 and 283–293 were written by different hands and were added later); 345 × 244 mm (edges trimmed), main text 204 × 91/105 mm.

Written and illuminated in Germany ca. 1320–25.

Miniatures of a similar style can be seen in several Hebrew manuscripts executed in Germany in the first quarter of the fourteenth century, e.g., Österreichische Nationalbibliothek, Vienna, Cod. Hebr. 75 (a prayer book and ritual), the so-called Schocken Bible in Jerusalem, and the Sussex Pentateuch in the British Library.

**Open page** *(Fig. 15)*: fol. 100v, beginning of evening prayers for the Day of Atonement; initial words *Kol Nidrei* in monumental gold letters on a red ground at the center of a framed panel showing fierce fantastic creatures (unrelated to the text) set on a blue ground; vigorous drawing and vivid coloring.

### 17. MS. OPP. 161 (Neubauer No. 1051)

*Maḥzor,* with common prayers (the beginning is missing, as are six leaves between fols. 15 and 16) and prayers for the special *Shabbatot,* Passover, and Pentecost.

145 leaves; 315 × 247 mm, 220 × 163 mm.

Written and decorated in Germany in 1342 by "the scribe Jacob" (*Yaakov ha-Sofer*) (colophon, fol. 145r).

The illustrations and decoration are of a crude kind but can be placed within a popular style still prevalent in Germany during the first half of the fourteenth century.

**Open page** *(Fig. 16)*: fol. 84r, pen-drawn signs of the zodiac at the end of the Song of Songs, which is read on the Sabbath falling within Passover. This illustration bears no relation to the text, although the signs of the zodiac also illustrate the prayer for dew on fols. 62v–64v read at Passover.

### 18–19. MSS. REGGIO 1 AND 2 (Neubauer Nos. 1023 and 1024)

*Maḥzor* in two volumes: vol. 1 = prayers for the special *Shabbatot,* Passover, and Pentecost, the *ma'arivim* for the three festivals, the prayers for New Year, and the *haftarot* for the festivals (incomplete); vol. 2 = final kaddish for New Year and the prayers for the Day of Atonement and the Feast of Tabernacles.

MS. Reggio 1: 277 leaves; 324 × 237 mm ⎫ decorated parts 215 × 132 mm,
MS. Reggio 2: 259 leaves; 325 × 238 mm ⎭ other parts 227/228 × 135/136 mm.

Written in Germany by several hands. The original manuscript, a *maḥzor* in one volume for New Year, the Day of Atonement, and the Feast of Tabernacles, is now divided between the two volumes, i.e., vol. 1, fols. 158–253, and vol. 2, fols. 1–257. The other parts, i.e., vol. 1, fols. 1v–157v and 254r–277v, and vol. 2, fols. 257v–259v, were added by different hands, ca. 1400 and later in the fifteenth century, respectively.

The illustrations and decoration, reserved on a hatched ground, are pen-drawn in red and sepia ink; they are found only in those parts from the original manuscript. The style of the figures and forms is from the last decade of the fourteenth century.

*Fig. 16*

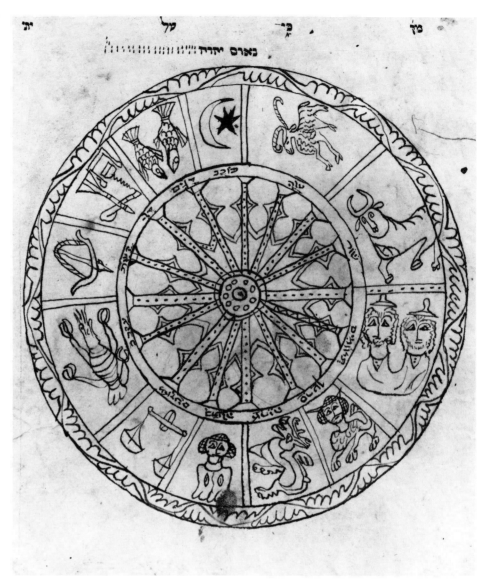

**Open pages:**

MS. Reggio 1 (*Fig. 17*): fol. 159v, initial word *Melekh* for the *piyyuṭ* read at the start of morning prayers on the Day of Atonement with a drawing of the sacrifice of Isaac. Abraham, holding a knife and pointing at Isaac kneeling on the altar, looks toward the angel, who in turn points to the ram caught on a branch, ready for the sacrifice; to the right a man blows the shofar, symbol of the sacrifice recalled at New Year. Various animals and drolleries. The illustration relates to the Day of Atonement prayer.

MS. Reggio 2 (*Fig. 18*): fol. 1v, initial word *Kol* (*Nidrei*); drolleries, two of whom are fighting—one wearing a helmet holds a shield and is ready to strike the other, who flourishes a club (perhaps a symbolic injunction against warfare, an illustration that would fit well with the prayers for the Day of Atonement).

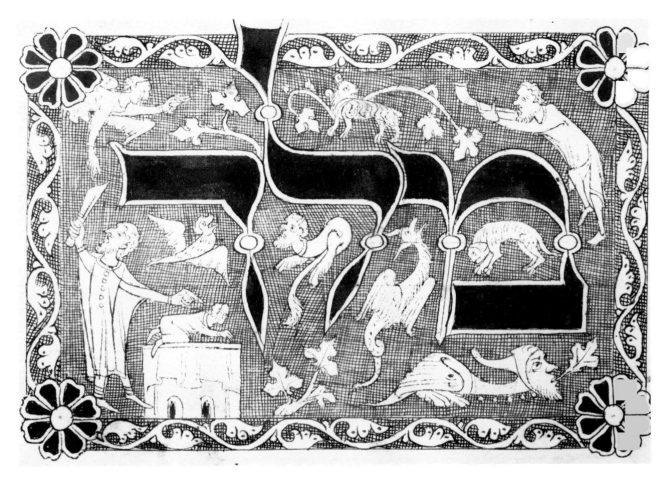

*Fig. 17*

**20. MS. OPP. 776** (Neubauer No. 1126)

*Siddur* (prayer book for the whole year, common prayers).

90 leaves; 94 × 84 mm, 70 × 48 mm.

Written and illustrated in Germany, ca. 1471; the *siddur* was written by Asher ben Yizhak Hasho(?) in [5]231 ( = 1471).

There are numerous well-executed decorative panels to many of the initial words, comprising figures of musicians or occasionally of men at prayer, set within architectural frames or rich foliage scrolls, and all kinds of animals. The illustrations are not related to any particular detail of the text but simply to the general idea of prayer and praising God. The miniatures are of a rather high standard of execution and may be narrowed down to southern Germany, ca. 1470.

**Open page** *(color plate 8)*: fol. 8v, musicians and singers for the initial words of Psalm 19.

**21. MS. LYELL 99**

*Siddur* (see No. 20) with *haggadah* (fols. 75v–93r), etc.; text incomplete, at least one quire is missing at the end.

264 leaves; 77 × 56 mm, 44 × 32 mm.

*Fig. 18*

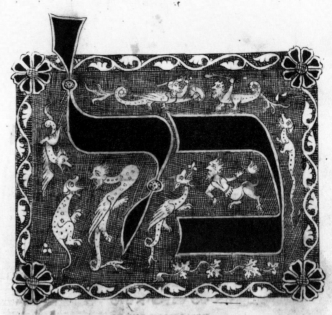

Fig. 19

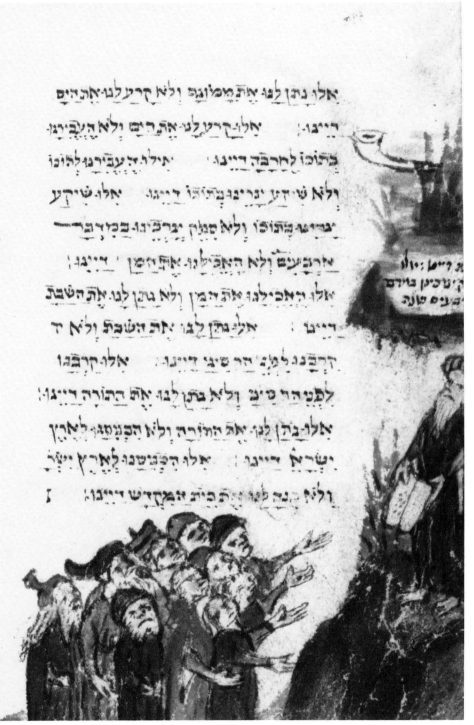

אלו נתן לנו את ממונם ולא קרע לנו את הים
רייגו׃　　אלו קרע לנו את הים ולא העבירנו
בתוכו לחרבה דיינו׃　אילו העבירנו לתוכו
ולא שיקע ינרינו בתוכו דיינו׃　אלו שיקע
ינרינו בתוכו ולא ספק ינרכינו במדבר
ארבעים ולא האכילנו את המן רייגו׃
אלו האכילנו את המן ולא נתן לנו את השבת
דיינו׃　אלו נתן לנו את השבת ולא ד
קרבנו לפני הר סיני דיינו׃　אלו קרבנו
לפני הר סיני ולא נתן לנו את התורה דיינו׃
אלו נתן לנו את התורה ולא הכניסנו לארץ
ישראל דיינו׃　אילו הכניסנו לארץ ישר
ולא בנה לנו את בית המקדש דיינו׃

**Codex:** some Italian characteristics, but written by an Ashkenazi hand, ca. 1460–70; the rite is also Ashkenazi.

It contains several miniatures, plainly German in style, that bear a strong iconographic resemblance to miniatures in two illuminated *haggadot* of ca. 1460–70, Sassoon MS. 511 (now Flörsheim Trust, Bermuda) and Darmstadt Cod. or. 28. Those *haggadot,* both of Ashkenazi rite, were written by Jews of Ashkenazi origin, and from some of their codicological features, unusual in German countries, they may have been copied in southern Germany or northern Italy. However, like MS. Lyell 99, both display an entirely German iconography and a strongly German style of painting, with (mainly in the Darmstadt manuscript) faint hints of Italian fashion in the young men's garments.

**Binding:** black morocco, with silver clasp and corner-pieces in cathedral style, nineteenth century.

**Open page** *(Fig. 19)*: fol. 83v, Moses on Mt. Sinai showing the Tablets to the Hebrews, who stand in front of the mountain, eager to receive the Law; colors, red and green.

This manuscript, which was received through the Lyell Bequest in 1950, was the last illuminated Hebrew manuscript to be received by the Bodleian Library before 1982, when the two former Sassoon manuscripts, Sassoon 499 and 516, were acquired.

### 22. MS. MICH. 610 (Neubauer No. 1059)

*Maḥzor* (part 1) containing the daily prayers and prayers for the Sabbath, Passover, and Pentecost.

207 leaves; 335 × 245 mm, 205 × 147 mm.

Written and illustrated in Italy, ca. 1460.

All the illustrations and decoration in this volume are pen-drawn, sometimes with wash (some initial letters are in gold leaf), and from their style belong to a group of illuminated Hebrew manuscripts of ca. 1450–70 from northern Italy.

**Open pages:** fol. 94v, a decorated circular panel drawn in red and blue ink, representing the *mazzah* (not illustrated); fol. 95r *(Fig. 20)*, an ornamental bowl containing leaves of bitter herbs (*maror*) drawn in red ink.

The illumination in most of these manuscripts was generally unknown in 1977 at the time of the exhibition but for the following notable exceptions.

The decoration and iconography of MS. Kenn. 1 (No. 4) had been studied by several scholars, principally Cecil Roth, *The Kennicott Bible* (Oxford, 1957) (Bodleian Picture Book No. 11), and Thérèse Metzger, "Les Objets du Culte, le Sanctuaire du Désert et le Temple de Jérusalem, dans les Bibles Hébraïques Médiévales Enluminées en Orient et en Espagne," *Bulletin of the John Rylands Library* LII–LIII (1970), offprint, pp. 81–82, and it was the only one of the group to have been included in Bezalel Narkiss, *Hebrew Illuminated Manuscripts* (New York/Jerusalem, 1969), pl. 17, p. 74.

The iconography of the Temple in MS. Kenn. 2 (No. 3) was studied by T. Metzger, "Les objets du culte," pp. 14–16. Micrographic decoration in it and in MS. Opp. Add. 4° 26 (No. 5) was located and analyzed by the same author in "La masora ornementale et le décor calligraphique dans les manuscrits hébreux espagnols au moyen âge," in *La paléographie hébraïque médiévale*, Colloques internationaux du CNRS, no. 547, September 11–13, 1972 (Paris, 1974), pp. 103–5 and 108–11.

Since 1977 two of the manuscripts, MS. Kenn. 1 (No. 4) and MS. Reggio 1 (No.

*Fig. 20*

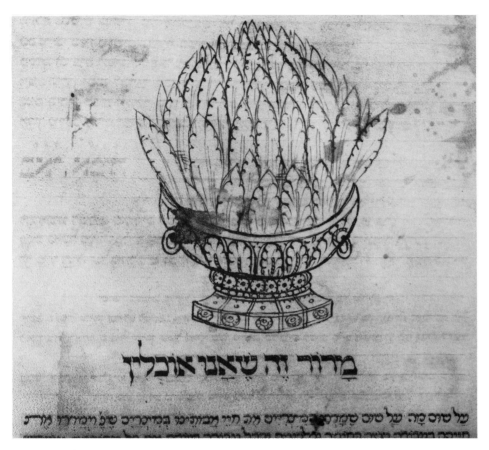

מדור זה שׁאנו אוכלין

על סום מַה על סוּם סמרייס מב חיי וַבומתיני במיקריך טלץ וימזרך מרק

18), have been mentioned by Joseph Gutmann, *Hebrew Manuscript Painting* (New York, 1978), p. 19 and fig. IX, and p. 25 and fig. XII.

Miniatures from 13 of the manuscripts—Nos. 3, 4, 6, 11–14, and 16–22, have been described or reproduced by Thérèse and Mendel Metzger in *La vie juive au moyen âge, illustrée par les manuscrits hébraïques enluminés du XIIIe au XVIe siècle* (Fribourg/Paris, 1982) and will be found in the catalog there, pp. 310–11, as Nos. 158, 157, 151, 153, 152, 163, 165, 164, 169, 173, 171, 160, and 162, respectively.

Four of the manuscripts, Nos. 3, 4, 5, and 9, have been described in Bezalel Narkiss, Aliza Cohen-Mushlin, and Anat Tcherikover, *Hebrew Illuminated Manuscripts in the British Isles* (Jerusalem/London, 1982), published Spring 1983, as Nos. 3, 55, 48, and 29, respectively.

Gabrielle Sed-Rajna describes three of the manuscripts, Nos. 13, 14, and 16, in *Le Maḥzor enluminé, les voies de formation d'un programme iconographique* (Leiden, 1983), no. 1, pp. 13–14, 63–64, and no. 7, pp. 16–17, 74–75.

T. Metzger has summed up the problem of the origin of the group to which MS. Opp. Add. 4° 26 (No. 5) belongs in "Les manuscrits hébreux décorés à Lisbonne dans les dernières décennies du XVᵉ siècle," in *L'humanisme portugais et l'Europe (Actes du XXIᵉ Colloque International d'Etudes Humanistes, Tours, 3–13 juillet 1978)* (Paris, 1984), pp. 778–9.

A facsimile of MS. Kenn. 1 has been published, *The Kennicott Bible* (London, 1985), with an introduction by B. Narkiss and A. Cohen-Mushlin.

The miniatures on fols. 442v and 443r of MS. Kenn. 1, reproduced in the present volume, have been commented on by U. Schubert in "Zwei Tierszenen am Ende der Ersten Kennicott-Bibel, La Coruña, 1476, in Oxford," *Jewish Art* 12–13 (1986/87), pp. 83–88.

Thérèse Metzger, in "Josué ibn Gaon et la masora du Ms. Iluminado 72 de la Biblioteca Nacional de Lisbonne," *Codices manuscripti* XV (1990), (5th fasc.), pp. 1–27 (20 figures), has published a series of hitherto-overlooked signatures of Joshua and reconsiders the authorship of copies of the *Masorah* in some unsigned manuscripts generally attributed to him.

## Notes

1. The catalog text, first distributed as offset, has been revised, corrected, and completed on some points by the authors.

2. The following order has been adopted: Nos. 1–7, Biblical texts—Ashkenazi, Sephardi, and Italian; Nos. 8–12, Nonbiblical texts (Halakhah, Philosophy, Commentaries)—Ashkenazi, Sephardi, and Italian; and Nos. 13–22, Prayer books—Ashkenazi and Italian. The order is chronological within each part.

3. All the manuscripts on display are described in *Catalogue of the Hebrew Manuscripts in the Bodleian Library and in the College Libraries in Oxford . . .* compiled by A. Neubauer (Oxford, 1886) with the exception of MS. Lyell 99, which was acquired by the Bodleian in 1950 and is described in *Catalogue of the Collection of Medieval Manuscripts Bequeathed to the Bodleian Library Oxford by James P. R. Lyell,* compiled by Albinia de la Mare (Oxford, 1971), pp. 276–77, No. 99.

4. The first measurement is the size of the parchment or paper leaf, the second (and occasionally a third) measurement the size of the written area.

# Isaiah Shachar: Curriculum Vitae

| | |
|---|---|
| 1935 | Born Haifa, Israel. |
| 1941–45 | Réali Elementary School, Haifa. |
| 1946–53 | Réali Gymnasium, Haifa; graduated 1953. |
| 1953–56 | Military service, Israel Army. |
| 1956–58 | Agricultural labourer (member of kibbutz Reim) |
| 1958 | Began academic studies at the Hebrew University of Jerusalem in History and Jewish History. |
| 1961 | B.A., summa cum laude. |
| 1962 | Assistant to Professor J. L. Talmon, Department of History, the Hebrew University of Jerusalem. |
| 1963 | M.A., summa cum laude; thesis title: "Criticism of the Jewish Community and Its Leadership in the Ḥasidic and Non-Ḥasidic Literature of Eighteenth Century Poland—A Comparative Study" (in Hebrew). |
| | Assistant Curator of Judaica, Bezalel National Museum, Jerusalem. |
| | Began work on doctoral dissertation at the Warburg Institute, University of London, under the supervision of Professor E. H. Gombrich. |
| 1964–66 | Junior Research Fellow, Warburg Institute. |
| | Recipient, Charlotte and Moritz Warburg Scholarship for Advanced Jewish Studies, the Hebrew University of Jerusalem. |
| 1967 | Ph.D. (History), University of London; thesis title: "Studies in the Emergence and Dissemination of the Modern Jewish Stereotype in Western Europe." |
| | Curator of Judaica, The Israel Museum, Jerusalem. |
| | Lecturer in Jewish history (part-time), the Hebrew University of Jerusalem. |
| 1970 | Lecturer in Jewish history (full-time), the Hebrew University of Jerusalem. |
| 1971 | Senior Lecturer in Jewish history, the Hebrew University of Jerusalem. |
| 1973–74 | On sabbatical leave in London. |
| 1974–75 | On leave from the Hebrew University and The Israel Museum, in London. |
| | Visiting Lecturer, Oxford Centre for Postgraduate Hebrew Studies. |
| 1975–76 | Littman Fellow, Oxford Centre for Postgraduate Hebrew Studies. |
| 1976–77 | Visiting Fellow, Oxford Centre for Postgraduate Hebrew Studies. |

## Publications *

"The Token-Money of Palestine," *The Holy Land Philatelist* vi (64/5) (1960), pp. 1306–7.

*Jewish Textiles,* Jewish Art Exhibitions at the Bezalel National Museum, 1 (1960) (in Hebrew and English).

*Joy in Shushan,* Jewish Art Exhibitions at the Bezalel National Museum, 3 (1961) (in Hebrew and English).

"Burial Society Glass," *Bezalel* (Bulletin of the Bezalel National Museum) ii (1963) (in Hebrew, English, and French).

*Heinrich Feuchtwanger Memorial Exhibition,* Jewish Art Exhibitions at the Bezalel National Museum, 5 (1964).

"The School of Moravia: A Popular Trend in Jewish Art," in *Third World Congress of Jewish Studies . . . Report* (Jerusalem, 1965), pp. 358–59.

Additions and index in L. A. Mayer, *Bibliography of Jewish Art,* ed. O. Kurz (Jerusalem, 1967).

*The Feuchtwanger Collection: Jewish Tradition and Art* (Jerusalem, 1971) (in Hebrew).

"'Feast and Rejoice in Brotherly Love': Burial Society Glasses and Jugs from Bohemia and Moravia," *The Israel Museum News* ix (1972), pp. 22–51; also in Hebrew edition of the *News* ix (1972), pp. 22–49.

*The Seal of Naḥmanides* (Jerusalem, 1972) (in Hebrew and English).

*The Judensau: A Medieval Anti-Jewish Motif and Its History,* Warburg Institute Surveys, 5 (London, 1974).

"The Emergence of the Modern Pictorial Stereotype of the Jew in England," in *Abraham Harman Jubilee Volume: Studies in the Cultural Life of the Jews in England,* ed. D. Noy (Jerusalem, 1975), pp. 42–68.

*The Jewish Year,* fascicle 3 of Section XXIII of *Iconography of Religions,* ed. Th. P. van Baaren, L. Leertouwer, F. Leemhuis, and H. Buning (Leiden, 1975).

*Jewish Tradition in Art: The Feuchtwanger Collection of Judaica,* English edition, enlarged (Jerusalem, 1981).

## Incomplete:

A book entitled "The Jew by His Looks: A History of a Race Stereotype."

Two articles on hitherto unknown seventeenth-century Hebrew sources bearing on the Chmielnitzki massacres (and the Swedish *Gezerot*) and on the Sabbatean movement in Holland.

---

* This list excludes editing, book reviews, etc.

# About the Editor and Contributors

CHIMEN ABRAMSKY was Goldsmid Professor of Hebrew and Jewish Studies at University College, London (now Emeritus), and was a Senior Fellow, St. Antony's College, Oxford.

BERNHARD BLUMENKRANTZ was a director of research at the Centre National de la Recherche Scientifique, Paris, and a prolific worker in the field of Jewish studies. He founded the Commission Française des Archives Juives, Paris, and the journal *Archives Juives*.

JOSEPH GUTMANN is Professor Emeritus of Art History, Wayne State University, Detroit, Michigan.

MENDEL METZGER is a director of research, Centre National de la Recherche Scientifique, Paris; former Visiting Professor, Hochschule für Jüdische Studien, Heidelberg; and a former Visitor at the Institute for Advanced Study, Princeton.

THÉRÈSE METZGER, Docteur és lettres, is the author of many books and articles in the field of Hebrew illuminated manuscripts and is a former member of the Institute for Advanced Study, Princeton.

ALFRED MOLDOVAN is a practicing physician in New York City, a collector of Judaica, and founding chairman of the Friedman Society of Judaica Collectors.

CLARE MOORE was at the time of the conference a member of the staff at the Oxford Centre for Postgraduate Hebrew Studies. While at the Oxford Centre, she and Isaiah Shachar worked for many months on the organization of the conference. She has since worked at the Whitechapel and Tate galleries in London.

VIDOSAVA NEDOMAČKI was until her retirement Professor of Near-Eastern Archeology at the University of Belgrade and is Honorary Director of the Jewish Museum, Belgrade. She lives in Paris and Belgrade.

HELEN ROSENAU was Reader in the History of Art, Manchester University, Manchester, U.K.

URSULA SCHUBERT is Curator at the Austrian Jewish Museum in Eisenstadt and Lecturer in Jewish Art at the Institute of Jewish Studies, University of Vienna.

# Index of Manuscripts

# General Index

*Manuscripts are listed separately (see p. 173) but their informal titles will be found below.*

Aaron (high priest), 32
  in the Tabernacle theme, 25
Abrabanel, Samuel, 147
Abraham (patriarch), 132, 162, 163(fig.)
Abramson, Abraham, 84–85
Abramson, Jacob Abraham, 84
Academic realism in art, return to, 13
Adam, 37, 38–40(figs.), 41–44
Adam and Eve, 71(nn 5, 7), 148(fig.), 149
Adler, Hermann, 3
Adler, Nathan Marcus, 2
*Adversus haereses* (Eirenaeus of Lyons), 42
Aelfric Paraphrase of the Hexateuch. *See* Index of MSS.,
  London
Aḥa bar Jacob, 26
Amalek, 156, 157(fig.)
Ambrosian Bible. *See* Index of MSS., Milan
Amor, 84(fig.), 85
Angels, 43, 44. *See also* Cherubim; Winged beings
Anhalt-Dessau, duke of. *See* Leopold Frederick Franz
Animal-headed figures, 49, 156, 157(fig.). *See also* Lion-
  headed human figure
Anti-Christian polemics, 75(n30), 80(n55)
Anti-Jewish iconographic motifs, xii
Antique (period), 25, 26, 27, 37, 38, 42, 43, 44, 88
  controposto figures, 43
  imitation of, 83
  symbol, 40(fig.), 41, 84(fig.), 85
*Antiquities* (Josephus Flavius), 42
Anti-Semitism, xi, 3, 4, 5
Aquamaniles, lion-shaped, 115–118(figs.)
Aramaic inscription, 32
*Arba'ah Turim* (ben Asher), 138
Architecture, 10, 83–104(figs.), 123, 124(fig.). *See also*
  Synagogues
*Architecture Civile* (Lequeu), 90
*Architektonischen Stylarten, Die* (Rosengarten), 99
Ardon, Mordecai, 16
Ark (Torah shrine), 88, 91, 95, 133
Arnold, Matthew, 3
Art. *See* Jewish art
Art, ethnic purity of, 21

Art nouveau, 100
Asaph, 59(fig.), 60, 62(fig.), 63
Ashburnham Pentateuch. *See* Index of MSS., Paris
Ashkenazim, 88
Ashkenazi *mahzor,* 138, 154, 155, 156–166(figs.)
Ashkenazi manuscripts, color plates 5 and 8, 47–53(figs.),
  68, 137, 138, 141–142(fig.), 143, 149, 151–152(figs.),
  153, 154, 155, 156–166(figs.), 167
*Ashrei* (initial word in Book of Psalms), 47, 48(figs.)
Assimilation, 3
Astrolabe, 105, 106–107(figs.)
Avicenna, 8
*Avodah Zarah,* 25

Baal-Zephon, 33, 34, 35. *See also* Phihahirot
Babylonian Talmud, 2
Baillie, Edward Hodges
  Moses Montefiore monumental centerpiece, 84–85(figs.),
  86
Bakhman, L., 100
  builder of St. Petersburg synagogue, 100, 101(figs.)
Balak, 144
Basevi, George, 97
Baskin, Leonard, 14
Basque Museum (Bayonne), 126
"Battle to save the Jewish art which has survived the ravages
  of persecution, The" (Shachar), xiv–xv
Bauhaus, 100
*Bava batra,* 73(n20)
Bayer, Melchior, 113
Bellini, Leonardo, 77(n41)
*Bellum Judaicum* (Josephus Flavius), 25
Bendemann, Eduard von, 10
  painting of "By the Waters of Babylon," 10, 11(fig.)
Benguiat, Ephraim, 5, 106, 108
Benjamin, Israel Joseph (Benjamin II), 2
Ben Sasson, H. H., xi
Benzinger, Immanuel, 2
Berenson, Bernard, 3
Berlin Ethnographic Museum, 5
Berlin Museum, 116
Beth Alpha synagogue, 26

Bezalel (biblical artist), 2, 15
Bezalel National Art Museum. *See* Israel Museum, The
Bezalel School of Arts and Crafts (Jerusalem), 13
Bible. *See* Hebrew Bible
Biblical anthropology, 42
*Bibliography of Jewish Art* (Mayer), xii
Bibliothèque nationale (Paris), 90. *See also* Index of MSS., Paris
Bindings, manuscript, 137, 144, 149, 166
Birds' Head Haggadah. *See* Index of MSS., Jerusalem
Bitter herbs. *See Maror*
Blessing before a meal, 36. *See also under* Joseph
Bodleian Library (Oxford), 137, 138. *See also* Index of MSS., Oxford
  catalog of Hebrew manuscripts exhibited (1977), color plates 5–8, 141–168
Bohemia-Moravia, xiii, 170
Bordeaux synagogue, 93, 94(figs.), 95
Bordes, Auguste, 93
  watercolor of Bordeaux synagogue, 94(fig.)
Borochov, Ber, xi
Braga, Isaac ben Solomon de, 144
British Library (London), 138. *See also* Index of MSS., London
British Museum (London), 106
Brother to the John Rylands Haggadah. *See* Index of MSS., London
Buber, Martin, 3, 5
Budapest synagogue (Hungary), 95
Burial societies, xiii, 133
Bury St. Edmunds (England), 28
Butterfly, 41, 84(fig.). *See also* Psyche
"By the Waters of Babylon" (painting), 10, 11(fig.)
Byzantine art, 26
Byzantine style, 95, 99
Byzantium, 26

*Canon of Medicine* (Avicenna) (Hebrew translation), 8, 9(fig.)
Carpet pages, 147
Cassel synagogue (Germany), 98(fig.), 99
Catacombs, 2, 5
Cats and mice, wars of, 144, 146(fig.)
*"Caveat Emptor Judaeus"* (Roth), 105
Central Archives of Jewish Art, xiii, xv, 121, 127–128
Ceremonial art, 1. *See also* Judaica; Synagogues
Ceremonial objects, 4, 6. *See also* Judaica
Chagall, Marc, 6, 14
Charleston synagogue (South Carolina), 95(fig.)
Chauvinism in art, 13
Cherubim, 26. *See also* Angels; Winged figures
Chicago Planetarium, 106
Christian architects, 83, 88(fig.), 89–97(figs.)
Christian Councils, 43
Christian humanists, 68

Christian inquisitors, 26
Christian manuscript illustrations, 14, 27, 28, 31, 35, 36, 38, 41, 44
  of Jewish origin, color plate 1, 27, 28–29, 35–37(fig.)
Christian symbols, 11, 66(fig.), 68, 84(fig.), 85
"Christ in the Tomb" (sculpture), 6, 8(fig.)
Classicism, 100. *See also* Neoclassicism
Clermont-Ganneau, Charles, 5
Cluny Museum (Paris), xiv, 5, 126
Cohen-Mushlin, Aliza, 167
Cohn-Wiener, Ernst, 6(fig.)
Colophon, 69, 141–161 passim
Columbian Exposition (1893 Chicago), 5
Column of Pompey, 85(fig.)
Commentary
  on the Bible (Rashi). *See* Index of MSS., Florence and Munich
  on Ecclesiastes (Farissol). *See* Index of MSS., Oxford
  on the Pentateuch (Naḥmanides). *See* Index of MSS., Manchester
  on the Pentateuch (Rashi). *See* Index of MSS., Oxford
  on Psalms (Kimḥi). *See* Index of MSS., Berlin
Commission française des Archives juives (Paris), 121, 129
  descriptive list of objects, 131–134
  questionnaire, 130
Contrapposto figures, 43
Corcelles, Arnaud
  architect of Bordeaux synagogue, 93, 94(figs.), 95
Corinth, Joseph Louis
  portrait of Karl Schwarz, 6(fig.)
Cotton Genesis and recension. *See* Index of MSS., London
Cow, 144
Creation, three stages of. *See* Trichotomic anthropology
"Criticism of the Jewish Community and Its Leadership in the Ḥasidic and Non-Ḥasidic Literature of Eighteenth Century Poland—A Comparative Study" (Shachar master's thesis), xi, 169
Cup, 49(fig.), 50, 54, 55(fig.), 113–115(figs.), 116(fig.). *See also* Kiddush cup; Passover, "drinking vessel"
Cymbals, 54

Dance, George, 88
Daniel ben Samuel, 153
David (king), 26, 47, 48(figs.), 49, 51(fig.), 52, 53(figs.), 59(fig.), 60, 61(fig.), 63, 64, 65(fig.), 67(fig.), 68–69(fig.), 80–81(n56), 144
  anointed by Samuel, theme, 25
  as Orpheus, 64–65(fig.)
  "Psalm of," color plate 3, 56, 57(figs.), 58
  with halo, 66(fig.), 68
David ben Isaac, 142
Day of Atonement prayers, 157, 158(fig.), 160(fig.), 161, 162, 163(fig.), 164(fig.)
Deer, 49(fig.), 50, 54, 55(fig.), 56, 59(fig.), 60, 64(fig.). *See also* Hart; Stag

De la Mare, A., 68, 78
Del Buono, Mariano, 68
Democratic Fraction, 5
De Rossi collection, color plates 3–4, 56, 57–59(figs.), 60, 61–62(figs.), 63
Deuteronomy, color plate 5
Diaspora, 22, 23, 26
Diaspora Research Institute (Tel-Aviv University), 127
Di Niccolo di Lorenzo, Antonio, 68
Diocletian (Roman emperor), 85
Dogs, war of hares and, 144, 145(fig.)
Dothan, color plate 2, 36
Double-headed eagle, 11
Dresden synagogue, 95, 96(fig.), 97
Drolleries, 54, 55(fig.), 145(fig.), 146(fig.), 152(fig.), 157(fig.), 160(fig.), 162, 163(fig.), 164(fig.)
Duke of Sussex Pentateuch. *See* Index of MSS., London
Dura Europos synagogue, 25, 26, 27, 28(fig.), 29, 30, 31(fig.), 32, 33, 35, 36, 41, 42(fig.), 43, 44, 77(n43)
Duran, Profiat, 2
Durand, P. Ch., 95
Düsseldorf synagogue and precentor's house, 91, 92(figs.)

Ecclesiastes, 49, 52, 141, 149, 150(fig.)
*École juive,* 11, 13
Egypt
   symbolic representations of, 27, 28(fig.), 29(fig.), 30(fig.), 31(fig.), 32(fig.), 34(fig.), 35
   *See also* Exodus from Egypt, theme
Egyptians drowning in Red Sea, 32, 33, 35
Eirenaeus of Lyons (bishop), 42
Elḥanan ben Abraham, 149
Emancipation. *See* Jewish emancipation
"Emergence of the Modern Pictorial Stereotype of the Jew in England, The" (Shachar), xii, 170
Engel, Giuseppe (Joseph)
   bust of David Salomons, 87(fig.), 88
Enlightenment, 85, 95
Erasures, 71(nn 6, 7), 141, 149, 150(fig.)
Erdmannsdorff, Friedrich Wilhelm von
   architect of Wörlitz synagogue, 89(fig.)
*Eretz Israel* (journal), 115
Esther, story of, theme, 25, 141, 142–143(fig.)
Ethnographic museums, 4–5
*Etrog* box, 105, 132
Ettinger, Shmuel, xi
"Etwas über jüdischer Kunst" (Kaufmann), 1
Eve, 43. *See also* Adam and Eve
Exhibitions. *See* Jewish art, expositions of
Exodus from Egypt, theme, 25, 31–34(figs.), 35, 45(n8)
Ezekiel (prophet), 41, 42(fig.)
Ezekiel, Moses Jacob, 6, 14
   sculpture of "Christ in the Tomb," 8(fig.)

Fakes. *See* Judaica, attributions

Farissol, Abraham, 149, 150(fig.)
Feast of Tabernacles. *See* Tabernacles, Feast of
Feiwel, Berthold, 5
Feuchtwanger Collection of Jewish Art catalog, xii–xiii, 170
Filigree spice containers. *See* Spice boxes
Flowers, 54, 56, 74(n24)
Folklore. *See* Jewish folklore
Forgeries. *See* Judaica, attributions
"Forgeries of Jewish Ritual Lavers" (Kurz), 115–118(figs.)
Franconia, 26, 48(fig.)
Frankel, Zacharias, 2, 95
Frauberger, Heinrich, 3, 4(fig.)
Freud, Sigmund, 3

Garrett collection, 69
Garucci, Raffaele, 5
Garzelli, A., 68
Gaza synagogue, 26, 77(n43)
*Genesis rabbah,* 43
Genesis, themes, 27, 36, 37(fig.), 41, 43, 148(fig.), 149
*Genizah,* 126
German rococo style, 11, 12(fig.)
*Gesamtkunstwerk,* 97
*Geschichte der Kunst des Alterthums* (Winckelmann), 1
Gesellschaft für Sammlung und Conservierung von Kunst und Historischen Denkmälern des Judentums (Vienna 1895), 3
Gesellschaft zur Erforschung jüdischer Kunstdenkmäler (Frankfurt 1897), 3–4
Ginzberg, L., 36
Glass dishes, engraved, xiii
Golden Haggadah. *See* Index of MSS., London
Goliath, 63, 66–67(figs.), 68, 76(n38)
Gombrich, Ernst, xii
Goodenough, Erwin Ramsdell, 2
Graetz, Heinrich, 2
"Grandfather's Blessing, The" (etching), 126(fig.)
Grandval Bible. *See* Index of MSS., London
Great Synagogue (London), 91(figs.)
Great Synagogue of Sardis, 26
Greco-Roman art, 14. *See also* Antique
Greek (language), 26
Gregory of Nazianzus, manuscript of. *See* Index of MSS., Paris
Gros, Antoine-Jean, 86
Grotte, Alfred, 3–4
Günzburg, D., 139(n3)
Gutmann, Joseph, 35, 167

*Hadas* (myrtle), 108
   box, 108(fig.)
*Haftarot,* 141, 146, 149, 161
Haggadah. *See* Index of MSS., passim
   psalms within, 70–71(n3)
Hagiographa, 73(n20). *See also* Index of MSS., Paris

prohibition of images. *See under* Representation of living
    beings
religious forms, 6, 11, 22–23
science of, 4
and statehood, 5, 13, 22
Jewish artists, 6–16 passim, 88
    in France, 135
Jewish emancipation, 3, 15, 83, 97, 100
    in Westphalia, 84(fig.), 85
"Jewish Empire," 86
Jewish ethnic consciousness, 3, 5, 26
Jewish folklore, xi, xii
Jewish manuscripts, burned (mid-thirteenth century), 26, 27
Jewish marriage, 132, 133, 134, 153, 156(fig.)
Jewish Museum (New York), xiv, xv, 5
Jewish patronage of the arts, 83
Jewish state, 5, 13, 22, 87
Jews
    British, 88
    German, 3
    and gift for pictorial art, 2–3, 5, 6
    Iraqi, 108
    Orthodox, on art, 1, 2
    Polish, 5
    Russian, 5, 16(n7), 18(n34)
    wealthy, 83, 100, 102(n7)
Johanan bar Nappaḥa, 25
Jonas, 144
Joseph
    meal of Joseph's brothers, color plate 2, 36, 37(fig.)
Joseph ben Ḥayyim, 144
Joseph ben Isaac, 141
Joseph ha-Mekanne (Joseph the Zealot), 26
Josephus Flavius, 25, 42
Judah, 36
Judaica, 4
    attributions, 105–119(figs.) passim, 121–123, 126, 127,
        131–133
    collections, xii–xiii, 5, 17(n30), 105, 106, 116, 125, 127
    museums, xiv–xv, 5, 105, 126
*Judensau, The: A Medieval Anti-Jewish Motif and Its History*
    (Shachar), xii, 170
*Jüdische Kunst, Die* (Cohn-Wiener), 6
Jüdischer Verlag (Berlin), 5, 13

Kaddish, 161
Karlsruhe synagogue, 91, 92(fig.), 93
Kaufmann, David, xiv, 1, 3, 4
Kaufmann collection, 52, 161
Kaufmann Haggadah. *See* Index of MSS., Budapest
Kayser, Stephen, 6
Kiddush cup, 113–114, 132. *See also* Cup; Passover,
    "drinking vessel"; "Passover set"

Kimḥi, D.
    commentary on Psalms. *See* Index of MSS., Berlin
    *Sefer Mikhlol,* 144
Kings, Book of, 52
Kirschstein, Salli, 5
Köhler, Peter
    Düsseldorf synagogue and precentor's house, 91, 92(figs.)
Kohler, Rose, 1
Kolb, Eugene, 13
*Kol Nidrei,* 158(fig.), 160(fig.), 161, 162, 164(fig.)
Kornhäusel, Joseph, 89
*Kos. See* Cup
Krahe, Peter Joseph
    designer of Düsseldorf synagogue and precentor's house,
        91, 92(figs.)
Kurz, Otto, xii, 115–116, 118

Landesherr, Andreas, 95
Landsberger, Franz, 8, 10(fig.)
*Le'an Ne'elam Daniel Wacks?* (film), xiii
Ledoux, C.-N., 91
Lee collection, 116
Leopold Frederick Franz (duke of Anhalt-Dessau), 89
Lequeu, Jean-Jacques, 90
    synagogue design, 90(fig.)
Levi d'Ancona, M., 68
Levy, Henri, 135
    drawing of "Jesus ascending Calvary," 123(fig.)
Lilien, Ephraim Moses, 5
Lion-headed human figure, 47, 48(fig.). *See also* Animal-
    headed human figures
Lipchitz, Jacques, 13, 14
Loewe, Louis, 85
Logos, 43
Lopez, David
    architect of Charleston (South Carolina) synagogue,
        95(fig.)
Lüneburg aquamanile, 116, 117(fig.)
Lute, 56, 57(fig.), 62(fig.), 63

*Ma'arivim,* 159, 161
*Maḥmadim,* 19(n51)
*Maḥzor/maḥzorim,* 52, 53(fig.), 138, 154, 155, 156, 157–
    158(figs.), 160(fig.), 161–162(fig.), 163(fig.), 164(fig.),
    166, 167(fig.)
Maimonides, 149, 153
*Mappah/mappot. See* Torah binders
*Maror,* 166, 167(fig.)
Marranos, 114, 115
Marriage. *See* Jewish marriage
*Masorah,* color plate 5, 143(fig.), 144, 147(fig.), 168
    *Masorah Magna,* 51, 141, 142, 143, 144, 146
    *Masorah Parva,* 141, 143, 144, 146
Masoretic notes, 1
Mayer, Leo A., xii, 115

Pascin, Jules, 13
Passover, 154, 161, 166
"drinking vessels," 113, 114(fig.)
*See also* Haggadah
"Passover set," 115–116(figs.)
Patronage. *See* Jewish patronage of the arts
Paul's first Epistle to the Thessalonians, 42
Peacock, (?) James, 88
Pentateuch, 69. *See also* Index of MSS., Berlin, London,
Oxford, Paris, and Vatican
Commentaries on. *See* Index of MSS., Manchester and
Oxford
Pentateuch of Tours. *See* Index of MSS., Paris
Pentecost, 154, 161, 166
Perugia psalter. *See* Index of MSS., Parma
Peruvian silver, 109, 110–111(figs.)
*Phaedon* (Mendelssohn), 84
Pharaoh
dispute with Hebrew midwives, theme, color plate 1, 27,
28–30(figs.), 31
variant, 27–28
*See also* Baal-Zephon; Exodus from Egypt, theme
Phihahirot, 33(fig.), 35. *See also* Baal-Zephon
"Philosopher, A" (etching), 125(fig.)
Phoenician art, 99
Photographic records, 128
Pigeon, 54
Pinḥas, 144
Pipe (musical instrument), 54, 55(fig.)
*Pirke de-Rabbi Eliezer*, 35
*Pneuma*, 38, 41, 42, 43
Poalei Zion, xi
Prague, State Jewish museum, xiv
Prayer books, 154–167. *See also* Maḥzor; Siddur
Prayer for dew, 161
"Prayer of Moses, the man of God, A," color plate 4
Prometheus sarcophagi, 38
*Propylées* (toll houses), 91
Proverbs, 49, 67, 70(n2)
"Psalm of Asaph, A." *See* Asaph
"Psalm of David." *See under* David
Psalm 1, 59(fig.), 60, 61–62(figs.), 63
Psalm 6, 56, 57(fig.)
Psalm 10, 36
Psalm 19, color plate 8, 163
Psalm 22, 56
Psalm 23, 54, 55(fig.)
Psalm 30, color plate 3, 56, 60
Psalm 34, 56, 57(fig.)
Psalm 35, 56, 57(fig.)
Psalm 42, 50, 54, 55–56(figs.), 59(fig.), 60, 61–62(figs.), 63
Psalm 45, 56
Psalm 48, 57(fig.), 58

Psalm 56, 54
Psalm 59, 58(fig.)
Psalm 60, 54
Psalm 69, 54, 56
Psalm 72, 49
Psalm 73, 59(fig.), 60, 62(fig.), 63
Psalm 75, 49(fig.), 50
Psalm 90, color plate 4, 59, 60, 61(fig.), 63(fig.)
Psalm 97, 50(fig.)
Psalm 104, 56
Psalm 107, 59(fig.), 60, 63
Psalm 112, 60
Psalm 118, 69(fig.)
Psalm 127, 49, 58(fig.)
Psalm 137, 56
Psalm 150, 52, 54, 55(fig.)
Psalms, Book of. *See* Psalter text
Psalms 113–118, psalms of the *Hallel*, 70(n3)
Psalters, 43
Ashkenazi, 47, 48–50(figs.), 51, 68
Christian, 28–29, 43, 68
English, 28–29, 51
Greek, 58, 81(n57)
Italian, color plates 3 and 4, 56, 57–67(figs.), 68, 69(fig.)
Sephardi, in Bibles, 52, 54–56(figs.), 68
Psalter text, 47, 49, 52, 59, 60, 63, 65, 67, 68, 69
Psaltery, 54, 65(fig.), 66(figs.), 67, 68, 69
Psyche/*psychai*, 41, 42, 43, 44, 85. *See also* Butterfly
*Psyche* (soul), 38, 42
Putto, 60, 80(n55)

Raba, Abraham, 149
Rabbit, 54, 55(fig.). *See also* Hares
Ramsgate synagogue and mausoleum (England), 97,
98(fig.), 99–100
Rashi (Solomon ben Isaac), 14, 50, 51
Commentaries. *See* Index of MSS., Florence, Munich, and
Oxford
Reanimation, 41, 42(fig.)
Red Sea, 31, 32, 33, 35
Reinach, Salomon, 5
Rembrandt, 6, 13
Renaissance, 65
Representation of the Creator, 43, 44
Representation of living beings
earliest, 25, 26
prohibition of, 1, 22, 25, 26–27
*Resh* (letter), 47, 48(figs.), 49
Rheims manuscript. *See* Index of MSS., Jerusalem
*Rimonim*, 22, 105, 133
Roman Empire, 25
Romanesque style, 95, 98(fig.), 99, 159(fig.), 160
Romanticism, 83

Rosengarten, A., 99, 103(n23)
  architect of Cassel synagogue, 98(fig.), 99
  architect of Hamburg synagogue, 99–100(figs.)
Rosenthal, Max, 6
  painting of "Jesus at Prayer," 7(fig.)
Roth, Cecil, 8, 105, 106, 166
Rothschild family, 97, 102(n7)
Rothschild Miscellany. *See* Index of MSS., Jerusalem
Royal Albert Hall (London), 5
Rue Notre-Dame-de-Nazareth synagogue (Paris), 93,
  94(fig.), 97
Rylands, John, Library. *See* Index of MSS., Manchester

St. Mark's dome (Venice), 36, 37(fig.), 39–40(figs.), 41, 42,
  43
St. Petersburg Academy of Arts, 100
St. Petersburg synagogue (Russia), 100, 101(figs.)
Salomons, David
  bust, 87(fig.), 88
"Saltman." *See* Yehuda ben Shemuel
Samuel ben Joshua ben Joseph, 146
Samuel ben Moses ha-Levi, 141
Sandrié, P. J.
  builder of Rue Notre-Dame-de-Nazareth synagogue
    (Paris), 93, 94(fig.)
*Sanhedrin*, 36
Santa Maria Maggiore (Rome), mosaics, 31
Sarcophagus of Aix-en-Provence, 45(n8)
Sassoon, David, 108
Sassoon Bible. *See* Index of MSS., Jerusalem
Sassoon collection, 52, 70(n3), 166
Saulcy, Louis-Félicien de, 1
Schatz, Boris, 13
Schlosser, Julius von, xiv, 3
Schnaase, Carl, 2
Schocken Bible. *See* Index of MSS., Jerusalem
Scholem, Gershom, xiii
Schor, Ilya, 14
Schubert, U., 168
Schuchardt, August, 99
Schwarz, Karl, 5, 6(fig.)
Sculpture, 6, 8(fig.), 84–86(figs.), 87(fig.), 88
Seals, xiii, 132, 133
Second Comandment, 1, 22. *See also* Representation of living
  beings
Second Nuremberg Haggadah. *See* Index of MSS., Jerusalem
Sed-Rajna, Gabrielle, 127, 167
Sefer "Emet." *See* Index of MSS., Jerusalem
*Sefer Mikhlol* (Kimḥi), 144, 145–146(figs.)
*Sefer Mizvot Gadol* (Moses of Coucy), 149
Semper, Gottfried, 99, 100
  architect of Dresden synagogue, 95, 96(fig.), 97
  designs for Paris synagogue, 96–97(figs.)

Sephardi/sephardim, 88, 93, 95
Sephardi manuscripts, color plate 6, 52, 54–56(figs.), 68,
  137, 138, 143–147(figs.), 153, 154(fig.)
Serpent, 148(fig.), 149
*Shabbatot*, special, 154, 156, 161
Shachar, Isaiah (Ishay) (1935–1977), vii–viii, x(photo), xi–
  xv, 169–170
  as bibliophile, xiii–xiv
  and Central Archives of Jewish Art, vii–viii, 121, 128
  children, xii, xiii, xiv
  curriculum vitae, 169
  education, xi–xii
  Hebrew University lecturer, xii
  illness, xiii
  Israel Museum curator, xii–xiii
  medieval Jewish art, interest in, xi
  military service, xi
  as movie actor, xiii
  name, xi
  at Oxford Centre for Postgraduate Hebrew Studies, xiii
  work on *Bibliography of Jewish Art*, xii
  writings, xii–xiii, xiv–xv, 170
Shahn, Ben, 14
Shaposhnikov (Russian architect), 100
*Shivḥei ha-Besht*, xiii
Shofar, 133, 162, 163(fig.)
*Shulḥan Arukh*, 1
*Siddur*, color plate 8, 138, 159(fig.), 160, 163, 165(fig.),
  166
Silveyra, Jacob
  builder of Rue Notre-Dame-de-Nazareth synagogue
    (Paris), 93, 94(fig.)
Sima, Miron, 13
Sister to the Golden Haggadah. *See* Index of MSS., London
Skirball Museum (Hebrew Union College), 5
Smithsonian Institution, 106, 109
Soane, John, 97
Société des arts juifs (Paris), 13
Société d'histoire des Israélites d'Alsace et de Lorraine, 126
Solomon (king), 26, 48(fig.), 49, 58(fig.)
Solomon (scribe), 149
Solomon, Solomon J., 13
*Soma*, 38, 42
"Song at the Dedication of the House, A," color plate 3, 56
Song of Songs, 161
Soutine, Chaim, 13
Spain
  pre-Expulsion ritual objects, 105
Spanish Gothic art, 11
Spanish haggadot, 27, 30, 35, 36
Spice boxes, 106, 107–110(figs.), 111, 112(figs.), 113
Spiller, James, 91